POSTMODERN ART EDUCATION:

AN APPROACH TO CURRICULUM

D0829828

Arthur D. Efland
The Ohio State University

Kerry Freedman
The University of Minnesota

Patricia Stuhr
The Ohio State University

1996

The National Art Education Association

About NAEA...

Founded in 1947, the National Art Education Association is the largest professional art education association in the world. Membership includes elementary and secondary teachers, art administrators, museum educators, arts council staff, and university professors from throughout the United States and 66 foreign countries. NAEA's mission is to advance art education through professional development, service, advancement of knowledge, and leadership.

ISBN 0-937652-89-X

TABLE OF CONTENTS

(continued)

CURRICULUM PROBLEMS AT CENTURY'S END: ART EDUCATION AND POSTMODERNISM

THE WANING OF MODERNISM

In the 1980s, curriculum discourse in art education was centered on the pros and cons of discipline-based art education (DBAE). Art educators debated the implications of adding aesthetics, art history, and art criticism to studio studies. In the midst of this discussion, there seemed to be little recognition of the fact that within these disciplines a disquieting set of new critical issues was taking shape. A number of ideas pervading modern art since its initial appearance at the end of the 19th century were being questioned. As part of the conflict, some theorists argued that modernism itself had become the academic style of the present and the style of the American mainstream cultural establishment, just as French academic style became the art of the French upper classes of the last century. Other theorists claim that modernism, both as an art style and an epoch in Western culture, had entered a postmodern cultural condition.

Several symptoms lend support to the possibility that we are in a new cultural era. One is the fact that the parade of new styles, the various "isms" from Impressionism, Cubism, and onward to Abstract Expressionism and Minimalism, which was thought of as evidence for the progressive advance of art, is being questioned by art critics and historians. Increasingly, they ask whether the relentless pursuit of the new as a value is really progress at all. Moreover, this criticism is mounting at a time when the professional fine art community feels itself to be in a state of stylistic exhaustion.

Lest there is doubt that the issue of cultural disjunction and change is real and, if real, of sufficient importance to warrant our attention, consider Kim Levin's (1979) description of the professional fine art community of the late 1970s.

> *Something did happen, something so momentous that it was ignored in disbelief: modernity had gone out of style. It even*

seemed as if style itself had been used up, but then style—the invention of sets of forms—was a preoccupation of modernism, as was originality. The tradition of the New, Harold Rosenberg called it. At the start of the '70s there were dire predictions of the death of art by modernist critics and artists. By now it was obvious that it was not art that was ending but an era. . . We are witnessing the fact that in the past ten years modern art has become a period style, an historical entity. (p. 3)

According to Suzi Gablik (1984), more was at stake than a change of style, for change itself was a specific attribute of modernism. In the midst of all this activity, the professional fine arts community entered a period of confusion over its aims:

The overwhelming spectacle of current art is at this point, confusing not only to the public, but even to professionals and students, for whom the lack of any clear and validating consensus, established on the basis of common practice, has ushered in an impenetrable pluralism of competing approaches. (p. 14)

From Gablik's perspective, historical modernism supported a self-sufficient art with aesthetic values as ends in themselves. Modernism's destiny was seen as a crusade to generate new social and spiritual values in a world increasingly dominated by materialism. Artists, as part of an avant-garde, were dedicated to this quest. Early modernists sought to preserve a pure vision of truth by maintaining their distance from the social world. Unable to find meaning in the world of the late 19th and early 20th centuries, they sought it within themselves, and thus the attitude of "art for art's sake" was born. This is described by Gablik as a "forced response to a social reality that [they as artists] could no longer affirm" (p. 21). The retreat into self-expression, and the resulting proliferation of novel forms that followed worked against the possibility of a unified style. In the years following World War II, such artists as Pollock and deKooning could still claim a spiritual kinship with early modernists like Kandinsky and Malevich; but by the 1960s, according to Gablik, the situation had begun to change.

Late modern artists such as those reflected in the circle around the noted art critic Clement Greenberg, including Helen Frankenthaler, Morris Louis, and Jules Olitski, claimed no transcendent, higher, social, or spiritual purpose to art. Art's meaning was reduced to formal aesthetics. Gablik concludes, "the real problem of modernity has proved to be the problem of belief—the loss of belief in any system of values beyond the self" (pp. 29-30). Having abandoned its social and spiritual mission, the professional fine

2

art community reduced art to a commodity in the marketplace, and indeed, high art has become a dazzling commercial success.

Whereas Levin and Gablik write as critics and historians about the apparent loss of direction in modernism, Arthur Danto does so as a philosopher of aesthetics. In the introduction to a recent book of essays (1990) he noted:

> [In] the mid-1960s a deep revolution in the history of art took place—so deep, in fact, that it would not have been an exaggeration to say that art, as it had been historically understood, came to an end in that tumultuous decade. (p. 6)

Impact of Modern Thought on Art Education

If modernism as an artistic movement is being transformed or possibly is approaching its end, why should this concern teachers of art? One reason is that many, if not most, practices used by today's art teachers are grounded in modernist conceptions of art. For example, it is customary for today's teachers to evaluate their students' abilities by the degree of originality or creativity exhibited in their studio accomplishments. The high premium placed on originality and self-expression began to take hold during the emergence of the professional field of psychology and was justified in the arts through modern theories of expressionism. Expressionism distinguishes works of art from other objects by virtue of their creation by artists for expressive purposes. Originality refers to production that is both innovative and unique. Creative self-expression became an important philosophy, which has guided many art teachers since the 1920s. In premodern times the chief indicator of talent would have been the student's ability to represent the natural world with realistic images and accuracy and skill. From a modernist perspective, students should be rewarded who are able to appear to reach within themselves and reveal emotional states through abstract characterizations. As will be discussed in the next chapter, many postmodern artists appropriate images and forms from previous times and places, include representation in their work, and often make social statements. Therefore, the value placed on originality and personal self-expression may need to be reconsidered to reflect differences in artistic philosophies.

A second illustration of the modernist legacy is the persistence of the practice of teaching art by introducing elements and principles of design as a basis for studio production and art criticism. The focus on these formal characteristics of art began in education early in the 20th century. From a formalist perspective, coherence and strength of form is the principal source of its aesthetic value when judging a work of art. This justification made sense in the early decades of this century when abstract and nonobjective art styles were first making their appearance, but such emphasis may be

less warranted today. Contemporary artists and critics are more likely to create and interpret works in the context of the culture when and where the work was created. Many artists now deny the importance of attention to elements and principles of design altogether. At any rate, formal considerations may be less important today than would have been the case earlier, when a principle effort of artists was to draw attention away from the work of art as a representation of nature.

The adoption of these pedagogies was once justified when modernism was the prevailing development in Western art, and it made sense to set aside premodern teaching practices and replace these practices with approaches in accord with modernist art principles. But, now that modernism itself is being challenged, can we expect that present pedagogical practices might also change? If so, what should replace them? How germane would a postmodern approach to art be for school children who may be unaware of modern art, let alone the postmodern? These are some of the fundamental issues we address.

Purpose of the Book

The general purpose of this book is to explore the implications of the postmodern philosophy as a curriculum problem. In order to do this, a number of key issues need to be examined. The first task is to contextualize several current art educational practices within the modernist framework. This is done to illustrate the limitations of that framework for interpreting the recent developments in the arts.

A second task will be to look at theories about postmodernism, including its social and cultural origins, through the writings of European and American social theorists and critics. This examination will describe how and why postmodern ideas have gained currency in the humanities, social sciences, art history, and current professional educational discourse.

A third is to explore the connections between multicultural approaches to curriculum and postmodern issues. We focus on the extent to which different visions of multicultural curriculum content reflect a modernist or postmodern conception of pluralism.

A fourth is to identify some major characteristics of a postmodern curriculum and suggest implications for practice. We do this by providing illustrations of art activities that show teachers and students attempting to embrace these issues.

Plan of the Book

In the remainder of this chapter the leading characteristics of modernism are examined. These have prevailed throughout most of this century and are now being challenged. The next chapter provides a detailed look at

the postmodern with emphasis on a range of conflicting opinions. David Harvey's (1989) description of the postmodern "as a mine-field of conflicting notions" aptly describes the terrain of the postmodern. In Chapter Three we take stock of where art education has been by looking at past curricula that became popular throughout the modernist era. Four modernist paradigms influential in 20th century art teaching practices are identified. These are interpreted not as a series of progressive advances but as pedagogical responses to specific educational, social, and cultural needs and conditions.

We examine multicultural problems in art education with an emphasis on differing conceptions of multiculturalism in Chapter Four. Though postmodern and multicultural issues are related, they are not identical. Some conflicting conceptions of multicultural curricula are shown in terms of their differing proponents, objectives, and intended audiences.

In Chapter Five we discuss some characteristics of a postmodern curriculum, identifying examples of content issues a postmodern curriculum might need to address. The final chapter contains a series of classroom portrayals illustrating postmodern curriculum activities.

Defining Modernism

In this section, attributes of modernism are discussed to help distinguish it from the postmodern. Attributes of postmodernism are discussed in the next chapter. The features used to differentiate the two are not necessarily recognized and accepted by all observers of the contemporary scene. Moreover the shift from modern to postmodern appears to be occurring at different rates in different arenas. A chart in Chapter Two (p. 42) summarizes and contrasts these characteristics for purposes of highlighting their main differences. The reader is warned that making a clear line of demarcation between the two is conceptually risky as the two realms of cultural phenomena overlap to a considerable degree. Adding to the difficulty is the fact that many writers interpret postmodernism as a late phase of modernism. Changes in the modern cultural landscape and the emergence of postmodernism are a source of bewilderment to many.

Attributes of Modernism

The term *modern* means "of, pertaining to, or characteristic of recent time or the present" (The American Heritage Dictionary, p. 806). It has been used to identify the rise of a new style in the arts: one that repudiated all the traditional styles that preceded it. The modern era in philosophy has been dated as far back as the Renaissance, but most often is identified with the rationalist views that developed or emerged in the 17th and 18th centuries, a period referred to as the Enlightenment. The concept of modernism

is fundamentally dependent on the belief that progress is made possible through the use of reason and scientific knowledge. From this perspective, true knowledge extends human dominance over nature and provides us with material abundance. The discipline of history tells the story of this development and, typically, this narrative illustrates the progress of civilization.

The modernist also thinks in terms of rational utopias created by social engineering or the planning of ideal social orders. Modernity, whether in social planning, art, or education is future oriented; the future is portrayed invariably as a better time than the present. Indeed, one of the indicators used as evidence of the shift to the postmodern is that the current images of the future rarely picture things as being better. Rose put the matter cryptically when she remarked that "the future is not what it was" (1991, p. 169).

Modernism also has negative connotations. For example, technology is often used to represent the underside of modernism. Other examples can be found in the critiques of the urban renewal schemes of the 1960s: industrialization, alienation, the degradation of contemporary urban life, loss of community, global warming, and other tragedies. In his attempt to grip the essence of modern experience, the urban social critic Marshall Berman (1988) wrote:

> *To be modern is to find ourselves in an environment that promises us adventure, power, joy, growth, transformation of ourselves and the world—and, at the same time, that threatens to destroy everything we have, everything we know, everything we are. Modern environments and experiences cut across all boundaries of geography and ethnicity, of class and nationality, of religion and ideology: in this sense, modernity can be said to unite all mankind. But it is a paradoxical unity, a unity of disunity: it pours us all into a maelstrom of perpetual disintegration and renewal, of struggle and contradiction, of ambiguity and anguish. To be modern is to be part of a universe in which as Marx said, 'all that is solid melts into air.' (p. 36)*

Modernity has "no respect even for its own past" (Harvey, 1989, p. 11). It attempts to break with all previous historical conditions. Thus when a new art style is proclaimed, all its antecedents are either abandoned as passé or are dismissed pejoratively as "history." Modernism is also subject to "internal ruptures and fragmentations within itself" (p. 12). Harvey notes that an avant-garde has usually played an important role in the growth of modernism, "interrupting any sense of continuity by radical surges, recuperations, and repressions" (p. 12). Some may find these characterizations of modernity adventurous though bewildering.

Contemporary architectural critics such as Charles Jencks (1987) have tended to emphasize the negative side of modernism, as when they describe the monotony of modernist built environments. They justify postmodern architecture as a welcome reaction. One might also view modernism as a kind of stylistic totalitarianism in its insistence on the subordination of all parts to the unity of the whole.

Modernity in the curriculum. In retrospect, curriculum reforms of the early 1960s were like the urban renewal schemes of that same time period. Both are spiritually linked to modernism in several ways. First, they were based on the assumption that the new is a progressive reform of past practices. They focused on disciplined rationality beginning with utilization of disciplined experts (urban designers, subject matter experts) to design housing for the urban poor or "teacher-proof" curricula. Finally, there is an insistence on progress through standardization whether it be in land-use schemes, the plans of housing units for various income levels, or in the orderly sequence of subject matter during instruction.

The movement to teach art as a discipline also began in the 1960s. Today's discipline-based approaches are offsprings of these endeavors and are sometimes burdened by this legacy. It is not surprising that critics of DBAE accuse it of such faults as "technocratic rationality" (Hamblen, 1989).

In successive eras in the history of art teaching, there has been movement toward stability, rational control, and standardization and, at other times, movement toward fragmentation and ephemerality. These conflicting attributes can be found in differing curriculum proposals put forth during the modernist epoch. Curricula favoring creative expression in the spirit of Herbert Read and Viktor Lowenfeld tended to move toward ephemerality; whereas the kind of academic rigor advocated by Barkan and early Eisner implied stability, rational control, and standardization.

The idea of progress. Historical modernism is grounded in the belief that culture and society have a progressive, evolutionary development based on the advance of science and the cultivation of human reason. By the late nineteenth century, the progress notion was given scientific sanction by Darwin's explanation of evolution. Some even applied Darwin's notion, "survival of the fittest," to justify the competitive business and elitist social practices of the day, thus creating the doctrine called social-Darwinism. However, social-Darwinism was not a scientific theory, but an ideology that expressly favored the well-to-do social classes of the day.

Such modern ideas of progress are also reflected in the professional fine art community, where presumably each generation of artists makes advances in the expressive potential of their media. Beginning in the late 19th century, progress in fine art became equated with the movement away from the conventions of representation associated with the academic art of

previous centuries. These conventions were abandoned in the late 19th century because artists viewed the academy as a constraint on their originality. This came to be seen as the basis for artistic progress.

British art critic Roger Fry wrote at a time when Darwin's theory of evolution had already met with wide acceptance. Fry succeeded in persuading his professional contemporaries that abstract art had validity and was an advance over previous art because his audience had already accepted the notion of progress as a guiding principle in the evolution of human culture. By relying on this principle of progress, he could explain how Cezanne's compositional designs were an aesthetic advance.

Currently, people tend to be less certain that new art indicates progress over older art. Perhaps more individualistic and abstract styles merely estrange public audiences resulting in a loss of socially shared content. Certainly there was a prevailing belief that modern artists were not "of their time," but "ahead of" their time: that they were making the art of the future, and that at some point, their time would come, though as Gablik noted

> To the public at large, modern art has always implied a loss of craft, a fall from grace, a fraud or a hoax.... It remains one of the more disturbing facts about modernism that a sense of fraudulence has, from the start, hung round its neck like an albatross. (p. 14)

The avant-garde. Embedded in the idea of progress is the related idea that cultural growth is the product of an artistic and intellectual elite, an avant-garde who devised new social forms or lifestyles and also new forms of art. Their cultural role was to construct new forms of reality that would enable progress to take place. These innovative forms were to challenge the beliefs and assumptions of the public. Hence, the expectation existed that the public would initially misunderstand the new ideas or the new art; though, with the passage of time, they would gradually become receptive to these advances. The presence of forms of art that are considered in advance of the public at large has given many art teachers their reason for teaching: to bridge the cultural gap between the public and the vanguard.

Modernist models of aesthetics. Discussions of modernism tend to focus on two models of aesthetics: formalism and expressionism. Formalism was advanced early in the century by Bell (1914) and Fry (1925). Expressionist theories were advanced by Croce (1913/1922) and Collingwood (1938). The two views also figure in the critical writings of both Greenberg and Rosenberg in their support for Abstract Expressionism during the post-World War II era. Greenberg's (1961) support "was based on a progressive, evolutionary formalism" (Freedman, 1989, p. 222). He considered the elimination of subject matter from art an advance in the his-

tory of art. He described art as being "beleaguered by mass culture" in need of reform around "those values only to be found in art." "Content [was] to be dissolved so completely into the form that the work of art or literature cannot be reduced in whole or in part to anything not in itself,...subject matter or content becomes something to be avoided like a plague" (Burgin, 1986, p. 11). Greenberg's view, like that of his formalist predecessors equated stylistic progress with a search for purity. His interpretations and judgments of various artist's works were predicated on this view of progress and reflected his stress on "the ineluctable flatness of the surface. . ." (p. 14).

Rosenberg also supported Abstract Expressionist painting but tended to equate the style with the existentialism that pervaded postwar intellectual thought. However, it is not that a doctrine best accounts for the Abstract Expressionist style, but the fact that American postwar painting could find critical support by both formalist and expressionist criteria within an argument for a progressive history of art.

Primitivism. Late in the nineteenth century so-called "primitive" art was seen as a new beginning for art. Modern art, being a new style, was sometimes equated with primitivism. It was thus no accident that modern painters such as Klee and Picasso appropriated motifs from other cultures as well as from the art of children. The impact of primitivism on modern art can be linked to the colonialism of the 19th century by the dominant powers of Europe and America. Large collections of "primitive" artifacts were assembled in ethnographic museums where they could influence such artists as Picasso and Klee. Primitive art was a dawning art, young in a cultural sense and thus vital; whereas the older art of European academies was seen as a dying tradition that had run its course.

Art education in the modern sense was tied to the "discovery" of child art, which was seen as a form of primitivism in its own right, especially in the juvenile art classes of Franz Cizek. Today's teachers may be totally unaware of the cultural significance that child art had in the minds of its early proponents. They may continue to encourage free self-expression without realizing where these ideas originated and what relevance the practice may have had in the time and place of origin.

Abstraction. Early modernism moved quickly toward increased abstractness, until it became the pursuit of pure formal relationships capable of evoking aesthetic experience. This search for purity was seen as a rejection of the materialistic culture that had grown up in the industrial world. Formalism in this context was a way to reform art. It also had become the basis of an assumed universal aesthetic, the common denominator for all the world's art. This can be seen in the teaching of elements and principles of art by such individuals as Arthur Dow and also in the teachings of the Bauhaus masters. Today it is questioned whether the claim to be a universal

aesthetic is warranted, though this tradition lives on in a number of current textbooks. The impulse to pursue abstraction is akin to reductionism in science with its tendency to break down complex phenomena into simpler parts.

Universalism. The search for a universal reality that lies at the core of all understanding may have been one of the reasons that artists ventured into abstraction. In art the universals were believed to be the elements and principles of form that underlie the diversity of innumerable styles from all over the world. Though there was diversity, modern artists strove for an international style. This was most apparent in the field of architecture.

Creative destruction. Harvey (1989) notes that modernism has within itself an image of "creative destruction,"that in order to create a new world one is forced to destroy much that has gone before. The cubist image of humanity was achieved by processes involving an analysis of form coupled with its rearrangement to create a new unity. Sculptors of the postwar era used a cutting torch to dismember old or wrecked automobiles, the parts of which were reassembled to produce art. Throughout the 1950s, School Arts Magazine offered numerous lessons based on the idea of "making art from scrap." Similarly one can see in the urban renewal projects of the 1960s a tendency at work requiring the destruction of urban landmarks in order to create a renewed environment. It was not uncommon for individuals to justify the resulting destruction as the price paid for progress.

The functions of art. Within the modernist view there are conflicting views concerning the functions of art. From one perspective, works of art are regarded as phenomenally distinctive objects whose point and purpose is to give the viewer aesthetic experience. From another perspective, art is to therapeutically free both artist and viewer from the unhealthy effects of society. A third perspective, held by many modern artists, is that art is to free society from the constraints of conservative middle-class views by the creation of objects that shock and expose those views to ridicule. In *The Painted Word*, Tom Wolfe (1975/1989) questioned the sincerity of the latter aim, as it was a middle-class patronage that ultimately sustained the artist and assured the success of the art.

Trivialization of popular culture. In championing a striving for purity in art, critics such as Clement Greenberg advocated the view that modern artists should be disdainful of the imagery of popular culture and commerce. Books on modern design decried the lack of good taste in the bulk of mass produced items. In fact, Laura Kipnis redefined modernism "as the ideological necessity of erecting and maintaining exclusive standards of the literary and artistic against the constant threat of incursion and contamination" (1986, p. 21). Referring to popular visual culture as "kitsch," Greenberg dismissed it as an unfit subject for serious study in favor of the high art of the avant-garde. When artists such as Warhol and Lichtenstein

began to appropriate imagery from popular culture and commerce, Greenberg and many others within and without the fine art community had difficulty accepting this as art.

Kipnis (1986) suggested that the appearance of a number of books on popular culture by both social and art critics is one of the indicators of the passage from the modern to the postmodern, and Seymour Levine (1988) showed how cultural distinctions between "highbrow" and "lowbrow" forms of art accompanied the formation of social class hierarchies. For instance, Shakespearean drama was a popular entertainment form throughout most of the 1800s in the U. S. and did not enter the exalted domain of high culture until the turn of the century. The differentiation among entertainment forms into high and low forms paralleled the development of social classes based on wealth. This suggests that the rejection of popular or lowbrow arts in modernist criticism and art curricula had little to do with their level of aesthetic excellence or cultural importance.

Attributes of the Postmodern

The term *postmodern* is sometimes used as an umbrella term for the larger cultural shifts of a postindustrial society. Others use the term to refer to a repudiation of the modern or modernism, in the same way that modernism was a repudiation of traditional art styles. It is here that the definition of the postmodern becomes problematic. For if modernism is the style that repudiates past styles, then the postmodern style that repudiates the modern can be seen as maintaining the modern tradition. Arac and others have argued that postmodernism is not a successor to modernism as that implies a progress of sorts (Arac, 1988, p. vii-x).

Though Rose (1991) finds instances of the term used as early as the 1930s, it was during the 1970s that the term gained wide currency. There were many who assumed, as did Harvey (1989), "that it would disappear under the weight of its own incoherence or simply lose allure as a fashionable set of ideas." In the years since then, the "clamour of postmodern arguments increased rather than diminished with time [while] in recent times it has determined the standards of debate, defined the manner of 'discourse' and set parameters on cultural, political, and intellectual criticism" (p. viii).

From Burgin's (1986) standpoint, the postmodern project is to call into question the philosophical assumptions of the Enlightenment, especially the idea of progress. The postmodernist does not deny change, but questions the assumptions that changes can be legitimated as positive advances in human culture. In addition, postmodern thinkers often challenge such grand visions of history as Marx's idea of class struggle. They refer to these as "grand or meta-narratives," which are in need of replacement with what Jean François Lyotard calls "little narratives." These can be said to represent the

views of smaller groups, (e.g., subcultures, women, etc.). Bergin (1986) described little narratives as being "good for the moment, or good for the foreseeable future" (p. 199).

The postmodern view of culture is rooted in the present rather than the future. It looks to the past to discover whether current predicaments might have a genealogy or be the result of illusions handed down from the past. Postmodern cultural critics point to instances where progressive advances have led to runaway technologies that pollute and destroy the habitat or to instances where experts use knowledge not to make life better but rather to bring specific social groups under the dominance of oppressors.

The bewildering changes in the visual arts and the absence of any style commonly agreed on by the artworld as being significant are outward expressions of these transformations in culture. Architecture, photography, filmmaking, painting, and the other visual arts bear witness to these changes.

Terry Eagleton (as cited in Harvey, 1989), a neoMarxist theoretician, defines postmodernism in a less than supportive way.

> *There is, perhaps, a degree of consensus that the typical postmodernist artifact is playful, self-ironizing and even schizoid; and that it reacts to the austere autonomy of high modernism by impudently embracing the language of commerce and the commodity. Its stance toward cultural tradition is one of irreverent pastiche, and its contrived depthlessness undermines all metaphysical solemnities, sometimes by a brutal aesthetics of squalor and shock. (pp. 7-8)*

To some extent Eagleton's characterization of the postmodern tends to lay stress on negative attributes such as "depthlessness" and "irreverence." Yet there are also positive attributes that characterize the postmodern. In a curious way the postmodern artist, composer, and writer each has an openness to the cultural resources of past epochs and often appropriates motifs and inserts them into new works in order to comment on the deep and serious complexities of the contemporary world. The chapter that follows examines the concept of the postmodern in greater detail.

THE ISSUE OF MULTICULTURALISM

A number of contemporary educational researchers have turned away from the pursuit of knowledge as an end in itself and have turned instead to activities that might serve to empower socially and economically oppressed groups. An example of this might be the effort on the part of teachers and scholars to bring the artistic heritage of neglected or underrepresented groups into greater prominence through instruction.

Adding multicultural content to the curriculum appears to be an obvious remedy for problems of exclusiveness, but how can teachers be expected to widen the range of content to include those who are underrepresented, or excluded? The existing canon is heavily subsidized by a host of private foundations, corporations, government agencies, and cultural institutions all working either consciously or unconsciously to affirm the canon. One has only to look at the catalogue of a major show such as "Monet in the Nineties" to see how economic support makes such a show possible by both underwriting its costs and supporting the research that certifies the redoubted excellence of Monet as an artist.

There are a limited number of support structures that bring to light the art of ethnic minorities, women artists, and other oppressed or neglected groups; unfortunately, they lack the level of institutional support enjoyed by mainstream artists. How can the classroom art teacher hope to find out who the underrepresented artists are and what they have accomplished without such support? How do we determine how many of the canonical masterpieces should remain in the curriculum? Do we exclude Monet to make room for Judy Chicago? Should Linda Nochlin's historical writings replace Janson's? Is adding Hopi Kachinas, Navajo blankets, Appalachian quilts, and a few African-American or Hispanic-American artists sufficient to make the curriculum multicultural? Does it require a fundamental rethinking of the canon and an awareness of the institutional apparatus that forms and maintains it? Does it challenge the notion of canon itself? Some argue that, whether we like it or not, the canon exists to affirm the excellence of great works. How can one be satisfied that the canon is democratic as well?

Why Multiculturalism Is a Postmodern Issue

With the last question we begin to see why multiculturalism is a postmodern issue. Early modernism introduced the material culture of "so-called" primitive groups into the consciousness of Europeans and Americans but conceptually located these artifacts outside the realm of art. These artifacts were reconceptualized as art objects within the Western tradition through the application of formalist aesthetics. Modernism in this sense is universalist; it involves a measure of impartial universality while nevertheless being fundamentally Western.

By contrast, postmodern attitudes toward culture are conditioned by the notion of pluralism, by the sense that all cultural production has to be understood within the context of its culture of origin. From a postmodern perspective the use of distinct categories such as "folk art," "primitive art," "tribal art," or "popular art" marginalizes less dominant groups and enables them to be seen as part of a hierarchy culminating with Western "fine art." Such works are not always made "as art" in the Western sense and do not necessarily ask to be judged aesthetically "as art."

Artist Brower Hatcher reflects the postmodern desire to develop a way in which diverse people and their creations can be represented. In his 1988 work, "*Prophecy of the Ancients*," Hatcher

knits together a series of oppositions— logic and reverie, past and future, public and private, symbol and image, heaven and earth— in an effort to build an inclusive model ... of the diversity of things as we know them. (Walker Art Center, 1990, p. 239)

A second aspect that makes multiculturalism a postmodern issue is that its content is not merely taught to enable individuals to acquire knowledge and understanding of art for its own sake but to change social relationships. Because all art, including fine art, is part of visual culture and therefore reflects multiple dimensions of culture, the political dimensions of art may, at times, override the teaching of art to further the aesthetic sensitivity of individuals.

Brower Hatcher, *Prophecy of the Ancients*, 1988. Stone, stainless steel, steel, bronze, aluminum. Collection Walker Art Center, Minneapolis. Gift of the Lily family, 1989.

Multicultural art education can also sensitize students to issues that deal with social oppression and inequity as moral issues. Some art educators have questioned whether such political objectives are proper functions of art education or whether art education should stray into the political arena at all. There are several ways to respond to this objection. One is to recognize that the curriculum prior to the appearance of multicultural approaches was itself politically determined and that the canon of what is currently deemed excellent in art is also political, if not by intent, then by its consequences. Other responses to this concern will be addressed in Chapter 4. A second argument is that the tendency to divorce social and political content from art in favor of an attitude of aesthetic disinterestedness was also a modernist attribute that may no longer be viable.

In 1990, the white population of the state of California became a minority for the first time, outnumbered by a combination of African-Americans, Hispanics, and Asians. In all probability, this will occur soon and by 2050 the whole nation may have a different ethnic mix. Questions concerning multicultural curriculum will be answered in different ways by different people, even within a cultural group. Such differences depend, in part, on whether curriculum goals are seen from a modernist or postmodernist perspective.

Leading Questions

Throughout this chapter a number of curriculum issues have been identified and brought together under the postmodern label. It might be useful to summarize these issues as a way both for concluding the chapter and for setting the stage for the next chapters. The following questions serve to do this.

- If modernist art theory is no longer the universal theory it was once thought to be, how would this affect the teaching of art? Would this require a wholesale rejection of modernist content and methods?

- How would a postmodern curriculum differ from a modernist curriculum; and how would one make the transition, if one were intent on addressing the issues brought to the foreground by the postmodern condition?

- How shall present curricula be altered in order to be sensitive to multicultural issues, given that there are differing views of multiculturalism? How can teachers learn more about artists and cultures that are underrepresented in present curricula, and what

would culturally representative art education curriculum look like?

- Though Western culture currently occupies the dominant position in most curricula, to what extent should an increase in cultural pluralism modify this position in future schemes of art education; and, as Western culture is the tradition from which American society has historically drawn strength, should it continue to occupy the dominant place in future curricula?

There are several answers to these questions, and each is sustained by different arguments. The succeeding chapters explore these questions in detail and raise new questions.

Postmodern Theory: Changing Conceptions of Art, Culture, and Education

In this chapter the effects of modern and postmodern thought on art and art education are explored. First, a brief discussion of some fundamental aspects of modern social theory that underlie educational practice is presented. Second, selected concepts and positions taken by postmodern theorists are discussed to illustrate their conflicts and agreements. Third, some postmodern conceptions of knowledge and art are identified that relate to current practice and suggest directions of art education for the future. Finally, the problems raised by the growing application of computer technology are discussed to exemplify postmodern issues in art education.

CULTURAL AND AESTHETIC MODERNISM

Modernism has been described by many theorists as a recent way of thinking in Western culture that is scientific, individualistic, and progressive in an evolutionary sense. This general condition is referred to as *cultural modernism*. It has provided the possibility for an *aesthetic modernism* to emerge within the larger culture that involves contemporary art and criticism.

Most contemporary social theorists assign the beginning of cultural modernism to the 18th century Enlightenment. Enlightenment philosophy, or what is sometimes referred to as *"the Enlightenment project,"* embraced ideals that have become the foundation of contemporary Western (Euro-American) thought. These ideals have saturated the practice of politics, economics, and the arts, as well as the study of social life, such as history and the social sciences. It has been argued that the group consciousness of people alive today in Western cultures has been shaped by the structure of the Enlightenment for two centuries and that the Enlightenment project has provided the medium, possibilities, and limitations of contemporary thought (e.g., Foucault, 1966/1970).

In part, the Enlightenment began as a response to the authoritarian control of people in several nation states by aristocracy and church. herald-

ed at this time. Ideals to promote political freedom and socioeconomic equality. Prior to this, knowledge of the past had been based on the interests of clergy and aristocracy. However, with the Enlightenment, the emphasis shifted to the "discovery" of a "natural" form of knowledge through disinterested philosophical (and later scientific) investigations, which involved the creation of new branches of philosophy, including epistemology and aesthetics. The early part of this period was marked by dramatic shifts in the conditions of power, such as those resulting from the French and American Revolutions. The awareness of a relationship between knowledge and power was an underlying current of the Enlightenment project.

The Rise of Modernist Epistemology

Four key concepts of cultural modernism rooted in the Enlightenment project became intertwined with aesthetic modernism and also become important educational mechanisms (Freedman, 1989a). First, an assumption has existed that epistemological arguments in philosophy can reveal an objective, neutral truth versus falsity. For example, the development of a philosophical stance characterized by an asocial, formal, and quasi-scientific analysis of art objects became important in the art community. Scientific representations of formal and expressive concerns of the art community have taken at least two conflicting forms in modern thought. Art has been represented as objective (in terms of a science of formalism) and subjective (as characterized by the psychology of a mythological, generic, and freely-expressing childlike artist). Each of these representations made use of differing conceptions of knowledge.

Modernist thought and representation has tended to universalize and depoliticize art as reflected in the aesthetic doctrine of "disinterestedness." From this perspective, truth (or the "aesthetic experience") has been assumed to be without vested interest. Social, political, and economic interests have been considered ideological, and ideology has been defined as a false representation or masking of the truth. This mainstream perspective of Western epistemology has been questioned by recent theorists and is now seen by some as a fact only within the context of a particular social and cultural milieu. In other words, it is a fact because it has been constructed as such and maintained through belief by people of a certain time and place (Rorty, 1979).

The Modern Conception of Location

Second, a particular conception of time and place began to emerge in the modernist sense of history and geography. History is considered in the past, whereas geography is concerned with stable land forms that contain closed cultures within their boundaries. Allied with this perspective is a per-

vasive belief in the cultural supremacy of the West. This representation of progress is built on a linear and progressive sense of time. Within cultural modernism, social history has been thought of as evolutionary: society continually progresses to a better state as evidenced by increased knowledge, more complex technology, and greater freedom. The U. S. has been portrayed by American social scientists as exemplifying this advancement. In many arenas (economic, political, social, etc.), the professional disciplines in the U. S. harbor a "cutting-edge" view of progress and a belief that this nation will bring enlightenment and prosperity to the world. This perspective of international relations, which has prevailed in the social sciences since their emergence in the U.S., has also been apparent in the art community since World War II. A modernist confidence has existed since that time. It places America as the art center of the world; and although the art community has become highly commodified in the U.S., there is little concern about international competition.

The Relationship of Individual to Society

Third, a modernist concept of identity, based on the idea of the uniqueness of the individual, has prevailed. Individualism has been emphasized as a cultural ideal in the West. Different Western countries have alternate versions of individualism, with the "rugged individualism" valued in the U. S., representing an extreme form. Through the lens of individualism, history has been viewed as the accumulation of individual acts of expression or power embodied in objects made by particular people belonging to certain socioeconomic groups. For example, artists are thought to be innate "geniuses," who are untouched by social, political, and economic interests and who are thus able to represent that which is true, universal, and eternal, while showing what is personal. Art curriculum has maintained this notion of individualism through the promotion of autonomous expression in the production of art within the school that, in spite of its democratic rhetoric, is a highly regulatory institution. Later in this chapter, the ways in which this modernist conception of individualism is being challenged through a recognition of its internal contradictions are discussed.

The Concept of Psychological Health

A fourth concept of cultural modernism, which heavily influenced aesthetic modernism, is that of "natural" psychological health. The notion of psychological health took root in the U. S. near the turn of the century and began to become prominent in educational discourse by the 1920s. Through this discourse, educators sought to protect children from the unhealthy social influences they encountered daily. A particular fear of authoritarian personality traits and a general understanding of these traits as unhealthy,

developed after World War II (see Adorno, Frenkel-Brunswick, Levinson, and Sanford, 1950). At this time, professional psychologists worked to help the general public and educators prevent these traits from developing in children. Although artists were represented as being eccentric, the older vision of creativity as bordering on insanity was challenged by the newer idea that artists were sane but forced to live in an insane world. The strain between the reverence for an epistemology of certitude and fears of authoritarianism provided support for the therapeutic perspective of school art.

These four concepts, *epistemology, social identity, location,* and *psychological health,* have shaped curriculum and determined the meanings of the information that made up its content. Questioning these modernist concepts is part of postmodern thinking. In what follows, recent shifts in social theory involving these concepts is summarized.

NEW ISSUES AND PRACTICES IN SOCIAL AND CULTURAL THEORY

Although postmodernism may appear to focus on aesthetic issues, its roots are political and located in general culture (Hutcheon, 1989). Recent cultural theory indicates that conceptions of social life are changing. This theory has drawn on critical sociological perspectives such as neo-Marxist theory, feminist theory, and French semiotic and poststructural analysis. For example, by the 1970s, a particularly strong critique of humanism and rationalism existed in France.

> *Postmodern theory, however, is not merely a French phenomenon but has attained international scope. This is fitting because ... German thinkers like Nietzsche and Heidegger already began the attack on traditional concepts and modes of philosophy. The American philosopher William James championed a radical pluralism and John Dewey attacked most of the presuppositions of traditional philosophy and social theory, while calling for their reconstruction. Further, it was the English historians Toynbee and Barraclough and North American social theorists such as Drucker, Mills, Etzioni, and Bell who introduced the concept of the postmodern age in history and social theory, while North American cultural theorists introduced the term in the arts. (Best & Kellner, 1991, pp. 27-28)*

A common thread in current social and cultural theory is the concern with the relationship between power and knowledge. Theorists have grappled with this relationship by analyzing the implication of modernist conceptions of epistemology, representation, location, social identity, and psychological health.

Epistemology: The Problem of Knowing

According to Richard Rorty (1979), "the notion that there is an autonomous discipline called 'philosophy' distinct from and sitting in judgment on both religion and science, is of quite recent origin" (p. 131). Philosophy assumed this position within the scholarly communities of the 18th century, when theories of knowledge began to focus on the central question: "How is our knowledge possible?" (p. 132). Rorty argues that the philosophical community claimed the question of how and what one knows is the underlying basis for all intellectual life. Epistemology was constructed by a professional community of scholars and is both produced and reproduced by a certain discourse of rules. Yet mainstream Western epistemology and even the notion of knowing truth versus falsity are now seen as facts only in the social realm. These socially constructed facts control much of what one believes and does, but they are not the only way to approach understanding.

Feminist and other recent critical theorists have pointed out that our thinking has been shaped in relation to epistemology. For example, in some representations the world is pictured as dichotomous (Derrida, 1976; de Lauretis, 1987). Such an epistemology presents only certain oppositional possibilities for the ways we think about culture. Theorists argue that the use of oppositional language promotes a belief system that involves the attribution of positive characteristics to one term and negative to the other. By relying on dichotomous representations, knowledge is presented with an assumed hierarchy of values based on dualisms such as male/female, black/white, culture/nature, emotion/logic, etcetera.

Anthropologist Paul Rabinow (1986) drew on the work of Michel Foucault (1970) in laying out recommendations for confronting epistemological difficulties in conceptions of culture. He insisted that epistemology must be seen as a historical event with a distinctive social practice, one among many, articulated in new ways in 17th-century Europe. From Rabinow's perspective, one should attend to the peculiarity of the historical conditions of this practice and develop an understanding of the ways in which it has been projected onto people with different histories. In order to accomplish this, one needs to "anthropologize" the West by illustrating the exotic character of its constitution of reality and those domains most taken-for-granted as universal. In the process, "we must pluralize and diversify our approaches: a basic move against either economic or philosophic hegemony is to diversify centers of resistance" (p. 241).

The Issue of Representation

As mentioned above, one of the issues that has been given special attention by theorists involves the concept of representation. They have

raised questions about the faith people tend to have in various representations as presentations of truth. For example, questions have been asked about whether science can represent the natural world, whether one group of people can represent another, or, for that matter, whether language can represent reality. In her discussion of postmodernism, political scientist Pauline Marie Rousenau (1992) pointed out that some postmodern theorists take a skeptical political stand, contending that an ideal democracy can never be a reality because people cannot actually represent other people. These skeptical postmodernists argue that representative democracy is an illusion because politicians do what is in *their* best interest, not in that of their constituency.

A more optimistic perspective of postmodern politics is argued by theorists such as Stanley Aronowitz (1988), who supported a representative democracy built on mutual agreements to support antielitism, decentralization, and popular control over federal and state resources. Such a policy would require the knowledgeable participation of all people and the continual critique of political activism.

Rousenau (1992) used the extreme position of the skeptics to illustrate concerns about the notion of representation that more optimistic theorists accept as problematic. She stated:

> The crisis of representation crosscuts post-modernism in every field from art to psychology, and in each case 'the end of the Order of Representation' is heralded.... What is really interesting cannot be represented: ideals, symbols, the universe, the absolute, God, the just, or whatever.... According to skeptical post-modernists, representation is politically, socially, culturally, linguistically, and epistemologically arbitrary. (p. 94)

The concept of representation can lead to a dangerous illusion because representation can signify mastery, and people cannot master knowledge (p. 94). Rather, people create knowledge, which continually changes in form and meaning. When people represent, they suggest that there is an isomorphic relationship between that which is represented and the representation. However, this relationship is arbitrary because the act of representation inherently deletes something or adds to that which is represented. Representations are always distillations and distortions of ideas or events that in many ways work to change the meaning of what is represented.

Location: Conceptions of Time and Space

Current social theory includes at least two reconceptualizations of time. In the first, time is not thought of as linear but rather is represented as a multidimensional space where various cultural and socioeconomic groups

coexist. Culture, as well as art, is shaped by crises that ensue when cultures, classes, and social groups collide.

In the second reconceptualization of time, history is not conceived of as existing only in the past. People continue to live in the space of a historical and cultural structure, which conceptually locates and shapes them. The structure restricts the possibilities for change while being its medium. An example of this condition is the modernist conception of art that, at one level, enables art to become part of public schooling and, at another, denies its relevance for the public.

Part of the reconception of history involves a response to Marxism as well as the rejection of positivism. Jean-François Lyotard (1983) has argued that a move to a postmodern conception of culture necessarily includes a shift away from "grand narratives." Both positivism and Marxism are totalizing frameworks: that is, they are based on the assumption that they could and should become universal positions and practices. From each perspective, an internally consistent, yet completely different, analysis of history can be undertaken. Lyotard points out that one reason for the development of a postmodern consciousness is the apparent erosion of modernist ideals of the Enlightenment. The idea that theory can be internally consistent, that there is a correct interpretation of history, and that a single, universal interpretation will emerge through greater knowledge, is a part of those ideals.

Geography, as well as history, has been reconceptualized. From this new perspective, culture is no longer viewed as contained within a certain land form. Cultures intermingle, mix, and impose on each other, the result of which are crises that change the face of maps. Cultures also have increasingly fluctuated as travel has increased. Through mass media, international politics, and the world economy, the globe appears to be shrinking. Multinational corporations, satellite communications, and the deployment of United Nations troops to Somalia are examples of the interconnectedness of countries and a new consciousness of space. Travel in outer space and even science fiction (arguably a postmodern invention) has influenced our conceptions of "home."

Such changing conceptions of time and place are exemplified in the book *Postmodernism and Islam* by Akbar Ahmed (1992). Ahmed wrestled with the Western and Christian character of modernity in his attempt to decipher its meanings in a global context. He pointed out that the project of modernity was based on colonial and industrial prescriptions for solving social problems. He explained that "'modern' was translated by Muslim leaders as a drive to acquire Western education, technology, and industry" (p. 31). Ahmed described modern Muslims as those who understood the West, were perhaps educated at Cambridge or Oxford, and had adopted certain Western traditions. "Through their understanding of British ways and ideas they could engage successfully with the colonial power. These

Muslims would turn the skills they had acquired from the British against them to best represent the interests of their community" (p. 30). However, by the 1970s, the Muslim people had developed a growing awareness of the inherently Western character of modernism and a concern about Western economic and cultural power. Ahmed described postmodernity, in contrast, as increasingly secular, de-centered, and pervasively transmitted through the media. He stressed that the power of the media in current sociological shifts includes its ability to set up juxtapositions, such as of Saddam Hussein with Hitler, that convey and create meaning. Ahmed argued that vital cultural differences, stemming even from the refusal of Arabs to interact with ancient Greeks, have now re-emerged as glaringly apparent. These differences have become vital through the collapsing of history and cultural location by the media and has resulted in a mutual mistrust. Consider the influence on American and British attitudes about Muslims of the Ayatollah Khomeini's fatwa, (declaration of death) for the writer Salman Rushdie. The profound cultural differences suggested by that single act cause the awareness of the overlapping of cultures.

Identity Within Society and Culture
In part, social and cultural theory has shifted in focus from surface behaviors to deeper linguistic constructs. Consider the modernist conception of individualism discussed earlier. It is based on a mythological character called "the individual," who at one level is supposed to act freely and independently, and at another is to act the same as all free and independent individuals. Recently, cultural theorists have investigated these contradictions to illustrate that they are culturally and institutionally mediated. For example, although the "free self-expression" reflected in the art of children and such art styles as Abstract Expressionism have been represented as unmediated by culture and institutions, it is nevertheless the case that artists and art educators intentionally and unintentionally fulfill cultural, socioeconomic, and national agendas (Freedman, 1987;1989a).

Part of the shift in focus is toward cultural conflicts in the control of knowledge and discourse. Although discourse often works to promote cultural stability, power arrangements within a discourse may cause conflicts that result in new social patterns. Groups are excluded or included through discourse, and those with little power are given new legitimacy by adopting legitimate discourse. Attention has shifted away from the idea that social change is a natural process and a generalizable condition toward the idea that it is the transformation of a particular, cultural, and historical context that maintains its structure but shifts certain aspects of social life.

Cultural theory also reveals a new debate about the relationship of individuals to the structure of history. The new vision of the location of the subject (or, what might be called the theoretical individual) includes a rejection

of the traditional approach to history as a linear progression of political events controlled by a few high ranking, white, male agents, thus bringing this notion of historical change into question. In postmodern theory, the subject is often de-centered (i.e., power is dispersed and diversified) and collective subjectivities are viewed as located in certain positions in the social structure, none of which has complete control of social change. Foucault (1961/1965) has explained power as having multiple sources and moving in multiple directions simultaneously.

The debate about structure and agency involves de-centering the individual, while maintaining the belief that what one does can improve one's life. Rather than supporting the idea that individual agents take voluntary action that produces change, current theory focuses on the existence of pre-determined structures containing contradictions that instigate change. For example, a pervasive explanation for the emergence of postmodern thought is based on the internal contradictions of Enlightenment philosophy. A case in point is the underlying principle of the Enlightenment project that all citizens should have political and personal freedom. The inherent contradiction was that only certain people were allowed to be citizens.

Anthropologists have become discontent with the ways in which culture is represented in academic discourse (Rabinow, 1986). The struggle of social groups previously excluded from academic discourse to gain legitimacy and a growing intellectual consideration of the pluralism and fragmentation of postmodern consciousness have contributed to the ways culture is now being studied and understood. Although it was generally assumed that the challenge for the anthropologist, as for the educator, has been to try to accurately represent a culture; recent anthropological work has denied the possibility that research, including ethnographic research, give a "true" account of a culture (Clifford & Marcus, 1986). While rejecting the notion of accuracy, anthropologists continue to struggle with the problem of how best to describe the "other." Ethnographic study has become accepted as a means of understanding a culture, but writing ethnography is a matter of telling "likely stories" or constructing reasonable fictions that are but fragments of what happens in life (Clifford & Marcus, 1986).

Part of the problem of telling stories about culture is that one can never actually replicate the self-concept of the people studied. The writing may reflect the writer's culture more than the culture of the people studied Consequently it has been newly viewed as being more fundamentally about the structure of what one accepts as accurate, scientific reporting than about the identity of the "other."

Further, once one culture has been written about by another, there has been an interaction between them that changes both. The cultures we have had contact with have been influenced by the contact, just as knowledge of other cultures has influenced ours. Even in our definitions of "oth-

ers," we define "ourselves." So, the notion of separate cultures, while we struggle to maintain it for identity's sake, is becoming more and more difficult to think of as stable and real.

This recent shift in anthropology has provided a new metaphor for thinking about the problem of representation in modern life. "Ethnographic surrealism" (Clifford, 1988) has been used to describe the ways that anthropologists come to understand culture. Surrealism in this instance is a matter of putting together fragments taken out of their context into a new context: a type of conceptual collage where none of the pieces "fit" but are somehow organized to exist on a common surface in ways that provide them with new meanings and help to construct a culture.

Psychology as Construction of the Self

Postmodern theorists do not tend to begin their analysis with the notion of subject. For example, they view the subject as created, as part of the structure of lived culture and/or ideology. Poststructural theorists rely on the symbolic character of discourse (text or image) to construct the subject. It was during the Enlightenment that the subject became objectified, that is, the subject became the object of study (Foucault, 1966/1970). Through this process, people became represented as individuals in a generic sense. "The individual" was a mythical character that stood for humanistic values and hopes for autonomy and freedom.

A poststructuralist position is that the subject is invested with certain characteristics when the individual is represented symbolically in language (Lacan, 1977). At a certain point in development, within 18 months of birth, the subject enters into a stage of mirroring behaviors based on human interactions; maturation occurs based on these continued interactions and through images and language. The effects of images and language shape the innate characteristics of development. Through the use of language, the subject appropriates the characteristics of "the individual," and the representation becomes reified when the subject adopts the representation as a description of him/herself.

Following Freud, French theorist Jean-François Lyotard has developed psychological conceptions of art and aesthetics in his work. His analysis involves a new definition of the therapeutic value of art. He has sought to explain contemporary imagery, particularly figures, as celebrating imagination and the senses, promoting the natural flow of desire, and intensifying feeling. The view of some postmodern theorists, such as Baudrillard, contrast with Lyotard's, in that they discuss contemporary imagery in terms of psychological manipulation and commodification. From the perspective of these theorists, the psyche is bombarded with images antithetical to its nature and, therefore, detrimental. Baudrillard, Harvey, and others point to developments in technology, advanced levels of industrial capitalism, and

totalizing mass media as having instigated late modern social conditions. The work of these theorists has revealed that societal shifts that may seem on the surface unrelated, have occurred simultaneously and reflect a larger ongoing cultural and psychological change. Lyotard has been criticized for not considering these processes of social production and reception (e.g., Best & Kellner, 1991).

The shift in conceptions of self and mental health has included a growing awareness of the tendency of modernist psychologists to establish universal norms based on the characteristics of a certain group (e.g., Ragland-Sullivan, 1986), relatively small samples, and social prejudices. Included in this awareness has been a re-evaluation of normative judgments about cognitive development and so-called "innate" traits of women and men of color that illustrates how such "norms" have helped reproduce unequitable conditions and shape the subjects' conceptions of self.

Freedman (1989a) has analyzed these conditions in art education through historical examples of the valuing of white middle-class boys' art over the art of girls and children of other socioeconomic groups. Other educators and psychologists have questioned the notion of a linear, staged model of development and supported a more dialectic model that explains why children seem to revert at times to an earlier period of their development. For example, Wilson and Wilson (1982) have done extensive studies of the social influences on artistic development. These art educators have demonstrated that cultural images have a great influence on what were previously considered innate and universal forms of drawing development.

WHAT IS POSTMODERN THEORY?

The concept of postmodernism is evolving with the speed of other relatively new concepts, and a single, generally accepted definition has not yet emerged. Nevertheless many writers have attempted to set up working definitions and described postmodernism or given examples of the postmodern. Current descriptions of postmodernism are factionalized, involving multiple perspectives. Postmodern theory could be described as having at least two distinct factions: a culturally conservative faction that is remorseful and sees postmodern social change as destructive and an avant-garde faction that celebrates postmodern conditions (Best & Kellner, 1991; Rousenau, 1992).

The term "*postmodernism*" (or "*post-Modernism*") was first commonly used in the art community to describe a style of architecture that is disjunctive and open, in contrast to the conjunctive and closed space often seen in modernist buildings. Other arts disciplines, such as literary theory, have used the term to represent recent currents in aesthetics that oppose concepts

fundamental to modernism, such as genre, as a discrete style with distinct boundaries.

However, the term has a larger meaning than the realm of the aesthetic. It also is used to signify the whole sociological climate and phenomena that make shifts in the arts possible. The climate includes a skepticism about modernist conceptions of progress, hierarchies of knowledge, and objectivity in a fragmented and pluralistic world. From a theoretical point of view, the postmodern is located in the past and present rather than the future. The past is investigated to discover genealogies of current predicaments. For example, postmodern cultural critics point to instances where "progressive" advances have led to runaway technologies that pollute environments and harm people.

The postmodern condition involves a focus on process (Harvey, 1989). A sense of fragmentation pervades: of time, of place, and of subject (involving a decreased coherence in individual identity and production). Bits of the past are placed together in a collagelike fashion. The new conception of time and place suggests the ways in which a fragmented past continues to exist in the present. The de-centering of the subject is reflected in the postmodern refutation of the notion of innate genius and the realignment of thinking about the unique and disinterested works of individual "great men" as products of social influence and interest. With this de-centering, the subject has been dispersed because human creators are now seen as fragmented and socially integrated in various ways. Fragments of multiple cultures are also integrated to give attention to the eclecticism of contemporary life in a world where media technologies and other forces segment time and place. Postmodernism involves an acceptance of the chaotic character of life. It seeks to limit the imposition of modernist conceptions of psychical distance and replace them with participation and play. It also privileges cultural difference and alternative thought processes, such as women's ways of knowing (Belenky, Clinchy, Goldberger, & Tarule, 1986).

Generally, the focus on power and knowledge in postmodernism has emerged through attempts to unearth hidden, oppressive elements in democratic society. In its common usage, the term "*deconstruction*" can refer to this process. Deconstruction was developed by Derrida to reveal the multiple meanings, especially the contradictions, of literary texts. This method of analysis has been used in social theory, and the visual arts and has aided in the emergence of a discourse that bridges the two (Norris & Benjamin, 1988). In some cases, deconstruction involves a "turning upside-down" of old myths that have been taken-for-granted and the "unpacking" of social constructs that have become so embedded in society as to appear natural. This process can be helpful in illustrating the fragility of meaning and the relation of truth to power.

The mass media is central to discussions of postmodernism as a mechanism of social control and as a tool to enable empowerment. Daily, contradictions ranging from "facts" to ethical positions are presented to us through information technology. For example, both racism and the postmodern condition of environmental awareness have been supported and reified by the media (Ahmed, 1992).

Fundamental to postmodern theory is a consideration of imagery in art and the media. This consideration is related to the earlier discussion of representation. Through the mass media, a hyperreality has been created (Baudrillard, 1983). Time is cut and pasted together in ways impossible in lived experience; but enough of our lives are spent watching television, for example, that television becomes lived experience. Consider the example of the computer graphics seen every day on television. These computer graphics often move at breakneck speeds through environments that seem real, but are sharper, brighter, and more intense than physical space. A hyperreality is created through these images that are, in a sense, beyond reality.

Postmodern Art

Theorists of art and literature, such as Suzanne Sontag (1972) and Ihab Hassan (1971), celebrated postmodern investigations as alternatives to aesthetic modernism. These theorists saw the boundary-breaking qualities of 1960s pop art, happenings, art films, and mixed media events as powerful and positive responses to the more serious modernist vision of the avant-garde (Best & Kellner, 1991). These changes in art, characterized by Eagleton (cited in Harvey, 1989, pp. 7–9) as *depthless* and *irreverent,* were tied to the youth culture of the 1960s in which traditional values had broken down and a new mass culture emerged. Mass culture was to enable democratic forms of art by infiltrating the elitism of so-called high art and integrating those art forms with kitsch and other artifacts of the masses. However, the same mass culture became a commodity and an industry. In a curious way, postmodern artists, writers, and composers have established a new openness to the important cultural resources of past epochs and pervasive influences of everyday life (Fiedler, 1964/1971).

Postmodern artists are often interested in *surface*, juxtaposition, and illusion. In Debra Butterfield's 1988 sculpture *Woodrow*, viewers are fooled into thinking the pieces that made up the horse are made of wood. Wood is further suggested by the title. However, the sculpture is made of cast metal and suggests contradictory concepts, such as strength and fragility, natural and human-made, movement and stasis, etcetera.

One of the most prolific commentators on postmodernism is architect and critic Charles Jencks. Jencks' first book, *The Language of Modern Architecture* (1977), "celebrated a new post-modern style based on eclecticism and populism, and helped to disseminate the concept of the postmodern" (Best

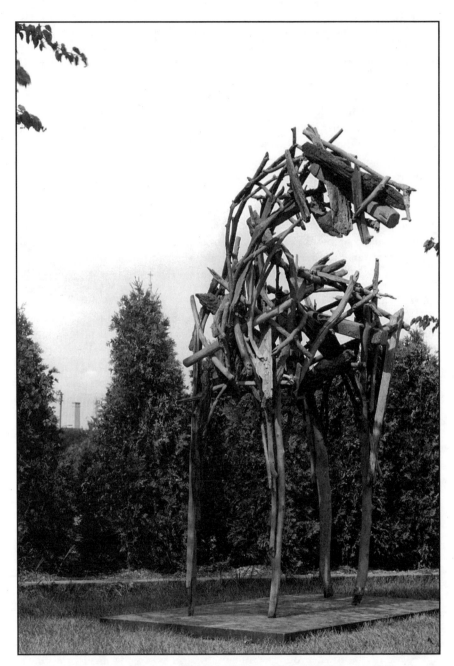

Deborah Butterfield, *Woodrow*, 1988. Bronze, 99" x 105" x 74". Collection Walker Art
Center, Minneapolis. Gift of Harriet and Edson Spencer, 1988.

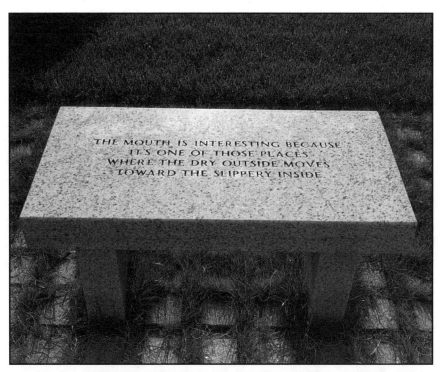

Jenny Holzer, THE MOUTH IS INTERESTING BECAUSE IT'S ONE OF THOSE PLACES
WHERE THE DRY OUTSIDE MOVES TOWARD THE SLIPPERY INSIDE, from *The Living
Series. 1989.* Granite, 17-1/4" x 36" x 18". Collection Walker Art Center, Minneapolis.
Anonymous gift from a local resident with appreciation for the Minneapolis Sculpture garden
and contemporary art, 1993.

& Kellner, 1991, p. 11). He has produced several other essays and books
that explain postmodernism in art and architecture from a stylistic perspec-
tive. For example, Jencks (1987) uses the term *post-modern* and explains
that by hyphenating the word, "modern" maintains its integrity as a word.
He uses the hyphenated word because he believes that post-modern art still
contains many aspects of modern art, but these have been added to, adapt-
ed, or embellished. Jencks (1989) also distinguished between what he calls
High-Modernism and Late-Modernism or Neo-Modernism, arguing that
much of the art labeled Post-Modern is actually modernistic. He includes in
this group artists who take abstraction to an extreme, such as many
Minimalists.

Postmodern artists, such as Jenny Holzer have focused on the use of
art as cultural critique (Hutcheon, 1989; Best & Kellner, 1991). In much of
her art, as in the example here, textual commentaries are made using tradi-

tional sculptural materials. Often these are juxtaposed with newer media and environment.

Environment is another focus of postmodern art. For example, David Nash is an environmentalist as well as an artist who uses whole trees for his series of sculptures (Walker Art Center, 1990). He uses all the parts of the trees, including making charcoal for drawing from pieces left over from the sculptures. This example is made from the branches still connected to the trunks of two white oaks.

David Nash, *Standing Frame.* 1987. Charred white oak, linseed oil. 172 x 209-3/4 x 209-1/2 in. Collection Walker Art Center, Minneapolis. Gift of *Star Tribune* and Cowles Media Foundation, 1987.

The *Regis Gardens* are another example of environmental art. The gardens and the conservatory in which they are located are parts of a work of art that is protected, alive, and constantly growing and changing.

Artists such as Cindy Sherman, who photographs herself as various people; Sherrie Levine, who rephotographs famous photographs and other works of art; Holzer; and Lillian Schwartz, who digitizes masterpieces and manipulates them with a computer, undermine modernist notions of self-expression, originality, and ownership. These artists produce art as a commentary on

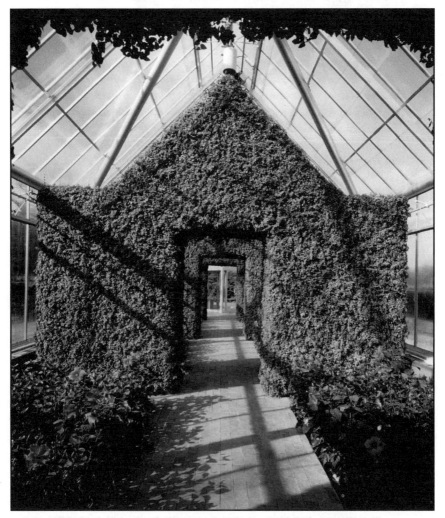

Design by Michael R. Van Valkenburgh and Barbara Stauffacher Solomon, Vine covered arches as part of the *Regis Gardens, North House, Cowles Conservatory.* 1988. Creeping fig: *Ficus pumila,* on stainless steel armature. Minneapolis Sculpture Garden.

mainstream ideologies and forms of representation. They work with photography and other technologies that are particularly postmodern media.

Premodern paintings in perspective once enabled monarchs, the original patrons and audience of art, to see themselves as the ones who put the universe in order through the placement of the viewer and the vanishing point (Lyotard, 1988/1991). Postmodern artists have recycled this idea using technology.

> *The modern notion of culture is born in the public access to the signs of historico-political identity and their collective deciphering Photography brings to an end the program of metapolitical ordering of the visual and the social Know-how and knowledge as worked out and transmitted through studios and schools, are objectified in the camera. One click, and the most modest citizen, as amateur or tourist, produces his picture, organizes his space of identification, enriches his cultural memory, shares his prospectings The old political function splits up, the ethnologist is a painter of little ethnic groups, the community has less need to identify with its prince, its centre, than to explore its edges Painting thus becomes a philosophical activity. (pp. 120-121)*

However, Jencks (1987) argued that the revival of classicism as part of postmodernism has also revived painting and includes the following stylistic "canons" (paraphrased from pages 330-350).

1. Post-modern artists tend to use dissonant beauty or disharmonious harmony, rejecting modernist ideas about composition, such as the notion that changing one compositional element in a work of art will change its quality as a work of art.

2. Cultural and political pluralism have become important. Pluralism also refers to a radical eclecticism in style.

3. Urbane urbanism is reflected through the acceptance and use of new technologies and a focus on urban issues, such as recycling.

4. Artists have an increased interest in anthropomorphism or the use of human forms in art, including decorative elements that resemble the body.

5. The relationships between the past and present are given attention in works of art.

6. Content and painting have been revived. However, post-modern content has multiple meanings. Painting involves divergent signification using suggestive narrative, and there is a deliberate use of intertextuality.

7. Double-coding is frequently used. Artists intentionally create irony, ambiguity, and contradiction in their work.

8. Multivalence or the quality characterized by a reaching out to the environment, various references, and multiple associations is pervasive. Post-modern art is not self-referential only.

9. Post-modern artists reinterpret tradition.

10. New rhetorical figures are created through changes made to old artistic forms, such as eroding a classical arch.

11. The return of the absent center in architecture reflects a desire for communal space and a celebration of what we have in common.

According to Jencks, postmodern society has been reflected in art through these stylistic canons, which may also be viewed as consistent with fundamental elements of contemporary urban life.

Against modernist seriousness, purity, and individuality, post-modern art exhibits a new insouciance, a new playfulness, and a new eclecticism. The elements of sociopolitical critique characteristic of the historical avant-garde (Burger, 1984) and desire for radically new art forms are replaced by pastiche, quotation and play with past forms, irony, cynicism, commercialism, and in some cases downright nihilism. While the political avant-garde of the modernist movement celebrated negation and dissidence, and called for a revolution of art and life, most postmodernist art often took delight in the world as it is and happily coexisted in a pluralism of aesthetic styles and games. (Best & Kellner, 1991, p. 11)

It has been argued that aesthetic modernism failed because it has left people without hope, previously an important characteristic of art (Gablik, 1984). Much avant-garde modernism also lacked meaning to the general public. Some modern artists deliberately separated themselves from the public, claiming a need for isolation, and denied that they were influenced by social conditions (including their education). However, the public was "convinced that the programme of artificial perspective must be completed and does not understand how one person can spend a year painting a white square, i.e. representing nothing" (Lyotard, 1988/1991, p. 121).

Postmodern artists often promote the recognition of social conditions and, in doing so, confound cultural as well as aesthetic modernism. Pairs and groups of artists, such as Gilbert and George, work together to challenge the heroic myth of individual genius, sometimes by focusing on the artists' very average flaws. For example, Lyotard (1988/1991) stated; "If

Gilbert and George can be taken as any yardstick, it is from his unfitness that the contemporary artist draws his power" (p. 114).

Postmodern art is retroactive and might be said to conceptually float from place to place. Artists, such as Ann and Patrick Poirier, seek to collapse history and geography through the use of fragments from various times and places. In her work *Without Words*,

> Shea establishes a temporal dialogue through the juxtaposition of the ancient head fragment—modeled after an Egyptian Eighteenth Dynasty sculpture of Queen Tiye—and the unmistakably contemporary overcoat. Mediating between them is the slender dress form, evocative at once of ancient Greek Kore sculptures and of mid-twentieth century contour. *(Walker Art Center, p. 467)*

Artists such as Shea recycle imagery and objects, placing a simulated Grecian column here and a decaying torso there, in order to provoke questions about the conceptual location of art and confront the modernist notion

Judith Shea, *Without Words*. 1988. Bronze, cast marble, limestone. 78 x 80 x 118 in. Collection Walker Art Center, Minneapolis. Gift of Jeanne and Richard Levitt, 1988.

of a progressive art history. For example, in Elizabeth Diller and Ricardo Scofidio's traveling installation, titled *Tourism: suitCase Studies*, the ephemeral yet culturally predictable concept of travel was the focus. Suitcases, situated with postcards and mirrored maps inside, hang open from the ceiling. The suitcases have quotations about travel by famous people attached to them. The postcards have formula comments, such as "salutation," and "having a wonderful time," written on their backs.

Postmodern art often involves the use of imagery and objects in ways that point to the cultural collapsing of the world and reminds us that images continually become appropriated and recycled. The appropriation and eclecticism is also used for social commentary, such as in the exhibition *The Year of the White Bear*, which includes a series of photographs of two artists dressed in several combinations of clothes and arrangements of artifacts from various cultures and times. The visual and textual commentary is about colonialization and the appropriation of land, spirit, and people.

A postmodern critique might also be applied to modernist museum installations. For example, *AMISH: The Art of the Quilt* was a 1990 museum exhibition in San Francisco. The exhibited quilts were collected by Doug Tompkins, co-founder of Esprit clothing. The quilts were hung flat on walls in a gallery without lights except for the single, circular track light, which shone on the center portion of each quilt so that the colors looked brighter in the center and dimmer and duller toward the edges. Tompkins "especially designed this installation and its dramatic lighting to underscore the luminous beauty of the quilts, to bring out their rich colors, and to minimize visual distractions" (Exhibition statement posted in *AMISH: The art of the quilt*, 1990). In this case, modernist fine art interests were laid on top of functional, traditional objects originally used on beds, where they would be softly lit, draped horizontally, and surrounded by "distractions." The context of appreciation for the quilts was almost antithetical to their context of production. As a result, the art was transformed, in this case into modern art. To walk into this exhibition was like walking into a room filled with Vasarely Op Art paintings. A critical discourse that plays on the contradictions between the original object and its transformation by display in a museum setting may help promote the understanding that aesthetics is not static but rather is in flux and continually redefined.

Postmodernism is channeled through various forms of culture, which have resilience, and survive attached to those forms. As a result, some theorists warn that an important aspect of the postmodern is that it ironically "manages to legitimize culture (high and mass) even as it subverts it" (Hutcheon, 1989, p. 15). This is illustrated by the display of postmodern art in museums, galleries, and other institutions; the reproduction of these works of art; and the written texts that have been built around them.

A Summary of Ideas and Attributes Concerning Postmodern Art

Art as cultural production. In postmodern discussions, art is represented as a form of cultural production, inherently dependent on and a reflection of cultural conditions. Rather than being seen as peripheral to the formal and expressionistic aspects of art, social and cultural issues are viewed as fundamental to any discussion of aesthetics. Because art is a commentary on and embedded within culture, the postmodern critic engages in a form of *cultural critique.* The role of critics and teachers is to analyze art within cultural contexts.

Postmodernists question the separation of high culture from culture as a whole and argue that the separation of popular and ethnic cultural production from fine art is an illusion in the current global community. They unpack the social and cultural forces reflected in words such as "masterpiece" and descriptions of "the artist" in terms of a mythical genius who works in isolation from the rest of society. Postmodern texts display a disregard for the mysticism surrounding much of modern fine art and the purity of its producers' motives with regard to capital reward. Postmodern artists often reveal their personal motives to their audience, realize these motives have some relationship to society, and draw on cultural symbols in their work. Postmodern criticism challenges elitism in high modernism through, for example, an emphasis on figural realism; although, much of its own discourse is as mystifying as the modernist discourse it seeks to transcend.

Temporal and spatial flux. Postmodern theorists question modernist conceptions of progress as linear, accumulative, and positive. The questioning results from debate about whether such a notion of progress is really progressive, whether it is an indication of the betterment of life for all people. For example, the modernist conception of progress made possible the idea of Manifest Destiny in the late 19th and early 20th centuries. This justified U.S. imperialistic takeovers, the assertion that social science could solve any social problem, and the assumption that technological development was always an improvement over the past. Postmodern cultural critics argue that this notion should be set aside, especially if we are to explain events like Vietnam, the Holocaust, and ever more destructive weapons. To exemplify the complexities of progress, Michel Foucault (e.g., 1970) pointed to the ways that the human sciences have enabled increasingly more subtle control over people's lives. Postmodern art critics have argued that modern artists' pursuit of abstraction to pure form, which Clement Greenberg championed as progress in art, also promoted the alienation of audiences. From this standpoint, modern artists communicated less to relatively fewer people.

The modernist notion of linear progress is illustrated in Greenberg's argument that art has progressed through representation to abstraction and nonobjectivity. Postmodern views of change are more complex and varied.

One postmodern model is like the "big bang" theory of the universe resulting in a multiplicity of changes radiating from a common center. Another theory of change reflected in postmodern literature might be likened to several jumbled pieces of string, in that it carries a depiction of many progressions and digressions that may occur simultaneously within a culture and in different cultures. Most postmodern theorists do not believe life is hopeless simply because progress is complex. Quite the contrary—they usually argue that the critique of our underlying assumptions and that which we take for granted is part of the process of change. Postmodern theory is rarely relativistic; rather, it tends to be contextualistic and often reflects strong ethical positions, such as the promotion of environmentalism. In art, we see postmodern views of progress reflected in the common use of pastiche and eclecticism that borrows from and recycles the past, transforming it and bringing it into the present.

Democratization and a concern for otherness. An important issue given attention in postmodern theory is the relationship between *power* and *knowledge*. In postmodern art, culture, and critique, the ways in which certain ethnic, gender, and social groups have been controlled are investigated. Support is given for multiculturalism, feminism, and other positions that promote equity and have new potentials for democratization. Central to this idea is the concept of pluralism. Modernism has tended to include universalist conceptions of art and culture, among which is a reliance on formalistic and expressionistic elements and principles of design as a basis for art. Interpretations based on these elements might help a viewer make determinations in a Western sense; it would not reveal what the artifact meant in its culture of origin. Another aspect of otherness is the importance of local traditions and values in art.

The postmodern art community has shifted toward qualities of detante and placed less emphasis on "good" aesthetics or "good" design. Popular culture, which was rejected in much modernist criticism, is embraced in postmodernism and accepted as a relevant concern in everyday life. Characteristic of postmodernism is an openness and willingness to appropriate images from popular culture and other sources. Although there is a concern for otherness, attention is given to the overlapping and interrelating of arts and cultures. Appropriation often appears in postmodern art as a statement about the ways in which images are, in reality, continually moving and being transformed within and among popular culture, ethnic cultures, "high" culture, and so on.

Acceptance of conceptual conflict. In contrast to cultural and aesthetic modernists focusing on continuity, logic, equilibrium, and pure form, as seen in examples ranging from the concepts of the "melting pot" to "form follows function," postmodernists focus on the conceptual conflicts ranging from fragmentation to dissonant beauty. Postmodern theory challenges

modernist preferences for wholeness, organic unity, or integration with collage. Organic modernist architecture integrates each part of a building down to the last detail into a whole that equals more than the sum of its parts. In contrast, postmodern architecture often brings together dissonant elements, such as stylistic reminders of historical periods, which bear little or no apparent relation to the work as a whole but are suggestive of multiple meanings. These details are not subordinated and are full of surprises. Often, postmodern art and architecture are self-consciously, conceptually complex and demand a high tolerance for contradiction from their audience.

Modernist epistemologies are largely grounded in the assumption that there is a single, best answer to most questions. Scientific progress is equated with the progressive elimination of error in favor of that which is correct. Likewise, a modernist art critic would approach the definition of art or a work of art as involving a best interpretation derived from a logical method of analysis, as reflected in Harold Osborne's (1955) statement:

> *Unless [the critic] knows what is and what is not a work of art, and by what criterion a work of art is to be recognized, he has no standard of relevance; he will be at cross purposes with himself. (p. 40)*

From a postmodern perspective, information regarded as an objective reflection of the real world can be seen in more than one way, such as an effect of power. Truth and values (including aesthetic values) might also be effects of power and not determined by objective standards. As meaning is constituted within language and socially constructed (hence not absolute), conflicting (but tenable) meanings may exist and may be inherent in definitions. Theorists use deconstruction to uncover these inherent contradictions.

Multiple readings. Some postmodernist critics argue that viewers each read or interpret works of art from different perspectives to such an extent that through their viewing experience, they actually construct different works of art that may have little or no relation to the artist's intentions. Stanley Fish (1980) maintains that viewers become artists in that they remake the work in the act of understanding. From a postmodern perspective, representation is often read as reality; therefore theory should focus on issues of representation and art should actually promote or suggest many interpretations. These interpretations become attached meanings that are carried with the object. Such issues of representation and interpretation are among the more characteristic differences between modernism and postmodernism. In postmodern art, different interpretations may result from a deliberate use of contradiction, irony, metaphor, and ambiguity, also called double-coding. Jencks (1991) exemplified double-

coding in his critical description of Stirling's addition to the Staatsgalerie in Stuttgart:

> The U-shaped palazzo form of the old gallery is echoed and placed on a high plinth, or "Acropolis," above the traffic. But the classical base holds a very real and necessary parking garage, one that is ironically indicated by stones which have "fallen" like ruins, to the ground. The resultant holes show the real construction—not the thick marble blocks of the real Acropolis, but a steel frame holding stone cladding which allows the air ventilation required by law. One can sit on these false ruins and ponder the truth of our lost innocence: that we live in an age which can build beautiful, expressive, masonry as long as we make it skin deep" We are beautiful like the Acropolis or Pantheon, but we are also based on concrete technology and deceit. (p. 6)

Jencks also described the modernist forms and colors reminiscent of De Stijl art in the building as overlaping their classical background in ways that would make "both modernists and classists ... surprised, if not offended" (p. 6) In Jencks' opinion, the architecture expresses the postmodern sense of our time, of being caught between past and present, of refusing to give up either modernist technology or classical beauty. Double-coding "has been used as a strategy for communicating on various levels at once." (p. 6)

In some ways, postmodern artistic success has less to do with the exhibited features of a work of art and more to do with the success of a critic in persuading one of its importance. When modernist critics disagree, as they often do, the difference is often accounted for either by personal preferences or a focus on different perceptual qualities of the work. Postmodernism holds out no promise of an objective, impartial interpretation. However, postmodern critics generally acknowledge their biases as part of their criticism and use them as a context from which to see or read a work of art.

These attributes of postmodernism are discussed later in relation to art education. Table 1 contains comparisons between these attributes and some of the attributes of cultural and aesthetic modernism.

POSTMODERNISM AND EDUCATION

Because postmodern theory gives attention to the relationship between knowledge and power, it points to vital issues in education. Recent theoretical work in education has begun to draw on newer sociological and literary theory, as well as poststructural analysis. This literature deals with similar social and cultural issues in ways that we have discussed postmodern art. For example, the issues of representation raise questions such as: Why do

Table 1

Modernism

Art is a unique phenomenon involving distinctive objects whose point are to provide a disinterested aesthetic experience. Aesthetic modernists condemn the mundane and general public artistic preferences and promote an exalted position for fine art.

The modernist accepts the idea of linear historical progress. Each new style of art is assumed to advance the quality and expressive potential of art, thereby contributing to the progress of civilization.

The role of the professional fine art community,particularly the avant-garde, is considered revolutionary and isolated from many of the ills of society. Because the art community is considered pure in its motives, for example, its rejection of capitalistic motivations, it is thought capable of leading toward social change.

The use of abstraction is supported in the pursuit of pure formal relationships that can produce aesthetic experience. Realism is rejected in favor of a higher,personal reality behind appearance and behavior.

Modernistic style tends to favor organic unity as a guiding principle. Decoration and ornament are condemned. Consistency and the "pureness" of artistic form, beauty, and meaning are promoted.

Modernism involves the search for a universal style, implying a universal reality that transcends local, ethnic, or popular styles. "Primitive" motifs are redesigned and incorporated to be consistent with formalistic and expressionistic foci.

Modernism implies creative destruction of older realities to creative new ones.

Postmodernism

Art is a form of cultural production and reproduction that can only be understood within the context and interests of its cultures of origin and appreciation. The postmodernist attempts to dissolve the boundaries between high and low art and condemns elitism.

The postmodernist rejects the notion of linear progress, arguing that civilization historically has not made advancements without, at the same time, promoting non-progressive states, and even decline.

The previous role of connoisseurs and others claiming exclusive and/or private knowledge of the fine arts are questioned. The professional fine art community is viewed as reflecting society, such as for example, influences of capitalism and industrialism, and acting as a form of cultural critique, that is, responding to a society within which it is immersed.

Realism is revived in contemporary art, but unlike premodern realism, which was grounded in nature, postmodern realism is based on the study of society and culture. The way things appear (facade) is given attention.

A postmodern object may be eclectic and have a dissonant beauty combining ornamental motifs from classical and other styles. This combination produces dual, sometimes conflicting, meanings and is referred to as "double-coding."

Postmodern styles are pluralistic, even eclectic, and subject to multiple readings and interpretations. Multicultural objects are recycled in ways that reflect their origins.

Eclecticism and historical appropriation reflect an interest in the integration of past and present.

we assume that curriculum represents knowledge? How does curriculum and instruction affect the knowledge being represented? Is it possible to teach truth? Can teachers reasonably represent other people in other places and times? What is a postmodern conceptualization of cognition? Do student interpretations of curriculum content change knowledge?

Educators have begun to struggle with answers to these new and difficult questions. For example, Aronowitz and Giroux (1991) have applied postmodern theory to the analysis of a variety of cultural "texts," including the mass media, popular culture, and education. Their purpose is to shed light on the complex relations between schooling and the cultural, social, and economic politics of contemporary life. Part of their discussion focuses on the dilemmas of conservative versus liberal and radical educational missions and the representations of various social and cultural groups. Aronowitz and Giroux reveal the underlying assumptions on which educational policies are made and the foundations on which decisions about school practices are based. These authors call for an educational process of change that goes beyond a critique of schooling, to promote a culture of democratic social criticism. They state:

> *Postmodern educational criticism points to the need for constructing a critical discourse to both constitute and reorder the ideological and institutional conditions for a radical democracy …. It is important to emphasize that difference and pluralism in this view do not mean reducing democracy to the equivalency of diverse interests; nor does a critical postmodernism suggest situating difference merely within a politics of assertion and separatism. On the contrary, what is being argued for is a language and social practice in which different voices and traditions exist and flourish to the degree that they listen to the voices of others, engage in an ongoing attempt to eliminate forms of subjective and objective suffering, and maintain those conditions in which the act of communicating and living extends rather than restricts the creation of democratic public life. (pp. 188-189)*

Aronowitz and Giroux (1991) promote instruction about historically valued creations and discoveries but insist that these should be deconstructed as they are taught. The deconstruction can provide students with a broader picture of conditions and repercussions of creation in ways that traditional education does not. It provides a conceptual location of the people whose work has been valued historically and enables discussion about the work of people who have not been valued. Through this process, Aronowitz and Giroux hope to promote the development of a language of teaching and learning that depends on the voices of others, rather than a haphazard inclusion of various cultures.

Aronowitz and Giroux (1991) argue that the stability of the disciplines has been overturned by postmodern theory, as has been the Enlightenment conception of knowledge as based on "irrefutable foundations that are irreducible starting points of inquiry" (p. 140). This shift in the conception of knowledge has included a new critical assessment of methods of inquiry, teaching, and learning, as well as disciplinary content. A postmodern conception of curriculum involves interdisciplinary content and the study of a variety of visual culture. For example, because sociocultural context is vital to postmodern education, an awareness and analysis of the educational power of mass media and other electronic technologies has gained new importance as has media representations of race, class, and gender (Giroux & Simon, 1989).

The focus of postmodernism on critical engagement should not cause educators to be concerned about maintaining hope for the future. Feminist and cultural critique help to provide a hopeful discourse for postmodernism and postmodern education (e.g., Giroux, 1992; Nicholson, 1989; Smith, 1992). For example, the formal and structural characteristics of modernist theories of teaching and learning tended to produce models that have been considered universal. It has been assumed that all "normal" children learn in basically the same way at generally the same rate, all teachers can and should be trained to use the same teaching methods with all children, and standardized forms of curriculum and evaluation can be reasonably applied in all classrooms. By contrast, teachers with a postmodern perspective take part in a critical struggle to understand the ways in which sociohistorical contexts work to construct educational conditions, including the ideological milieu of teachers, students, administrators, and curriculum developers (Aronowitz & Giroux, 1991; Cherryholmes, 1988). The knowledge gained from this struggle is used to aid teaching results, which are considered processes in flux rather than end results. Such teachers try to guide students toward an understanding of the influence of social life on the generation of knowledge and construction of self. An understanding of the influence of context in one's self-creation can be a step toward understanding and accepting difference in others.

One of the fundamental dilemmas of reconceptualizing education consistent with postmodern theory is the dependence of educators on the Cartesian-Newtonian world view, including ideas such as "scientific" universality, cause-and-effect, mechanistic operationalism, and hypothetico-deductive reasoning (Kincheloe & Steinberg, 1993). Most American schooling is so fundamentally based on this scientific view of the world, it may seem difficult to imagine an alternative. Piaget, and many who have been influenced by him, built developmental models of cognition on a foundation of formal mechanisms, logical categories and sequences, and a grand narrative of intelligence.

Unconcerned with questions of power relations and the way they structure our consciousness, formal operational thinkers accept an objectified, unpoliticized way of knowing that breaks a social or educational system down into its basic parts in order to understand how it works. Emphasizing certainty and prediction, formal thinking organizes verified facts into a theory. The facts that do not fit into the theory are eliminated, and the theory developed is the one best to limit the contradictions in knowledge. Thus, formal thought operates on the assumption that resolution must be found for all contradictions. Schools and standardized test-makers, assuming that formal operational thought represents the highest level of human cognition, focus their efforts on its cultivation and measurement. Students and teachers who move beyond formality are often unrewarded and sometimes even punished in educational contexts. (Kincheloe & Steinberg, 1993, p. 297)

From this perspective and from those of Rousseau's "natural," male childhood and Lockean individualism, have emerged representations of a mythical, normal youth, often referred to as "the child," that is separated from social life and in whom thinking develops without the influence of life experience. Modernist developmentalists have often overlooked the fact that children come to school with different experiences, including varied amounts of cultural capital resulting from sociocultural conditions (Bourdieu & Passeron, 1977).

Kincheloe and Steinberg (1993) describe what they call a "tentative" response to modernist, or formal, cognitive theory. Their "post-formal" conception of cognition has the following conditions: etymology, pattern, process, and contextualization. Etymology involves understanding the origins of knowledge; an acceptance of "the play of imagination" (p. 303), particularly in the construction of ourselves and our reality, and problem-finding (in contrast to problem-solving). Pattern refers to the investigation of tacit knowledge, such as underlying assumptions and hidden influences that shape understanding; observation of metaphorical relationships between things; and discovery of life force designs, such as ecosystems. Process is constituted through the continuous deconstruction of texts, relation logic and emotion; and transcendence of simple notions of cause-and-effect. Contextualization refers to attending to settings, understanding interactions between particularity and generalization, and developing an awareness of the role of power in the world.

As discussed earlier, the issue of representation is of paramount importance in postmodern art and culture. Although some postmodernists insist that there can be, in fact, no representation (political, cultural, or artistic) because the limitations of language make it insufficient, educators

must understand that they are, nevertheless, in the business of representing. Much of what educators do is to represent what people outside the classroom have done. Educators attempt to represent knowledge and bring certain representations of art into school. Art educators are not unfamiliar with the problems of language and recognize that language is an insufficient means of representing all forms of knowledge. However, representations of knowledge, even those that rely on language to a lesser degree, are limited.

Perhaps the most important message about representation for education is that the process of teaching cannot provide the possibility for the representation of absolute truth. Teaching involves so many layers of interpretation, avenues of communication, and varieties of circumstances, that to suggest otherwise would seem unreasonable. For example, curricula contain the writers' interpretations, which are limited, simplified, and made systematic through intent and the possibilities of linguistic expression. Teachers interpret the curriculum content and reshape it through their presentation to the students; students reinterpret the information based on readiness, gender, ethnic background, and many other conditions.

These conditions and the modernist expectation that students will learn absolutely true representations appear to doom educators to failure. However, postmodern conditions within and without the schools are even now changing the ways educators conceptualize learning, how students learn, what they learn, and how learning is assessed. Still, the expectation of teaching and learning these representations survives in schools. Consider, for example, the accusation that American school children are not learning as much as other children in the world because they are not doing as well on standardized tests. Postmodern American children may have a great deal more knowledge than earlier children and children of other countries, but not the type of knowledge tested in a standardized format.

An important message of postmodernism for general education and art education is that teachers should make their students aware of the many layers of interpretation that exist, that continual flux influences and shapes understanding, and that this flexibility of knowledge is vital because it enables creative thought. Irony, metaphor, and double-coding, given attention in postmodernism, could not exist without the wealth of possible interpretations that language and other forms of communication provide. Rather than being negative and debilitating, the postmodern questioning of representation gets to the heart of the matter for education: Why and how do people create meaning and come to understand knowledge, art, etcetera?

To teach from a postmodern perspective would not be easy within the conditions of modern schooling. Consider the example of reform in education. Because education contains and reflects pervasive qualities of a larger structure of modernism, it reproduces those structural conditions. Educational reform usually involves a conscious and collective effort to transform an insti-

tution that will fundamentally remain the same. Education employs a rule-based professional discourse of modern systems of administration, teaching, and learning that promote cultural reproduction (e.g., Bourdieu & Passeron, 1977). Recent critical analyses of education have provided evidence of mechanisms that maintain and reproduce socioeconomic dimensions of structure (e.g., Apple, 1986). The mechanisms work by systematically complying with interests of industry and the state in an effort to produce an efficient labor force and sociopolitical consensus.

Directed by these mechanisms, school reform has involved two styles of knowing: productive and bureaucratic (Freedman & Popkewitz, 1988). The styles of knowing focus reform on a tinkering with systems rather than a "major overhaul," a technization and abstraction of knowledge (which provides the opportunity to think of practice as being separate from theory), and a sense of fractured or multiple (including bureaucratic) roles to be played by people in general and teachers in particular. These styles of knowing represent a structurally shaped consciousness that responds to conflict by seeking consensus. Although professing a desire for reform, educators tend to seek stability by maintaining a focus upon agreed on knowledge.

From a postmodern perspective, reform discourse takes on meanings outside and beyond its early users. During periods of intended reform, while at one level reproduction continues, at another level what is accepted as knowledge changes and social groups become relocated and redefined. In these instances, reform discourse can be instructive because it does not simply reflect consensus or society as a whole; instead, it illustrates conflicts of consciousness. Rather than the promotion of consensus among teachers and students, a postmodern educational reform might seek the use of conflict as a learning tool. For example, the students would be taught about the conflicts among professionals, rather than only the "agreed on" knowledge (Graff, 1987; 1988). Other examples of the postmodern in education include the growth of cooperative learning and other types of group work in school and the promotion of problem-finding, such as in Schon's (1987) account of studio-based learning. During types of learining issues about identity, conflicts of ownership, multiple interpretations, and epistemological instability are encountered.

The Critique of Modern Art Education

Few attempts to consider the implications of postmodernism to art education have been published. Some label the shift from Lowenfeld's view of child self-expression to a focus on the disciplines of art history, criticism, and aesthetics as being consistent with postmodern theory (Henley, 1991; Parks, 1989). This interpretation may have come from a surface reading of texts in which postmodernism is simply presented as any reaction to the

recent past and is not based on careful examination of postmodern theory. For example, although the definition of expression has become more culturally-sensitive, expressive freedom is still an ideal of postmodern thought. Postmodern theory may include an emphasis on some of the issues and topics previously considered in the realms of the disciplines of art history, criticism, and aesthetics. However, major differences exist between the traditional methods and underlying philosophies of these disciplines and postmodern conceptions of the past, critique, and visual culture. It has also been pointed out that many similarities exist between the philosophical positions of postmodernists and art educators who have criticized discipline-based art education (Holt, 1990).

It is difficult to accept the argument that art education has moved to a postmodern perspective when the major focus on art disciplines has promoted a greater distinction between fine art, other disciplines, and other forms of visual culture. Postmodern theory not only involves profound changes of meaning in the content of these disciplines but also the blurring of their boundaries with other subject areas, which is antithetical to discipline-based art education as conceived by Clark, Day, and Greer (1987). The sites of contestation and frayed boundaries among these disciplines are not stressed in school, nor is knowledge represented as socially constructed. An examination of standardized testing revealed that disciplinary knowledge usually is presented as truth and the disciplines themselves as concrete structures. Under these conditions art history may be taught from a 19th century modernist or even premodernist perspective that focuses on historically valued fine art objects and individual (white, male) artists who are represented as having natural genius and work in isolation from the rest of society (Freedman, 1991b). Art criticism as represented in discipline-based programs often focuses upon what professional critics agree rather than on disagreements within the profession and rarely does it take into account student or public opinion. Similarly, aesthetics tends to be reduced to formalism and expressionism in school (Freedman, 1989a). Women and men of color are simply injected into the curriculum and their stories are adjusted to conform to a modernist model of history. The focus on fine arts disciplines and the appropriation of the art of other cultures by educators who teach them from formalistic and expressionistic perspectives, as if they are modern fine art, can in no way be considered postmodern! To teach from a postmodern perspective, for example, history must be conceptualized as unstable, nonlinear, culturally integrated, identity specific, and highly interpretive (Freedman, 1991b).

Housed in public institutions, art educators have had to fend for themselves and adapt their field in order merely to survive. Resulting, in part, from these conditions and the difficulties of representation discussed earlier, art education has had little to do with knowledge in the art community

(Efland, 1976; Freedman, 1989a). Instead, art education has often been a hybrid of general education concepts and the cursory appearance of artistic activity. The fact that art education has only marginally reflected fine art disciplines is less a function of aesthetic modernism or postmodernism than it is of cultural conditions, such as the structure of schooling, conceptions of psychology, political events, family situations, and economic growth. These conditions made it possible to include art in school curriculum for purposes of self-expression and the acquisition of cultural knowledge, while denying its importance as either expression or knowledge.

In considering postmodernism and art education, two other related issues in curriculum surface as particularly important: individualism and multiculturalism. The focus on individuality in art education (through conceptions of originality, artistic talent, self-expression, and the promotion of competition in the excellence and accountability movements) and the recent focus on multiculturalism in education and public policy, brings to the surface a number of school dilemmas. To resolve these dilemmas in the past, educators have relied on meta-narratives of structure and control, such as histories based on colonialism and male domination that involve sweeping generalizations about culture and stereotypes of those who were not dominant. However, postmodern thought has produced a skepticism about the use of meta-discourses in education (see e.g., Cherryholmes, 1988; Nicholson, 1989).

In order to move away from metanarratives in addressing issues of individualism and multiculturalism, a theoretical analysis of the cultural fragmentation and dispersal of subject will be needed. The juxtapositions of cultural identity through the encounter of one culture by another are used to exemplify the complexities of multiculturalism (e.g.,Clifford, 1988). When the issues of multiculturalism are examined from a postmodern perspective, the pluralism that exists in life is promoted; but the impossibility of real and stable cultural boundaries and self-containment must also be acknowledged. Both are shaped by what are referred to as "mainstream" views of culture and often considered common knowledge. The question of whether mainstream culture is common culture is complex because, although it is not always agreed on, mainstream culture influences what is conceptualized as knowledge in and about nonmainstream cultures.

Postmodern curriculum must examine current approaches to individualism and multiculturalism. Curriculum reflects larger social conditions in its placing of disparate fragments together in a collagelike fashion and further promotes fragmentation by detaching old meanings and attaching new ones in and through the context of schooling. Individualism, even in student art-making, is often defeated because school is an inherently social institution with a socializing function. Students are confined by their developmental capabilities and are often required to do the same assignments as others in

their class, and these are basically the same assignments done by thousands of other students now and in the past. They work under controlled conditions, copy from one another and other sources, and so on. The modernist idea of promoting individualism in students through free self-expression ought to be questioned as an educational aim, if for no other reason than it simply is not possible. A postmodern perspective begins with the awareness of this impossibility and rejects the notion that the individual and society are dichotomous. It requires an understanding of individual students as idiosyncratic combinations of various types of shared experience(s) such as being: female, Native American, upper-middle class, handicapped, and urban.

Multicultural representation in curriculum is necessarily fragmented and unstable; the artifacts are decontextualized and transformed by their presentation in school, changing their "ownership" and redefining cultural identity (Freedman, Stuhr, and Weinberg, 1989). For example, in an analysis of published curriculums currently available, Freedman (1991b) found that cultural (non-Western) artifacts are not only dislocated through the unavoidable fragmentation of texts, but also tend to be analyzed through the use of modernist (Western) formal analysis without presenting the implications of such analysis to teachers or students.

As Sleeter and Grant (1987) pointed out, the problem of making school multicultural is usually assigned not to the institution as a whole but to the classroom teacher. Teachers are considered the agents of change toward multiculturalism and given that responsibility. In some cases, government and school officials have attempted to legislate equitable treatment and the inclusion of all cultures in curriculum. However, in practice, such legislation becomes reduced to requirements such as the presentation of a certain number of artifactual examples from various cultures in each lesson. Multiculturalism will be discussed in more depth in Chapter Four; however, it is important to point out here that this practice misses the point that multiculturalism is dependent on a new view of curriculum and artifact, the necessity of addressing concepts such as appropriation and cultural meaning, and the importance of student interpretation and critique.

As is illustrated here, a postmodern perspective of art education is inherently complex, at times challenging, and requires a subtle understanding of culture on the part of both teacher and student. Such a change in perspective is desirable, in part, because it is consistent with the increasing sophistication of adolescent experience outside school resulting from media influences. However, as Marilyn Zurmuehlen (1992) pointed out, caution is recommended when considering teaching young children

postmodern views of art. In her summary explanation of postmodern ideas she stated:

> *A Post-Modernist stance toward art is not one of innocence, and part of Post-Modernism's appeal surely is that it allows us to display, if only to ourselves, our knowledge of prior aesthetic and cultural conventions, our openness to cultural pluralism, our astute awareness of ironies and paradoxes. (p. 14)*

Yet, Zurmuehlen explained that devices that reflect the postmodern spirit, such as recollection, can be fruitful aids to teaching even young children about art. We also support the discussion of postmodern issues in elementary school, such as: recycling images, how the past is reflected in the present, the existence of multiple interpretations, and cultural differences and connections. Before bringing this chapter to a close, the results of research on the use of computer graphics in art education is cited to illustrate that postmodern issues of individualism in art and school can be made the object of instruction.

A Postmodern Example: Computer Graphics in the Art Classroom

Postmodern issues are raised when considering the influences of interactive computer graphics on our conceptions of art. This includes the acceptability of the idea that a computer can be used to create art. These issues prompt several questions that have become important to address (Paraphrased from Freedman, 1993, p. 198).

1. What is the work of art? Is it an art object; and, if so, is it the disk, the text of a program or the conceptual experiencing of an image?

2. Who is the artist? Is it the person who produces the particular image or those persons who developed the software? Are there necessarily many artists for each graphic image? On what assumptions are their roles based? Do hardware and software designers control what can be produced by computer-assisted-art?

3. How is the art to be perceived? Is it appropriate to take a disk with a graphics image on it (produced by an artist) and change the image? Is perception of the original important? In what space should graphics be viewed?

Several of these questions reflect postmodern concerns. Questions such as these also promote a consideration of the didactic purposes of art and the use of computers in education. Computers mediate encounters with symbolic culture and so demand careful consideration when used in education (Bowers, 1988). In education, a growing effort has emerged to direct the computer revolution in ways most beneficial to teaching and learning rather than allowing schools to be driven by technology (Sloan, 1980); and in fact,

research indicates that teachers often use software in ways similar to how they taught before they had computers in their classrooms (Hawkins, Sheingold, Gearhart, & Berger, 1982). Both art and general educators have stated concerns about computers controlling students to such an extent as to prohibit creativity, limit social interaction, and generally reduce critical thinking and learning. However, this need not be the case. The use of microcomputer paint system software for generating graphics, a computer capability that has greatly increased in sophistication in the last few years, may actually promote certain aspects of divergent thinking and critique skills (Freedman, 1989b; 1991a).

The example of a computer-assisted instruction can facilitate the examination of postmodern conceptions of the student, learning processes, and art knowledge. The following is based on the results of seven school case studies that involved elementary, junior high, and senior high school and university art classes. Parts of this section were taken from published reports of the research (Freedman, 1989b; 1991a; 1993), that describe the case studies in detail. The research questions focused on the themes of artistic production, gender and technology, and student social interaction. The forms and processes of production developed in relation to technology possibly being an art medium and computer software developers collaboratively making art, an activity is usually considered highly personal, were of particular interest in this research. Three general conclusions were drawn from the computer research.

1. Similarities but also striking differences exist between the ways students use computers to produce art and their use of other media. As the students learned, their focus shifted during production from manipulative and technical to formal and conceptual aspects of art. Students continued to focus on technical issues and manipulative activities whenever a new function or a new way to use a function was introduced and shifted to formal and conceptual aspects of image production as they became more familiar with the function. However, an experimental approach that involved "trying out," ("cutting and pasting," "undoing," etc.) pervaded the production process.

2. The structure of the software was both directive and, in a sense, liberating. Generating computer graphics was a continuous, dynamic process, rather than one of preconceived image transfer. The process tended to be "problem-posing" even when students followed a problem-solving assignment. The use of "seriation" (changing an image that has been saved and maintained in a previous form) provided opportunities for experimentation. The functions tended to stretch and sometimes even override students'

original intentions but provided new possibilities that were often preferred to the original intent of the artist. In a sense, the artist constructed the software and was constructed by it.

3. The social interactions among students when using computers influenced image development in at least two ways. First, students often helped familiarize each other with the functions at a technical level and ways in which to stretch or enhance their use. Second, students more generally critiqued each other's work and helped improve the imagery by making suggestions. The suggestions were often tried because the original image could be retrieved, if the suggested change is not considered an improvement by the artist. This implies that computers can make art a more social project and can disperse the artist, thus combating the mythology of the individual creative genius working in isolation as being the foundation of artistic enterprise. (Images are always recycled in art; computers make the process more apparent.)

The studies indicated that several aspects of postmodern theory can be acted out by students through the production of interactive computer graphics. For example, when using computer software to make a work of art, the artist becomes de-centered and dispersed; that is, the act of production focuses away from the individual artist (artist intent, physical manipulation of medium, kinesthetic production skills, etc.) toward a multileveled technology and community of production. People, including computer scientists, unknown to teachers and students, design the software used in art classrooms. Although computer paint systems simulate traditional art media, the software has certain characteristics quite unlike paint.

Besides technical and manipulative possibilities and limitations of traditional media, structural and conceptual elements of production are contained within computer paint systems. The software design is based on certain epistemological, aesthetic, and other cultural assumptions. Software is a text; and although it is culturally specific, it carries with it the assumption of a universal subject. The student is directed, one might say even constructed, by the structural possibilities of the software and hardware in ways that go beyond the limitations of traditional school media. The software reconfigures the producer and the viewer. Through capabilities such as high speed "cutting and pasting, "undoing," and "filling" (a shape with a solid or gradient color or pattern), it fragments and juxtaposes time and place. An analysis of these properties of computer software can be used to make students more aware of postmodern issues and attributes.

Computer software also presents students with various problems of representation (such as appropriation), mobile configurations of learning, and new forms of work. It is easy to scan an image and manipulate it on the

computer or create a work of art with someone in another state or country by using a modem. Through processes of appropriating and transforming texts and graphics, students and teachers may shift their conceptions of who the producer is (the software developers, the individual students, the class) and what constitutes an art assignment.

Although producing computer graphics has much in common with making art with traditional media, there are technical and conceptual peculiarities of computer hardware and software. Paint systems, for example, are designed to simulate paint, but not just any paint; they usually simulate the paints most commonly used in Western culture. The simulation limits possibilities, are not necessarily those of real paint. There are crucial differences between the use of computer paint systems and real paint. In these simulations certain culturally specific things are taken-for-granted, such as a white default screen, various types of "brushes," and special effects like "brushstrokes" and "airbrushing" techniques. (Some multicultural examples exist. For example, systems have been developed that simulate and appropriate Japanese calligraphic brushstrokes that look almost as if they were done with ink suspended in water.)

The example of the use of interactive graphics illustrates a number of new possibilities for education. For decades, educators have been cautioned about using computer technology in ways that present a narrow view of knowledge and of the processes of learning. As suggested by the use of computers in general and these studies in particular, the boundaries between previously assumed dichotomous perspectives of the world (such as the artistic vs. the scientific) are becoming less clearly defined. Computer technology can be used in education to present to students issues and concepts consistent with the attributes of postmodernism that redefine art, artist, and art education.

VISIONS OF PROGRESS IN 20TH CENTURY ART EDUCATION

INTRODUCTION

In this chapter we present an interpretation of the history of 20th century art education. We question the view that present day practices have evolved from the less enlightened practices of the past. We challenge the prevalent view that art education has made progress. In this interpretive perspective, the history of art teaching is likened to the "paradigm-shifts" or revolutions that occurred in the sciences as described by Thomas Kuhn in his book *The Structure of Scientific Revolutions* (1962/1970). The idea that change is progress has been a commonly held belief in the arts, the sciences, and in educational practice. Progress is one of the hallmarks of a modernist view of history. One of the definitive characteristics of postmodern thinking is the loss of faith in a totalistic notion of progress. This leads one to ask "How does one interpret change, if such a notion of progress is regarded as an illusion?"

Historical review is a useful first step in setting the stage for curriculum change. In addition, educators need to plan for instruction that is sensitive to today's problems. This is the second task of this chapter. In short, we will discuss the issues confronting art educators in their attempt to devise curricula for the visual arts at a time when U.S. culture is experiencing the postmodern condition. The difficulty is that there is not a definitive postmodern theory capable of representing all the ideas and issues dealt with by analysts of contemporary culture. What one has are collections of attributes, but no definitive consensus.

Among these attributes is a radical shift away from the idea that organized knowledge can faithfully mirror reality or nature and a shift toward the idea that knowledge is a representation of reality or a socially constructed interpretation that is shared by individuals and groups. This displaces the view that the disciplines are universally recognized sources of reliable knowledge. For example, the widely shared belief in the universality of the formal elements of design as a way to describe and analyze art forms is dis-

placed by the current view that these elements are applicable in specific contexts such as abstract and nonobjective painting in the Western world. One does not learn very much about the significance of Kente cloth designs from West Africa through formal analysis. One also needs to know something about the cultural context of these objects to grasp their significance.

Another is the change in the conceptions of individualism and individuality from the belief that the individual is a unified rational being capable of independent action to the idea of extreme individual autonomy is itself an illusion as no one can live outside of history. As the individual becomes decentered in discussions of art and artists, such qualities as individual genius, originality, and the uniqueness of individual expression may become less significant in the future. At the same time, a greater importance might be given to the ways that a given work sheds light on the social and cultural context of its time.

In Chapter Two it was noted that Western culture is shifting from a linear view of time, which is divided into past, present, and future, toward the idea that the past continues in the present. A shift from the geographic conception of place as discrete spaces where cultures develop in relative isolation from one another is being displaced by the idea of intersecting cultures and sometimes cultural conflict.

It is not hard to see how some of these transformations might affect our current notions of the curriculum. If there are problems with our current conceptions of disciplined knowledge, how justified are art educators in continuing with discipline-oriented curricula as conceived in the recent past? If much art knowledge is not universal, especially the elements of design, why do so many textbooks still continue to organize instruction around them? The historical review that follows is undertaken to help us see that many past practices, which were thought to be based on universal understandings of art and of human nature, were based on the peculiarities of a particular time and place.

PROGRESS, PARADIGM-SHIFTS, AND MODERNISM

Since the 17th and 18th centuries, progress in science was pictured as an uphill march toward enlightenment. Each cumulative advance in knowledge eliminated the falsehoods that obscured human understanding. The future of science, indeed, the future of humanity were pictured in terms of a rational utopia, a heaven on earth, which would some day be reached at the end of the march. It was a marvelous picture filled with buoyant optimism. The hopes of humanity were to be found in the certainties of the rational mind and the facts made available by science. In 1962, Kuhn (1970) advanced an idea that challenged this longstanding view of scientific progress.

Kuhn's representation of scientific progress was that the march to enlightenment was a series of conceptual conflicts or revolutions in which established views of nature were discarded in favor of more comprehensive paradigms. Paradigms in Kuhn's view are: "universally recognized scientific achievements that for a time provide model problems and solutions to a community of practitioners" (p. viii). These serve as the bases for the activities of groups within the scientific community. Newton's view of the universe provided the basic paradigm for physics for over two centuries. Einstein's relativity theory eventually supplanted it. Kuhn referred to the times when a prevailing paradigm dominates as periods of "normal science." Between these periods of normality are shorter, less stable periods, when contrary evidence begins to suggest that the paradigm is inadequate, and new explanatory attempts come to the surface.

Gablik (1991) also used the term *paradigm* to refer to social reality, as can be seen in the following passage.

> *A paradigm is very powerful in the life of society, since it influences the way we think, how problems are solved, what goals we pursue and what we value. The socially dominant paradigm is seldom, if ever, stated explicitly, but it unconsciously defines reality for most people, whose view of the world does not normally transcend the limits imposed by this cultural conditioning. (pp. 2-3)*

Kuhn used the terms *scientific revolutions* or "*paradigm shifts*" to characterize those shorter, less stable periods in the history of science when a transition from one paradigm to another is taking place. Whether progress is viewed as a steady march or episodic revolutions is important because it can affect the way one interprets his or her professional history and how one is inclined to regard his or her professional practices in the present. Change is virtually inevitable, but what entitles one to say that it is necessarily for the better? How can one be sure that one is not involved in self-deception?

Paradigm Shifts in Art Education

In applying the term *paradigm shift* to art education, we refer to specific sets of ideas or beliefs that have influenced practice. Cycles of change in art education have followed a pattern remarkably akin to Kuhn's depiction of such shifts in the history of science. Long periods of "normal art education" were followed by relatively short revolutionary periods that introduced new bases for practice. In practice, each transition began with the identification of some aspect of the normal, established practice as deficient. The proposed change resulted in a new system of teaching, often supplanting but never quite eliminating previous systems.

Paradigm Shifts in Modern Art

A strong parallel exists between this view of progress in art education and that affecting the professional fine arts community as modern art became the dominant art style. Starting with the Impressionists and continuing through the mid-1960s, artistic progress has been described as a series of stylistic revolutions, a process that typically dispatched earlier styles to history. The artist Wilhelm deKooning, for example, is reported to have said that every so often an artist has to come along that will "bust our ideas of art to hell, so that there can be painting again!"

Prior to Impressionism this notion of progress would have made little sense. Academic artists believed in maintaining high standards by remaining steadfast to what they regarded as the eternal principles of art—those discovered by the ancient Greeks and perfected in the works of Michelangelo and Raphael. A student could do no better than follow the precepts exemplified by these masters. As modernism gained adherents, the academicians lost ground and became the villains in the meta-narrative of modernist progress.

In what follows, four long-standing traditions of art instruction are identified beginning with the introduction of the elements and principles of design as a foundation for the study and practice of art. Although these changes in practice and purpose were justified by their proponents as ways to bring about progress in art education we interpret these matters differently. The changes they advocated and implemented were certainly different but not warranted by the unfolding of some ontological imperative or by historical determinism. If one is to understand the ways in which change is conceptualized in the postmodern era, one should first understand why a modernist conception of change as progress may no longer be tenable.

Elements of Design in Modernist Pedagogies

The teaching of art through design elements came about as a result of an increasing hostility toward academic approaches, which carried the assumption that instruction should be grounded in skills of representation such as life drawing and perspective. The study of design elements was also fostered by a growing awareness of art from non-Western cultures. The extensive collections of decorative art at the Victoria and Albert Museum, for example, gave rise to the possibility of a more systematic study of ornament from many places in the world and from many times in history. The encyclopedic *Grammar of Ornament* by Owen Jones (1856) would hardly have been possible without these collections. This systemization of the world's diverse art styles was a reflection of a universalist tendency at work in modernism in which all past art is shown to be governed by common underlying principles. (Closer to our own time, a universal notion of aes-

thetics is reflected in the architecture of the "international style" that can be found all over the world and in the Western style of dress that has been adopted in nearly all industrial countries.)

In the U. S., Arthur W. Dow (1899) was inspired by the collections of oriental art at the Boston Museum of Fine Arts. This led to his book *Composition*. He was one of the significant contributors to the study of art by means of design elements. Editions of his book appeared regularly, with the final printing occurring as late as 1942. What distinguished this book from its predecessors was that it was based almost entirely on elements and principles. Dow spent five years studying in French art schools only to find that the academic theory of art had left him quite unsatisfied. His account of his intellectual quest is quite informative as can be seen in the following excerpt.

> *In a search for something more vital I began a comparative study of the art of all nations and epochs. While pursuing an investigation of Oriental painting and design at the Boston Museum of Fine Arts, I met the late Professor Ernest Fenollosa. He was then in charge of the Japanese collections, a considerable portion of which had been gathered by him in Japan He at once gave me his cordial support in my quest, for he also felt the inadequacy of modern art teaching. He vigorously advocated a radically different idea, based as in music on synthetic principles. He believed music to be, in a sense, the key to the other arts since its essence is pure beauty; that space art may be called "visual music" and may be studied and criticized from this point of view. Convinced that this new conception was a more reasonable approach to art, I gave much time to preparing with Professor Fenollosa a progressive series of synthetic exercises. (p. 5)*

Dow's quest resulted in an alternative to academy methods, a tradition of art instruction dating back to the Renaissance. It was this willingness to abandon established practices that places his work in the stream of modernist art education.

Dow's pedagogy and social-Darwinism. Dow came to Teacher's College, Columbia University, in 1904, when this institution was an important center for manual training and vocational education. Among his faculty peers were such individuals as John Dewey and David Snedden. Snedden was an educational sociologist with strong social-Darwinist beliefs. He debated the long-standing assumption that art was educationally important and argued that art may have been important in "other civilizations than our own" at "other stages of evolution." Snedden then asked whether it might be possible that American society and culture had reached a stage of

development "when the social need of art of good quality ... is less vital and compelling than was formerly the case?"

> *Perhaps the functions of art in ministering to the primal needs of society are not what they once were, and so, as a consequence, while society may still be willing to spend of its energies and resources freely on art, it now refuses to take art seriously because it cannot make of it a means toward realizing the more serious and worthy things of life. Strong men decline to make the production of art works a career, although they are willing to see their daughters follow it as a lightsome and not too pro-longed vocation. (1917, p. 803)*

Dow's pedagogy must be seen in the context of an era when social-Darwinist ideology, as revealed in writings such as Snedden's, had a strong following. Educators were urged to eliminate subjects that were not considered socially efficient. Social efficiency referred to schooling as based on survival potential; and in the world of hard-headed businessmen, the artist became a marginal figure. In such a climate of opinion, it made sense to move art pedagogy in the direction of quasi-scientific doctrines like formalism. The art curriculum with the best chances of acceptance and survival was one that could demonstrate a structure organized in a scientific way. For the first time, art also had elements like chemistry and principles, which like the laws of science, were assumed to have universal applicability. These principles also embodied the principle of reductionism by which the extraordinary complexity of a phenomenon, in this case art, could be approached through a simple set of universal, teachable rules.

Creative Self-Expression: A Second Modernist Pedagogy

To understand how self-expression as a pedagogy for art teaching is related to modernism, consideration should be given to the social location of child art as a discovery, an event generally credited to Franz Cizek in Vienna, Austria at the turn of the century. Though psychologists made observations of children's drawings as early as the 1880s and 90s (Sully, 1890), it was Cizek who first saw child art as *art* and who then developed methods for nurturing it. Moreover, he was a member of the group of artists known as the Vienna Secession, which broke away from academy painting to develop an expressionistic style as exemplified by artists such as Gustav Klimt. He was also on the faculty of the Vienna School for Arts and Crafts where so-called progressive artistic tendencies were favored. In contrast, at Vienna's art academy, modernism was conspicuously absent.

In the U. S., the underlying factors supporting creative self-expression were ideological. In the years following World War I, beliefs about education underwent a major change. Malcolm Cowley (1934) recalled the pre-

60

vailing ethos in the Greenwich Village community of New York. He cited "the idea of salvation by the child....Each of us at birth had special potentialities which are slowly crushed and destroyed by a standardized society and mechanical methods of teaching." Another was the idea of self-expression, while still another was "the idea of liberty....Every law, convention, or rule of art that prevents self-expression should be shattered and abolished" (Cowley, 1934, pp. 69-70). In addition, Freudian psychology emphasized the destructive consequences of a repressed childhood. Repression was understood by the 1920s as largely social in origin. The concept of psychological health, discussed in Chapter Two, was wedded to the notion of freeing the child from social inhibitions. These ideas were pervasive in the movement known as progressive education.

An argument linking the rebellion of artists in the last century with the progressive education of the 1920s was obligingly provided by Harold Rugg and Ann Shumaker's manifesto *The Child-Centered School* (1928).

> *To comprehend the significance of the child-centered schools, one would need, indeed, to understand the attempts of the creative artist to break through the thick crust of imitation, superficiality and commercialism which bound the arts throughout the first three centuries of industrialism. (p. v)*

These authors also contrasted schools whose aim was social efficiency with those fostering creative growth. In their opinion, social efficiency as a rationale for prioritizing the curriculum had lost its former credibility.

> *The aim of conventional education was social efficiency. Growth was seen as increasing power to conform, to acquiesce to a schooled discipline; maturity was viewed from the standpoint of successful compliance with social demands....In the new school, however, it is the creative spirit from within that is encouraged rather than conformity to a pattern imposed from without. (p. 3)*

Inventing self-expression. A number of gifted art teachers including Franz Cizek in Vienna, Marion Richardson in England, and Florence Cane in the U. S. had begun to establish a new art pedagogy based on the premise that child art is inherently valuable in and of itself. A second premise was the idea that this was a vulnerable art, easily corrupted by inimical social forces. Children had to be protected from hostile influences poised and ready to crush their tender sensibilities. They were encouraged to create their own art rather than imitate the forms of others. Rugg and Shumaker contrasted this new idea of creative self-expression with Dow's teaching of the past generation.

[Dow] approached art instruction not from the traditional standpoint of teaching children to draw, but from that of principles underlying art, the fundamentals of design applicable equally to abstract compositions, costume design, the decoration of the home or the manufacture of a teacup. His object was to organize the work in art so that there would result "a steady growth in good judgment as to form, tone, and color through all the grades from the kindergarten to the high school." Appreciation was the outcome sought, and throughout Dow's exposition of his theses, as well as in those of his students and followers, appreciation chiefly was the end-aim of art instruction. Creative, constructive, manipulative activity with art materials was always to further the appreciation of some intellectual art principle. Thus was art in the schools intellectualized. (p. 217)

Rugg and Shumaker's writing about Dow in 1928 reads like a critique of the discipline oriented curricula of the 1980s. However, before looking ahead, the following questions need to be asked. Why had the change from the highly structured approaches of the early 1900s given way to self-expression in art and child-centered schooling? Why had the doctrines of the early 1900s shifted? What led to progressive education?"

The social context for creative self-expression. One reason may well have been the increasing popularity of Freudian and Marxist ideas, among artists and intellectuals, which called into question the mechanisms of personal and social oppression in modern society. This challenged the notion that the social efficiency of a society is defined by the interests of big business. A second reason may have been the rise of a large and well-educated urban, middle class responding to the rising pressures of urbanization and conformity in the early 20th century. Feeling the constraints imposed by what Rugg and Shumaker described as an aggressive materialism that put "the needs of things before the needs of people" (p. iv), these individuals felt the need for an alternative to the traditional school. This took the form of the child-centered school, a school where creative self-expression became a vehicle for personal liberation.

Art in Daily Living and Modernism

In the 1930s the Progressive Education Movement shifted somewhat in focus. It moved away from an exclusive preoccupation with the child and toward a concern for society as a whole. The boundless optimism of the 1920s ended dramatically with the Great Depression and the economic paralysis that ensued. It also transformed art education theory and practice. The two movements reviewed earlier could readily be linked with modernist tenden-

cies. The pursuit of pure form, which began to be seen in Dow's synthetic, universal principles, was carried further in the design teaching of the Bauhaus. Early modernists regarded the pursuit of the abstract and the universal as progress. Similarly, the movement promoting self-expression equated progress with the growth of individualism and with subjectivity in personal expression.

The Art-in-Daily-Living approach also bore the modernist stamp in that its practitioners believed that human beings could use their intelligence to improve their lives by applying pseudo-scientific art knowledge to solve problems. Good design provided the foundation of this knowledge. Good design was not merely a matter for enhanced aesthetic contemplation; it also increased the prospects for the survival of the community by creating objects that both looked good and were functional. Bad design, by contrast, wasted resources, created confusion, and discouraged social harmony. It was not art in its purity that was sought but art that would serve common people. The following passage is contained in the foreword of Leon Winslow's (1939) text on art education.

> *Activities that have become divorced from community life and purposes are perhaps suitable or even indispensible for a school purporting to give a timeless culture for its own sake, but they are unsuitable for a school as a living community....Art as a cult, as an esoteric experience for privileged devotees, may be an art that is needed in a school of the first type. Art as a service to men living a common life, art as a means of attaining community goals, is certainly needed in the modern school.*

Actually, Winslow did not oppose either the teaching of design or self-expression. Indeed he attempted to integrate these views but no longer support them as the sole preoccupations of art education. Emphasis shifted from pure design to design applied to the concerns of everyday life—to the home and the community. Moreover, Winslow advocated a curricular approach in which art would become integrated with other studies.

A decade earlier, Rugg wanted educators to use the story of the modern artists' rebellion against entrenched artistic traditions as the model for what should take place in the schools, if they were intent on educational reform. It was as though he equated child art with the art of the avant-garde; but, during the 1930s, modern art was still regarded with suspicion and ridicule in the U. S. Thus, when the emphasis shifted away from the art of elite groups to the concerns of society as a whole, Melvin Haggerty, who was dean of the College of Education at

the University of Minnesota, took pains to distinguish art in the American mainstream from the art of sophisticated elites. He stated

Art as the province of the sophisticated few lies outside the pattern of our thinking here. Art as a cult may be a hindrance rather than an aid to art as a way of life, and it clearly seems to be so in many cases. The teachers of art must be those of the broad and crowded avenues of life, the home, the factory, and the marketplace. It is this conception that must be clarified and dramatized in concrete ways if art is to take its place in the schools as a major and vital instrument of cultural education. (1935, p. 41)

With funds from the Carnegie Foundation, Haggerty had an opportunity to put his ideas into practice. He proposed that an experiment be carried out in a typical small community with a population between 5,000 and 8,000. The town chosen for the study was Owatonna, Minnesota. During the five years of this project, the staff surveyed the art interests within the community in order to determine where the emphasis should lay in the curriculum. Courses of study were developed for the elementary and secondary schools by a professional staff imported for this purpose. The staff also conducted lectures and demonstrations to show how art could enhance the quality of daily life in the home and community (Ziegfeld, 1944).[1]

The Discipline Orientation and Modernism

The idea of structuring the curriculum after the leading ideas of the professional disciplines first arose in discussions of science and mathematics teaching in the late 1950s. Criticism over the quality of U.S. schooling had been on the increase since World War II with progressive educators catching the blame for all the ills affecting the schools. In spite of this, art educators generally maintained their allegiance to the precepts of progressive education, especially those emphasizing self-expression; and to a large extent, postwar art teaching practices had reverted to a pedagogy akin to the self-expression found in the progressive private schools of the 1920s.

In October 1957, as the cold war deepened, the Soviet Union launched its first artificial satellite, which resulted in still another wave of educational criticism. Science and mathematics had to be strengthened if the U.S. was

[1]A number of art education historians have commented on the inconsistency of importing a faculty of experts to develop an art for common individuals that apparently they cannot do for themselves. See Freedman, K. (1989). The philanthropic vision: The Owatonna Art Education Project as an example of "private" interests in public schooling. *Studies in Art Education, 31*(1), 15-26.

to regain its technological superiority. Considering the ensuing psychological climate, it is easy to see how subjects such as art and music might well have been eliminated. However, several art educators felt that the way to avoid this was to come up with a new conception of art education that would emphasize art as a "demanding and disciplined field" (Barkan, 1965).

Jerome Bruner (1960) described the reforms in mathematics and the sciences. Common to these reform projects was their use of professional scholars such as scientists and mathematicians. They identified the leading ideas of their respective fields after which professional curriculum planners would develop and test new offerings in the sciences and mathematics, based on the disciplines. Bruner argued that the key to the riddle of curriculum was to be found in the "structure of the disciplines." He also contended that the disciplines could be represented in some intellectually honest form to students at all levels of instruction and that these should be made the basis of the curriculum. The forms used to represent these understandings should provide the readiness for more complex learning at later stages. Encounters with these basic ideas made up what he called *discipline-centered inquiry*.

Manuel Barkan (1962) adapted Bruner's ideas to problems in teaching the visual arts. In an address before the Western Arts Association, he reviewed the history of self-expression as a movement, arguing that it was an idea whose time was at an end. He proceeded to argue for a new conception of art education based on his interpretation of Bruner. Barkan recalled self-expression in the following manner:

> *in my opinion the dynamic impetus and creative emergence of truly new conceptions of the teaching of art occurred primarily between nineteen twenty-five and nineteen thirty-five. That was the decade of sharp conflict, debate, and controversy, when old established conceptions about the nature of art met their demise, along with the academic teaching procedures which accompanied them. That was the decade when living, dynamic, and progressive thoughts in education and in the teaching of art began their full ascendancy. Those ten years were in fact the period in which truly new educational ideas were born. They were the years when the creative ideological visions were invented.* [2]

He then described the next 25 year period.

[2] The extracts quoted from Barkan appeared in the draft of Barkan's address that was given before the Western Art Association Conference in Cincinnati, Ohio, in 1962. They did not appear in the version published in *Art Education*.

We refined and elaborated basic ideas which had already been germinated. Not to be overlooked is still another and very important accomplishment—slowly, painstakingly, day-to-day practices which put many imaginative and visionary ideas of the early nineteen thirties into reasonable operation in a great many public schools in the nation. But it is the very nature of these accomplishments, the fact that they primarily refined and applied the new and visionary ideas to practice, which would lead the historian to conclude that the work of the past quarter century was a mopping-up operation.

Barkan's description of progress was in two stages, quite similar to Kuhn's description of scientific revolutions. Three years later, Barkan (1966) presented his vision of the art education of the future. He argued that artistic inquiry is structured and that the curriculum should be based on the kinds of questions artists deal with in their work. Art education conceived as a humanistic discipline would have as its principle task that of leading students to ask similar questions. Moreover, from Barkan's view, the artist would not stand alone. He or she would be accompanied by the art critic and art historian who would also be deeply involved in the interpretation of the human meaning questions raised by artists. Thus all these professionals would become "models for inquiry," because the particular ways that they conceived and acted on such questions would be identical with the ways art educators would want students to study art.

In the years remaining to Barkan, he and his colleagues prepared a set of guidelines for a television series on art for elementary school children and also a set of guidelines for aesthetic education. The television series *Images and Things* was the end result. This consisted of 20 programs that were disseminated through public television to schools all over this country and Canada. The aesthetic education guidelines were used by the CEMREL Corporation[3] to produce a series of instructional packages in aesthetic education. The resulting products never yielded the richness of curricular offering promised by the theory. Many compromises were made as the idea entered the stage of practice, and some aspects of the idea to base the teaching of art on the disciplines were found to be unworkable (Efland, 1987).

By the 1970s the disciplines as a focus for curriculum reform went out of fashion within general education. Bruner had grossly oversimplified the characteristic differences between the ways novices form understandings

[3] The acronym CEMREL stands for the Central Mid-western Regional Educational Laboratory, which was located in St. Louis, Mo. CEMREL was involved with a program in aesthetic education between 1968 and 1980, when it closed.

and the ways of more accomplished learners. Experts certainly know more, as one would expect. However, it is of greater importance that there are also significant qualitative differences in the ways that an expert organizes and searches for new understandings as compared with those of the novice (Bransford, et al., 1980; Glaser, 1984). Thus Bruner's expectation that the curriculum can represent the structures of knowledge, as they are understood by disciplined scholars but in a form that the relatively naive learner could easily grasp, was overly optimistic.

There were other reasons why the discipline focus lost force. One was the fact that the movement tended to define disciplines as consensual communities of scholars, all of whom were in general agreement as to what were the leading ideas of their discipline and what the methods of inquiry should be. As noted in Chapter Two, postmodern theory brought about profound changes of meaning in the content of these disciplines, as well as a blurring of their boundaries with other subject areas. It was also noted that, within the discipline-based art education as conceived by Clark, Day, and Greer (1987), the problem of frayed boundaries was not addressed as a conceptual problem nor was the knowledge contained in them represented as socially constructed.

Kuhn and others have argued that disciplines should be pictured as fields marked by conceptual conflicts resulting in periodic revolutions. Indeed it was far more difficult for scholars to agree on which ideas were central to their field than Bruner and his contemporaries realized in the early 1960s. Nevertheless, a revival of interest in discipline-oriented approaches to curriculum reform returned to the educational scene by the early 1980s. The rhetoric heralding this return of the disciplines came in a call to reverse a deterioration in the quality of schooling that occurred in the 1970s when educators essentially abandoned the disciplines in their push to teach basic skills. The call came in such publications as *A Nation at Risk* (National Commission on Excellence in Education, 1983). This time the challenge facing the nation was not from Soviet sputniks but from Japanese Toyotas. Once more the push was for better science and mathematics instruction, but the demands for excellence that were sounded in the 1980s also were couched in suggestions calling for an overall balance in the curriculum that would include instruction in the humanities and the arts.

This historical overview ends with the revival of discipline-oriented approaches. We only described the major shifts in art teaching, however there were rival movements and counter movements. Table 2 summarizes these movements.

Table 2

MOVEMENTS IN 20TH CENTURY ART EDUCATION

Movement	Nature of Art	Content & Methods	Value of Art
Academic Art 17th - 19th Centuries	In the mimetic view, art is an imitation of nature.	Base teaching methods on copying from artists or copying from nature as in life drawing.	Values are found in the accuracy of representations. Art that imitates the good.
Elements of Design: early 20th Century	In the formalist view, art is formal order or significant form.	Teach line and color through systematic exercises.	Values of art are aesthetic in nature, not social or moral. They are found in the quality of formal organization possessed by the work.
Creative Self-Expression: early to mid-20th Century	Art is the original expression of a uniquely gifted individual artist.	Free the artist's or the child's imagination. Eliminate rules, don't impose adult ideas.	Values of art are found in the originality or uniqueness of the artist's personal expression.
Art in Daily Living: 1930-1960	Art is an instrument that enhances the aesthetic quality of an individual's surroundings.	Apply knowledge of art and design principles to problems of a visual aesthetic character.	Values are found in the enhanced quality of life provided by the intelligent application of design principles.
Art as a Discipline: 1960-1990	Art as a concept is a problem that is the subject of artistic and scholarly inquiry.	Base activities on modes of inquiry used by artists and disciplined scholars.	Values are found in the increased understanding of art.

THE FUTURE OF ART EDUCATION

Note the striking similarity among the vision of progress in the sciences, the arts of the modernist era, and change in art education. In each case progress was equated with the shifting from one paradigm, style, or philosophy of teaching to another in a series of revolutions. One was a shift away from the life drawing practices of the academy to the teaching of elements and principles of design. A second was the shift to the teaching of art as self-expression followed by attempts to focus art education on art in daily living, and then to the teaching of art as a discipline. Each new paradigm proposed to cancel out previous systems of instruction. Each time this happened, art education was thought to be making progress. Art educators paid dearly for this misperception. Whole generations of teachers were told that they were behind the times, that they were wrong and old fashioned, and in effect, that they were under a sanction to "get with the new!"

How could the inventors of these new paradigms know that their new practices would be better than the old? What did better mean in these instances? What does better mean in an educational sense? Looking back, these changes might be regarded as reasonable responses to circumstances affecting the teaching of art in the schools, given the circumstances affecting society. One can also see that in conservative times, when art was on the defensive, the tendency for teachers was to move toward a greater sense of organization and structure as with the pedagogy of Dow. This enabled art to remain in the school. In other times, when there was a liberal thrust, the field moved away from organization and control toward self-expression, abandoning textbooks and organized courses of instruction. During economic hard times the teaching of art assumed a pragmatic problem-solving approach; and during the period of Cold War tensions, the focus returned, once again, to structure and discipline. It is obvious that these directional shifts were responses to external pressures then affecting the whole of education. They were justifiable adaptations to changes in the social environment but not necessarily progressive changes.

The Present Crisis in Curriculum

In the 1960s, confident predictions were made that the U.S. was heading for a postindustrial social order. The problem of production was assumed to have been solved by automation. America had become an affluent society that was more enlightened with the explosion of information and electronic systems for its delivery. However, a series of crises shook the nation. Vietnam war protests were followed by revelations of the misuse of power in the Watergate incident. The Civil Rights Movement raised demands for social equity. An increasing awareness developed that the distribution of social rewards was hardly equitable; that productive processes

were counter-productive, polluting and degrading the environment; and that racism and sexism were and are pervasive. With new problems on the horizon and a loss of faith in what Jean François Lyotard has referred to as grand or meta-narratives, most especially in the belief in progress, the U.S. appeared to be at an impasse. Lyotard called this confused state of flux the "postmodern condition" (Carroll, 1987).

As the 1990s unfold, we find ourselves in a new situation. The Soviet Union has collapsed and is now a collection nations undergoing major transformations, which may lead eventually to market-oriented economies. Possibilities for international and economic cooperation, trade, and travel have increased; however, there is also a rise in ethnic conflicts and terrorism. The socialist world is in a state of internal collapse and the Cold War is over. The nations of Europe are moving rapidly toward economic integration. The world of the 1990s is one divided between tendencies drawing peoples together by political and economic ties and other forces driving them apart in movements for independence and freedom from oppressors. The problems of population growth, global warming, the destruction of rainforests, and the persistence of human suffering continue to plague the planet. The educational challenge has never been greater, and the problem facing U.S. educators in all subjects is the lack of a philosophical, cultural consensus. The cultural crisis, as according to Gablik, "is a crisis in belief." This in short is the postmodern condition.

The profusion of art styles that took place, in what has been called aesthetic modernism, was in the words of Donald Horne (1986) about "a great human predicament," or "a crisis in reality-construction," a situation that he claimed was "characteristic of societies as they modernized and industrialized" (p. 235). Much of the stylistic experimentalism of modernism was seen by him as an example of "art doing its job," in that new art is an organizer, as it were, of new experience, of new perspectives, of new perceptions of the world and of human vision (Horne, 1986, pp. 235-236).

Horne wrote about the need of current industrial societies to create new myths about human predicaments and human potential. The myths of economic salvation through 20th century market economics or 19th century socialism have not worked out for the vast majority of people. In a very real sense, aesthetic modernism had not succeeded in constructing a new myth for life in the 20th century. High art became another commodity in the marketplace, while the production of popular culture became an industry (Lewis, 1990). Modernism had indeed supported the creation of its own myths about the artist as a unique individual, but the imagery created in this world of high art alienated the people it had initially intended to reach. Avant-garde experimentalism, which at one level represented art as a way to bring about political and social reforms, at another level reduced the problem of cultural expression to problems of style.

However, a number of artists and social and cultural critics began to question these tendencies in modern culture, especially the self-imposed isolation of the high arts within it. Postmodern writings cover a range of topics and take conflicting perspectives. In the arts, they have sometimes questioned the long-cherished view of the artist or writer as an inspired individual who has a "godlike" power of creation. Moreover, postmodern critics question whether works of art can be interpreted with a single "true" meaning or whether there are, in John Berger's phrase, many "ways of seeing" (1972). In short, both the work of art and the artist have lost their place of privilege as sources of understanding; this also reflects the postmodern condition.

Can art educators generate a reasonable professional model for the remaining years of this century and the opening years of the next? How should art be taught in the postmodern milieu? What features of content and methods would art education likely exhibit? Finally, what would be the value of art and of such instruction? Answers to these questions are made difficult because many definitions of art have surfaced in the postmodern world. Indeed there are those who would claim that art, as it has been known in the modern and premodern past, is at an end (Danto, 1990). Others describe postmodern culture with such terms as "postparadigmatic."

Reality Construction: The Purpose of Art and Art Education

To begin to answer these questions another must be asked: "What is the purpose of art and hence, the purpose of art education in a postmodern era?" The function of the arts throughout human cultural history has been, and continues to be, the task of "reality construction." This purpose has not been fundamentally altered by the postmodern condition. Artists construct representations about the real world or imagined worlds that might inspire human beings to create a different reality for themselves. Much of what constitutes reality is socially constructed, including such things as money, property, marriage, gender roles, economic systems, poverty, legal systems, racism, governments, the humanities, and the arts.[4] The arts contain representations of social reality.

The arts comprise a significant part of the contemporary discourse of our society. However, a discourse needs speakers and listeners; and if students are

[4] John Searle notes that "there are also large sections of the world described by our representations that exist completely independently of those and any other possible representations. The elliptical orbit of the planets relative to the sun, the structure of the hydrogen atom, and the amount of snowfall in the Himalayas, for example, are totally independent of both the system and the actual instances of human representations of these phenomena." Rationality and realism, What is at stake? In *Deadalus, 122,* 4, 55-84.

to participate in the discourse, they will need to know the language. At present this discourse is fragmented along many lines, including ethnic differences as well as those of gender and class. Moreover, this discourse proceeds within many symbol systems and conveys a number of values, many of them in conflict. Meaning, understanding, and intuitive insight are elusive, perhaps more so today than ever before. Therefore, the purpose for teaching art is to contribute to the understanding of the social and cultural landscape that all individuals inhabit. A table representing a postmodern view of curriculum might look like Table 3.

Table 3
A MODEL POSTMODERN ART EDUCATION CURRICULUM: 1990–PRESENT

Definition of Art	Content & Methods	Value of Art
Art is a form of cultural production whose point and purpose is to construct symbols of shared reality.	Recycle content and methods from modern and premodern forms of instruction.	To promote deeper understandings of the social and cultural landscape
	Feature the mini-narratives of various persons or groups not represented by the canon of master artists	
	Explain the effects of power in validating art knowledge.	
	Use arguments grounded in deconstruction to show that no point of view is privileged.	
	Recognize that works of art are multiply coded within several symbol systems.	

The overall purpose of art education might be explained by contrasting it with science education. The fundamental reason for teaching the sciences is to enable students to understand the natural world (and representations of the natural world). A science curriculum should help students to encounter and understand the phenomena of the natural world and the representations of that phenomena in the form of scientific statements or theories.

The fundamental reason for teaching the arts is to enable students to understand the social and cultural worlds they inhabit. These worlds are representations created with the aesthetic qualities of art media. To understand how these qualities function to create meaning, students need to encounter these in their own experience with media. An art curriculum should also enable students to encounter the interpretations and understandings made by philosophers, art historians, and critics who have studied the arts in their complexity. Because these fields are interpretive in character, the statements of such scholars are not presumed true in the sense claimed for scientific representations but they are valued when they enable us to see possible worlds portrayed in the arts.

Art and science do not stand in opposition to each other and, in fact, are equal in importance. Our survival as an industrial nation depends on having reliable knowledge of the natural world. However, the will to use that knowledge wisely cannot come from science itself. No amount of scientific understanding can give individuals the wherewithal to help a society that is blind to its social and moral dilemmas. These are revealed in the private experience of individuals and are represented symbolically in the arts and humanities. It is this process that enables social reality to emerge. Tomorrow's children need the arts to enable them to understand their social world so they might have a future in it!

One may object to this conception of the purpose of art by arguing that it is overwhelmingly bound to social contexts and dilemmas. It shifts attention to the social functions of art, drawing attention away from the arts as valued forms of personal, aesthetic experience: the central issue in most modernist approaches to art education. To some extent this objection is valid. However, Eagleton's (1990) study of the concept of the aesthetic provides us with some insights to resolve this impasse. He opened by noting that there is no agreement as to the definition of the aesthetic and claimed that this very indeterminacy "allows it to figure in a span of preoccupations: freedom and legality, spontaneity and necessity, self-determination, autonomy, particularity, universality, along with several others" (p. 3). He gave the following explanation.

> *My argument, broadly speaking, is that the category of the aesthetic assumes the importance it does in modern Europe [and presumably in North America as well] because in speaking of art it speaks of these other matters too, which are at the heart of the middle class's struggle for political autonomy. (p. 3)*

For Eagleton, the division between the aesthetic and the social is not as pronounced as it has been regarded by many in the past. To understand a work of art, one must see its aesthetic aspects; yet as works of art are also

about experiences, the embedding contexts must be understood to sustain interpretation.

How should art educators represent these concerns in a meaningful way as they teach the art of the past and present? How should art educators represent the art of others, knowing that any interpretation is likely to contain distortions (because one cannot speak accurately for others)? How can postmodern works of art be introduced to children when their understanding strongly depends on prior knowledge? Many such works of art might lie beyond the reach of elementary children who have little understanding of the impulses behind modern art, much less postmodernism. Every time a child in an art class is confronted with a work of art he or she cannot grasp, the teacher should ask; Why is this so? Do artists make art that fails to communicate intentionally, or are the ideas they are trying to express truly difficult? In some cases the art and the ideas may not be accessible to younger minds, but often this is not the case. Many postmodern artists appropriate symbols that are widely experienced and understood within the popular culture, recognizable even to elementary children. Children have little difficulty recognizing the American flag in paintings by Jasper Johns or the Brillo boxes and soup cans by Andy Warhol, though it is likely that they might have trouble understanding why artists would choose such commonplace objects as the basis for their art. With prompting, older children might confront more fundamental questions, such as: Why do certain traditions get established that define and hence limit what a work of art can be about? Also, why, over the years, have artists challenged these traditions?

The problems posed within postmodern discourse are not limited to art. They have surfaced with force in philosophy, history, literature, and the social sciences. Many of the same issues have also come to the surface in the feminist critique of culture and in the proposals for a multicultural approach to the teaching of art. The issue of multiculturalism is often equated with a postmodern perspective. The interest in multicultural approaches to education overlaps with the postmodern but is not identical with it. This is the theme of Chapter Four. Chapter Five contains further elaboration on the problems and prospects for a postmodern curriculum.

Chapter Four

MULTICULTURAL ART EDUCATION AS IT RELATES TO MODERNISM AND POSTMODERNISM

INTRODUCTION

Postmodernism is often considered to be synonymous with multicultural education. Multicultural education is a concept and a process, identified as an educational reform movement (Banks & Banks, 1989). However, there are many versions and understandings of what multicultural education is, depending on decisions concerning: curriculum design, teaching methods, content, goals, and objectives (Sleeter & Grant, 1988). Not all versions and/or understandings of multiculturalism reflect the attributes of postmodernism. In fact, many multicultural programs actually conflict with postmodern tenets and can be linked to modernism.

A seminal source in discussions of the postmodern is Foucault's theory of the interrelationship of knowledge and power. Foucault suggested looking at this powerknowledge relationship with three thoughts in mind:

1. Power is exercised rather than possessed.

2. Power is not primarily repressive, but productive.

3. Power is analyzed as coming from the bottom up. (Sawicki, 1991, p. 21)

Modernist notions of the power/knowledge relationship differ from Foucault's postmodern assumptions.

1. Power is possessed (for instance, by the individuals in the state of nature, by a class, by the people).

2. Power flows from a centralized source from top to bottom (for instance, law, the economy, the state).

3. Power is primarily repressive in its exercise (a prohibition backed by sanctions) (Sawicki, 1991, p. 20).

Postmodern conceptions of power, based on Foucault's understanding of the powerknowledge relationship, are valuable to education for the following reasons: acceptance of pluralism; priority of the little narrative over the meta-narrative; practice of democracy; implementation of nondisciplinary

learning[5] and across-grade-level learning; analysis of conceptual conflict and the acceptance of multiple viewpoints, especially respect for and appreciation of diverse sociocultural and ecological perspectives; and support of radical social change for the purpose of making life better. Often these postmodern considerations are not present in multicultural education curriculum agendas.

New ways to consider cultural and ethnic diversity in the 1990s are presented by sociocultural anthropologists writing from the perspective of postmodern anthropology (Clifford, 1988; Collins, 1989; Nash, 1989). Understanding and investigation of culture and ethnicity (with all of the internal and external complexity of these socially constructed phenomena) are afforded through these anthropologists' insights. Implications for education in general and art education in particular can be drawn from the authors' recognition of social and cultural complexity and interaction (Stuhr, 1995).

Using some of the ideas from historical and postmodern anthropology perspectives, a conception of culture has been synthesized by Wasson, Stuhr, and Petrovich-Mwaniki (1990) to enable a better understanding of multiculturalism.

- We define culture as a people's way of perceiving, believing, evaluating, and behaving (Goodenough, 1976), which can be affected by the environment, the economic system, and modes of production (Harris, 1979).

- Culture has four characteristics: (a) it is learned through enculturation (living it) and socialization (formalized instruction), (b) it is shared by most of its members, (c) it is adaptive [to changes in ecological environments], and (d) it is dynamic (Gollnick & Chinn, 1986).

- Culture is...a transitional process. Cultures are remade through specific alliances, negotiations, and struggles. Cultural institutions are relational and political, coming and going in response to governmental policies and the surrounding ideological climate. (p. 235)

Whereas postmodern ideas about the term *culture* are inclusionary, those of modernism are often exclusionary. Bullivant (1993) made the following observations about the word *culture* and some of its descriptions.

[5]Nondisciplinary refers to a way of teaching wherein two or more subjects are taught as integrated structures within the school curriculum as opposed to teaching subjects in isolation from each other.

- First, it is commonly associated with such aesthetic pursuits as art, drama, ballet, and literature. These make up what is often called a society's *high culture*, as opposed to its *low culture*, such as more popular art, pop music, and mass-media entertainment.

- Second, such terms as *hippie culture, adolescent culture,* and *drug culture* imply that distinct groups in society possess these characteristics. Such groups are often termed *subcultures* (p. 29).

Modernists also define culture as a term for society. According to Bullivant, "the term *British culture* is often a loose way of referring to British society and its culture. When people use the term in this way, they are referring to the people in Britain as being members of British culture or belonging to British culture" (p. 30). However, he reasoned that this is an incorrect use of the word culture, as "People belong to, live in, or are members of social groups; they are not members of cultures" (p. 30). Just as a variety of understandings for the term cultures, all having different social and historical origins (some modern and others postmodern), so too various definitions for the term *multicultural* are in use.

In this chapter, various forms of multiculturalism will be explained and related to the field of art education. This explanation will draw on the analysis, by curriculum theorists Grant and Sleeter (1989; 1993), of the five multicultural approaches found in general education. Further discussion of the relationship between various multicultural art education projects and their association with modernism and postmodernism will be analyzed according to decisions concerning curriculum design, teaching methods, content, goals, and objectives.

MULTICULTURALISM

Multicultural education emerged in the early 1960s out of the Civil Rights Movement as a method for reconstructing the educational system to enable it to be more responsive to the climate of the times and issues of ethnic student diversity. The initial goal of multicultural education was to improve educational achievement for ethnic students who were disenfranchised by the existing educational system (Banks & Banks, 1989). The beginning of postmodernism has also been attributed to this same time period (Jameson, 1985). Since then, multicultural education, in some instances, has changed to

include a more expanded definition. It attempts to educate all students to

> become analytical and critical thinkers capable of examining
> their life circumstances and the social stratifications that keep
> them and their group from fully enjoying the social and financial
> rewards of this country. Or, if they are members of dominant
> groups, it helps them become critical thinkers who are capable
> of examining why their group exclusively enjoys the social and
> financial rewards of the nation...[and] teaches students how to
> use social action skills to participate in shaping and controlling
> their destiny. (Grant & Sleeter, 1989, p. 54)

Art critic, Lucy Lippard (1990), offered the following discussion to explain her inclusive and thought provoking definition of multiculturalism.

> Then there is the increasingly popular "multiculturalism," which
> many of us have used for years in grass-roots and academic
> organizing, although it has already been co-opted in institution-
> al and decidedly nonactivist rhetoric. It is confusing because it
> can be used interchangeably with "multiracial" (voluntary and
> conscious, and involuntary mixing); or it can be used to denote
> biculturalism, as in "Asian-American." I use it to describe mixed
> or cross-cultural groups or as a general term for all of the vari-
> ous communities when they are working together, including
> white. (p. 17)

In their (1987) article, "An Analysis of Multicultural Education in the U. S.," Christine Sleeter and Carl Grant explained and categorized the range of what was identified and defined as multicultural education in the general education literature. They reported on five approaches to multicultural education: "teaching the culturally different," the "human relations approach," "single group studies," "multicultural education," and education that is "multicultural and social reconstructionist." It is important to bear in mind that these approaches are often represented in classroom practice in a more fluid, interacting form than is being presented here for purposes of description and analysis.

Teaching the Exceptional and Culturally Different Approach

Those who align themselves with the exceptional and culturally different approach to multiculturalism perceive the teachers' responsibility as the preparation of "students of color, special-education students, white female students and low-income students to fit into the existing classroom and later into adult society" (Grant & Sleeter, 1989, p. 50). Equipping all students with cognitive skills, technical efficiency, conceptual information, and the aes-

thetic values of the U.S. dominant culture to enable them to get jobs in the arts field and to participate in artistic fine arts cultural events would be the idealized goal of such an approach.

Teachers using this approach use "White middle-class students as the standard to which the 'other' students should be brought up to" (Grant & Sleeter, 1989, p. 50). The underlying assumption in this approach is that the problem is with the students and their learning ability or circumstances and not with the curriculum or sociocultural/physical environment. The resolution of the situation is seen as helping the students to catch up to the norm. The remedy they use is the addition of examples from other cultures that are in line with what is being taught throughout the rest of the curriculum. This approach generally involves only minor amendments to the curriculum, which is based on a dominant cultural view of what is important to learn in order for that culture to reproduce itself.

An example employing the exceptional and culturally different multicultural program in art education is the discipline-based approach. Usually, a curriculum is constructed and implemented, based on the western formal qualities of art and on adult role models from the contemporary western art world: critic, aesthetician, art historian, and practicing studio artist. This approach rarely involves criticism of the content areas it has defined. In order to ensure greater participation of diverse cultures and social groups, this approach suggests including exemplars from the works of individuals who are members of such groups (Fleming, 1988). Graeme Chalmers (1992), a noted advocate of understanding art in its social and cultural context, expressed a belief that there is a possibility for this approach to become more socioculturally relevant. However, Lucy Lippard (1990) warned us that comparing other cultures to our own is the best way to misrepresent and misunderstand a different culture.

Those teaching the exceptional and culturally different multicultural approach argue that a body of knowledge exists that should be learned one which favors a meta-narrative of the art world over little and multiple art world narratives. According to Grant and Sleeter (1989) "Instructional procedures may be changed more than the curriculum when using this approach" (p. 51), as the essence of this approach is to make small changes in the curriculum to aid disenfranchised students in acquiring "the cognitive skills and knowledge expected of the 'average' White middle-class student" (p. 51). They contend that teaching the culturally different is primarily "an approach used to assimilate students of color into the cultural mainstream" (1987, p. 422).

Teaching the Human Relations Approach
The major purpose of the school in the human relations approach is to help students of different backgrounds cope in a world being made continually smaller by modern technology and mass media. With this multicultural

approach it is believed that if

> "*students learn to respect one another regardless of race, class, gender, or exceptionality the U. S. will eventually reach its goal of equality for all....*" *The societal goal promotes feelings of harmony, oneness, tolerance, and accord within the social system that exists (Grant & Sleeter, 1989, p. 51).*

The human relations approach mirrors this goal in that it "teaches positive feelings among all students, promotes group identity and pride for students of color, reduces stereotypes, and works to eliminate prejudice and biases" (p. 51). An art program that primarily relies on the human relations approach uses the arts to foster a sense of unity among its students by stressing the shared qualities and characteristics of art and art making. There is an emphasis on the similarities of art forms and methods of making them. It downplays the differences.

A human relations approach to art education often stresses cultural celebrations, holidays (sometimes shared), and festivals, emphasizing the visual symbols, decorative clothing, and other accouterments that go with these events. The sharing of cultural foods and regional musical performances is often included in the celebration of these events in addition to the visual elements. For instance, an art teacher might have students make pinatas, invite a Latino parent to come in to help make tacos, and/or play Mexican music for students to enhance appreciation for the Latino culture and to bring a sense of self-pride to the Latino members of the class. It follows the 1970s' adage, "I'm ok, and you're ok." The implication is that as members of the human species, we all enhance and celebrate social events with distinct visual imagery and artifacts, special foods, and particular music. The shortcoming of this approach is that unique differences in knowledge and understanding, and areas of power contestation may be overlooked in the search for the overarching qualities of a "melting pot" meta-narrative.

Generally, all of the teachers, including the art teacher in a school building (usually elementary), are encouraged to participate in this type of multicultural project. Grant and Sleeter (1989) advise that, if such an approach is advocated, it should also include attention to social and cultural groups that may not be represented in the school's student enrollment.

Teaching the Single Group Studies Approach

The single group studies approach leads teachers to construct courses based on the contributions and perspectives of one particular cultural group (Sleeter & Grant, 1987). It emphasizes "awareness, respect, and acceptance" of the studied group (Grant & Sleeter, 1989). The societal goals are:

to propagate that which is important in the dominant culture, to promote pluralism, and to establish social equity.

In an art program that promotes the single group studies approach, the focus is on the group as a people, for example, African Americans, Native Americans, or women. This type of program is found more often in high schools, colleges, and universities than in elementary schools. The specific group's art history, contemporary artists, and art forms are studied. It is deemed necessary to study the group's relationship to art because the artist and art forms of the group have not been validated by the mainstream art curriculum. The forms of oppression practiced to keep the group from being incorporated into the accepted curricular canons are often investigated. This approach focuses on raising the status of and respect for the group being studied. There is an implied visionary hope that the students doing the studying will at some future point in time effect social change for that particular group's art endeavors in the mainstream art world by combating White racism. The single group studies approach exposes a single little narrative of an oppressed art world, with the goal of broadening the dominant meta-narrative or mainstream art world.

Grant & Sleeter (1989) summarized the single group study approach in this manner.

> *The single-group studies approach views the student as an active learner, constantly seeking truth and knowledge and committed to reflecting on his or her learning. Instructional practices give special attention to the way members of that group learn best. The student works to develop what Freire calls a "critical consciousness." ... the single group studies approach involves making significant changes in what is normally taught, to provide an in-depth study of specific groups and a critical examination of their oppression. (p. 53)*

Teaching the Multicultural Education Approach

Multicultural Education, as defined by Sleeter and Grant (1990), can be understood as a cultural democracy approach, for it "promotes cultural pluralism and social equity by reforming the school program" (p. 422). This approach is the "most popular term used by educators to describe working with students who are different because of race, gender, class or disability" (Grant & Sleeter, 1993, p. 55).

The social goals of this approach are to provide a more equitable distribution of power, to reduce discrimination and prejudice, and to provide social justice and equitable opportunities for all groups. This approach calls for a total reformation of the schooling process in all schools, whether they have a diverse or totally homogeneous student population. Within this approach

schools are reconstructed so as to model equity and pluralism in all their practices and processes. This approach encourages the hiring of a diverse faculty and staff to be employed in roles that are not stereotypical. Teachers and staff use various teaching strategies to enable students of all learning styles to succeed to their full potential. In addition to the dominant (white male) perspective, other viewpoints are presented. Students are encouraged to use multiple outlooks when analyzing issues (Grant & Sleeter, 1993).

When employing this approach in the area of art education, art teachers present a lesson and relate it to members of many different groups through a selection of various social and/or cultural exemplars and perspectives. The unique contributions of individuals within these diverse social and cultural groups are stressed. When doing this type of presentation, teachers interpret the examples from the point of view of the group being studied. This often means seeking out artists who are members of the groups being studied and consulting with them about their art or other visual cultural production (Stuhr, Petrovich-Mwaniki, Wasson, 1992). For instance, if art forms of Native Americans are being studied, the teacher and possibly his or her students might visit with artists from that nation or invite them into the classroom. In cases where personal contact with artistic members of the group is impossible, information written by artists as an explanation of their work could be used. The teacher and student may even practice the favored learning style(s) of that culture when studying it, such as using a mentor apprentice relationship while studying traditional American Indian art. By using this method of instruction, the subject group is shown as dynamic and active (Grant & Sleeter, 1993).

> *In this approach, instruction starts by assuming that students are capable of learning complex material and performing at a high level of skill. Each student has a personal, unique learning style that teachers discover and build on when teaching. The teacher draws on and uses the conceptual schemes (ways of thinking, knowledge about the world) students bring to school. Cooperative learning is fostered, and both boys and girls are treated equally, in a non-sexist manner. The multicultural education approach, more than the previous three advocates total school reform to make the school reflect diversity. It also advocates giving equal attention to a variety of cultural groups regardless of whether or not they are represented in the school's population (Grant & Sleeter, 1993, p. 56).*

Education That Is Multicultural and Social Reconstructionist

Whereas cultural democracy seeks to reform the school, the social reconstruction approach prepares students to challenge social structural inequality and to promote the goal of social and cultural diversity (Sleeter

& Grant, 1987). Thus, education that is both multicultural and social reconstructionist in approach is an extension of the multicultural approach. It educates students "to become analytical and critical thinkers capable of examining their life circumstances and the social stratifications that keep them and their group from fully enjoying the social and financial rewards of the country" (Grant & Sleeter, 1993, p. 56). On the other hand, this approach helps students from a higher socioeconomic status to look critically at why they enjoy social and economic advantages almost exclusively. This approach seeks to

> reform society toward greater equity in race, class, gender, and disability. It draws on the penetrating vision of George Bernard Shaw, who exclaimed, 'You see things and you say, "Why?" But I dream things that never were, and I say, "Why not?"' (Grant & Sleeter, 1993, p. 56.)

Although this approach has elements of the multicultural approach mentioned before, education that is both multicultural and social reconstructionist incorporates four practices, which would be part of the program in schools adopting this approach. These practices are:

> *(1) democracy must be actively practiced in the school (2) students learn how to analyze their own situations (3) students learn social action skills that help them practice democracy and to analyze their own situations (4) students and groups are taught to coalesce and work together across the lines of race, gender, class, and disability in order to strengthen and energize their fight against oppression (Grant & Sleeter, 1993, p. 57).*

An art program based on the concepts of an integrated multicultural and social reconstructionist approach is interdisciplinary. Art is taught as it is experienced in life, as part of a social and cultural context. Thus, it is taught in relation to other school subjects, especially social studies. Students are encouraged to take part in the construction of curriculum by including their aesthetic experiences and by exploring diverse artists and art forms, which exist in their own homes and communities, as well as those of the state, nation, and world in which they live. The investigation of all artists and all art forms using ethnographic methods based in sociology and anthropology would include an analysis of issues of power as they relate to the following factors: ethnicity, socioeconomic status, gender, age, religion, and mental and physical abilities. Students and teachers, possibly with the assistance of community members, would: gather data related to these factors, clarify and challenge values currently held, make reflective decisions, and take action to implement their decisions (Stuhr, et al., 1992). Students could identify current sociocultural issues, such as: (a) the lack of Latino artists' work in art galleries across the nation, (b) depictions of sexism in popular

music videos, (c) treatment of religious art from other cultures as ethnographic museum material while past Christian art is handled as fine art material, and (d) the intercultural relationship and benefits of Indian powwows.[6]

Once the issue is identified, the class or individual groups of students can gather pertinent information related to the specific issue. With the help of the teacher, students can analyze the information, discuss their feelings and attitudes toward it, and challenge existing views and preconceptions. Students then need to negotiate and adjust their viewpoints in order to arrive at possible decisions and modes of action regarding the original issue. This action could affect how the students, the teacher, and/or the community look at, discuss, and produce art (Stuhr, et al., 1992).

Implementing education that is multicultural and social reconstructionist demands substantial curriculum revision. Ideally, it involves in-service training to ensure the program's continuity. Art lessons and units taught using this approach may take longer periods of time to complete than those using other teaching methods. Some community members, school administrators, teachers, and staff may consider the issues being addressed as controversial and too sensitive to handle. Some may be disappointed by how few meaningful positive actions students are actually able to contribute toward the resolution of problems or social issues (Banks, 1993). Students do not necessarily always choose to act democratically according to the moral views of the teacher or community. Those who are opposed to employing interdisciplinary curricula may argue that art should be a subject separate from others.

However, the reasons for implementing an education that is multicultural and social reconstructionist far outweigh these drawbacks. Through this approach students are empowered to understand the complexity of ways in which various social and cultural groups participate in life in the U.S. of America. This curriculum approach can help to eliminate racial and ethnic isolation and centrism. It offers a chance for the inclusion of all disenfranchised groups' perspectives to be incorporated into the curriculum. Greater attention is given to the contributions of often neglected and diengranchised societies and cultures in this country. Students from disenfranchised groups are empowered to deal with exploitation more effectively. The most significant aspect of this approach is the fact that all students are provided with the chance to improve their skills in critical thinking and analyz-

[6]For a description of this type of curriculum analysis see: Stuhr, P. (in press). A social reconstructionist approach to multicultural art curriculum design based on the powwow. In R. W. Neparud (Ed.), *A new art education for new realities*. New York: Teachers College Press.

ing and are taught to take democratic action based on their decisions. This curriculum approach allows students to develop their investigative abilities and teaches them to work cooperatively for common political ends (Banks, 1993). "Art taught in an interdisciplinary fashion is better able to reflect and create understanding about the social, cultural, ecological, and political conditions of which it is a part" (Stuhr, 1995).

RELATIONSHIPS OF MULTICULTURAL APPROACHES TO MODERNISM AND POSTMODERNISM

Along a continuum from modernism to postmodernism, the first two of Grant and Sleeter's approaches could be placed toward the modernist end. Teaching the culturally-different and human-relations approaches leave the mainstream system relatively intact. These approaches seek to help students fit into (the dominant) society. Both approaches embody such modernist principles as reducing cultural conflict and reinforcing one world view. Education that is culturally democratic, and especially that which is social reconstructionist, more fully represents the postmodern ideals of conceptual conflict, democratization, and a valuing of the attitudes of different participants. The single group studies approach can be understood to contain attributes of both modernism and postmodernism. This approach still leaves most of the dominant system intact, but does promote pluralism and different perspectives. As a result, single group studies is placed toward the center of the continuum.

Figure 1: RELATIVE PLACEMENT OF "FIVE MULTICULTURAL APPROACHES TO EDUCATION IN TERMS OF MODERNISM AND POSTMODERNISM

Modernism ◄--►Postmodernism

teaching culturally different	human relations	single group studies	cultural democracy	social reconstruction

(This figure is an arrangement of best fit rather than a spectrum of political ideologies.)

The relative placement of all five approaches are illustrated in Figure 1 (Cera, 1991).

Teaching the Culturally Different Related to Modernism and Postmodernism

The culturally different multicultural approach in the teaching of art education has more characteristics in common with modernism than with postmodernism. Although those practicing this approach may voice acceptance of pluralism, in actuality they accept it only on their own terms. This approach limits vision to one cultural model that all students are to be measured against, despite their culture or social affiliation. The foundation of modernism is rooted in a single meta-narrative based on universalism, which is upheld as truth in this approach. In this narrative there is one way to view art and that is through the role models of the European and Anglo-American fine art world. Rasheed Araeen questioned the motives of postmodern multiculturalists.

> It has been the function of Modernism since early in this century to 'eliminate' the importance of these differences in its march toward an equal global society. Why are these differences so important now? Instead of seeing the presence of various cultures within our modern society as our common asset, why are they being used to fulfill the specific needs of specific people? Does this not somehow echo the philosophy of Apartheid? (in Lippard, 1990, p. 30)

Postmodernist pluralism, on the other hand, erases the possibility that all art worlds can or should be interpreted through such a limited model.

The practice of democracy, as stressed in a postmodernist view, is not developed through the use of this art teaching model. Knowledge and its dispensation is limited to the teacher, who depends on the writings of recognized experts from the areas of criticism, aesthetics, art history, and studio practice (e.g. Brommer, 1981; Chapman, 1985). The knowledge that the students or the community may bring to consideration of diverse sociocultural art worlds is largely neglected.

This art teaching model upholds modernist concepts by maintaining that art education is a school subject area in itself and further that it is divided into four, and only four, distinct disciplines, at least as the proponents of discipline-based art education state the matter. In addition it asserts that art as a subject is best taught sequentially, according to grade levels (Chapman, 1985). The analysis of conceptual conflict is avoided in this approach because art forms and artists from diverse sociocultural groups, which are not in sync with the loci of Western art forms, are rarely dealt with. For example, art as a physical or mental healer is usually not discussed. Navajo sand creations might be taught and looked at through the Western lens of painting, as an aesthetic object, neglecting this art form's

religious, ecological, medicinal significance. Little respect or appreciation is afforded to diverse sociocultural perspectives when their art forms are denied their own context.

The agenda of the multicultural art approach for teaching the exceptional and culturally different is concerned with maintaining the status quo. Those who practice this approach feel that once all teachers and students are indoctrinated into the one right way to teach and learn about art, they will have a stake in the Western fine art world. There will then be no need to practice the kind of radical social change called for in a postmodern multicultural project.

Human Relations Approach Related to Modernism and Postmodernism

The human relations approach to teaching art recognizes and accepts the concept of cultural art at a surface level. In the spirit of postmodernism, all sociocultural groups' perspectives are included in the curriculum. Emphasis is placed on sociocultural similarities rather than differences. The positive aspects of a sociocultural group are stressed over the negative. Differences are often glossed over for the sake of good will. All groups are given a space in the curriculum, and the little narrative espoused by postmodernists is favored over the meta-narrative supported by modernists. However, this is done at a superficial level.

Disciplines and grade divisions are often dissolved in the form of celebrations of cultural diversity, which may be considered postmodernist. All sociocultural groups are seen as worthy of celebration. Privileged as well as oppressed groups are considered equally worthy as sources of curricular content. However, because so many types of diversity are included and compared in this approach, meaningful and in-depth investigation into power negotiations and relationships suggested by postmodernists is often sacrificed.

In the human relations approach, teachers and students are encouraged to bring in sociocultural information, production, and informants from their communities (family members are often relied on to aid in this activity). The expert knowledge required in modernism is relinquished in doing this.

The postmodernist is likely to analyze points of conflict, and this activity tends to be neglected in the human relations approach. One of the main goals of the human relations approach in multicultural teaching is the development by all students of self-esteem and self-confidence. Confronting sociocultural differences, often sources of conflict, is seen as being in opposition to this goal by the practitioners of this approach. As this approach deals with only a superficial view of social and cultural diversity, for the

most part ignoring conceptual conflict, the need for radical social change is not articulated.

Single Group Studies Approach Related to Modernism and Postmodernism

The single group studies approach to teaching art acknowledges postmodernist concepts of cultural pluralism and recognizes sociocultural oppression by privileged groups. This teaching approach emphasizes the investigation of specific marginalized little narratives, as opposed to the study of multiple sociocultural groups, in order to present a perspective that has been historically negated or ignored in the mainstream school art curriculum. Thus, it acknowledges the focus of postmodernism on conceptual conflict.

However, this approach may not necessarily further the postmodern concept that favors the practice of democracy. Instead, this approach may create a new ethnocentric, dogmatic little narratives. Considering the fact that the little narrative of, for instance, black studies or women's studies, remains alone in its struggle against a powerful oppressor, little headway may actually be made toward equity in opportunity and resources for that group. All that seems possible is a consciousness-raising within a specific community. However, this may be a necessary first step in the struggle for the acceptance of multiple narratives as typified by a postmodern approach. There is a possibility of this approach being appropriated by modernist institutions for the purpose of their own ends, and this approach may use this type of course provision to co-opt the reforming thrust.

Multicultural Art Education Approach Related to Modernism and Postmodernism

The multicultural art education or cultural democracy approach posits the introduction of multiple little narratives concerning the art worlds of many diverse sociocultural groups in opposition to the modernist approach with its one metanarrative or its one paramount art world. This approach examines the complexity of powerknowledge negotiations and divisions among and within these diverse groups by investigating issues of gender, class, race, ethnicity, religion, and exceptionality. Democracy is practiced through the inclusion of perspectives from the various sociocultural groups that make up the population of the U. S. in the art curriculum.

Expert knowledge is not assumed to be held only by the art teacher. Rather, in accord with postmodern tenets, the teachers, students, staff, and members of the community collaboratively assist in constructing a curriculum that reflects the demographics in the community, state, nation, and world (Stuhr, et al., 1992).

When this multicultural art approach is employed, it generally works best when the entire school is involved in the curriculum project. However, this is not a necessity, and should not be used as an excuse for not trying to implement such an approach. Ideally, this approach should be implemented free of subject or discipline constraints to ensure that the sociocultural knowledge be presented in as complete and complex a form as possible. As the implementation of this type of multicultural curriculum does not require it to be taught by a predetermined sequence, the division of students by exact grade levels is not seen as a requirement.

The postmodern preference to organize study around points of conceptual conflict is crucial to the understanding of multicultural subject matter and is a vital component of this approach. Students are not expected to accept unthinkingly all parts of the curriculum as presented. Rather, they are expected to develop a critical perspective toward each sociocultural art world, to consider the role that equities and inequities of power/knowledge have afforded in each instance. This critical approach enables the students in a postmodern mode to envision an ideal nation for all its citizens and hopefully to strive toward this goal.

Education That Is Multicultural and Social Reconstructionist Related to Modernism and Postmodernism

The social reconstructionist approach to multicultural art education fulfills all of the attributes of postmodernism and has little if anything in common with modernist theory. In this approach diverse sociocultural groups represented within the nation are expected to be present in the curriculum. These sociocultural art worlds are represented as little narratives with a diversity of power/knowledge relationships and possibilities for negotiation. No single art world is represented by a meta-narrative as the only truth.

The postmodernizing of pedagogy is based on the recognition that knowledge in and of the humanities is precisely a knowledge of enframing, of media and mise-en-scene understood not as a representation of something else but as itself a mode of action in the cultural world. The conclusion drawn from this recognition could be summarized by the axiom that... the observer in the observation; the organization and classification of knowledge are interested activities (Ulmer, 1985).

The importance of the distinction between the social reconstructionist approach and that of the social democracy approach is that, through the curriculum, teacher, students, staff, and community are enabled and expected to practice democratic action for the benefit of disenfranchised sociocultural groups. As Lucy Lippard (1990) contends, we cannot speak for the other, but we can speak *up* for them. This action will make the stu-

dents more informed and better citizens of a democratic nation (Stuhr, 1995).

This approach would require the institution of schooling to be completely transformed. Disciplines would dissolve through a process of forming contextual relationships among school subjects. Curriculum would depend on social, political, and economic conditions of the community, state, and nation rather than be based on a sequential, mandated, uniform national or state curriculum. Moreover, it would always be in a state of flux.

An art program based on this approach is a radical departure from what exists as art education today. A social reconstructionist approach ideally would entail cooperative planning among teachers from various subject areas: such as social studies and language arts in secondary schools, and classroom teachers in elementary schools. The teachers would select content to be investigated. It would be made relative to the students' understandings of the political and economic situations that exist around a particular topic. It would be up to the art teacher to direct attention to how art, or the cultural aesthetic production of diverse and complex (and/or specific) sociocultural groups, can contribute to this understanding and instigate democratic action.

CONCLUSION

In order for a multicultural approach in art education to claim a relationship to postmodernism, it is necessary that the approach have a curriculum design, teaching methods, content, goals, and objectives congruent with the beliefs being voiced in postmodern discourse. There are at least five approaches to multicultural education in general and art education specifically. Teaching the "culturally different" and "human realtions" approaches are more in line with modernist theory than the postmodern. The "single group studies" approach incorporates elements of the modern and postmodern and, depending on how it is practiced, could fall into either or both of these paradigms. Only two approaches, "social democracy" and "social reconstruction," share the main characteristics of postmodern discourse. These approaches are best suited to promoting postmodern ideas in art education, thus helping to create an informed citizenry who question authority and the status quo, accept differences, and act in defense of others and the environment.

THE CHARACTER OF A POSTMODERN ART CURRICULUM

This chapter contains a review of the general characteristics of post-modernism that were identified earlier in this book and explains how these might function as organizing principles for the teaching of art. First is Jean-François Lyotard's (1984) idea that there is a loss of faith in the grand- or metanarratives of history, which tend to portray humanity as being progressively involved in a steady march toward greater emancipation. This loss of faith is what he calls the postmodern condition. If the meta-narratives that have shaped cultural modernism have lost credibility, then aesthetic modernism is vulnerable, as it is based on narratives in which the movement toward abstraction was equated with progress in art.

Second, Michel Foucault (1970; 1965) characterizes power as bound with knowledge. Disciplines of knowledge, which have been assumed to be objective and value-free, generally seem to confer social advantages on the dominant groups in society at the expense of others. What is deemed "high art" appears to obtain this status through an identification with the socially dominant, whereas the products of less dominant groups often languish in obscurity. Uncovering the ways in which such determinations are made might become the object of instruction. The powerknowledge linkage raises questions for curriculum planners. For example, should the decisions about which art is high and which is low be passed to future generations through instruction?

Third, Jacques Derrida's (1976) method of cultural and art criticism, which he calls deconstruction, is a way of bringing to light the oppositions within cultural forms. This confounds the possibility of there being a single, true interpretation. No interpretation is privileged as the truth.

A fourth characteristic is derived from Charles Jenck's double-coding theory which implies that objects (especially architecture) need to be understood in semiotic terms as forms that communicate messages to viewers through various codes, for example, styles and ornamental devices (Rose, 1991). Jencks describes double-coding as the combination of modern building techniques with something else (usually traditional building) in order

for architecture to communicate with the public and a concerned minority, usually other architects (Jencks, 1986, p. 14).

If these four characteristics are features of postmodern discourse, they will likely be the characteristics of a postmodern curriculum as well. In many respects these four characteristics may be contradictory to one another. In what follows, no attempt is made to reconcile the differences among these characteristics. A postmodern curriculum will in all likelihood share some, most, or all characteristics. Indeed, the distinguishing feature of a postmodern curriculum is a questioning of long-standing interpretations by focusing on content selection to heighten points of conflict.

LITTLE NARRATIVES INSTEAD OF META-NARRATIVES

Jean-François Lyotard describes the postmodern as "incredulity toward meta-narratives," the root assumptions or paradigms that are typical of an epoch (see Carroll, 1987). Earlier it was indicated that history based on the belief in the inevitability of progress as a consequence of the advancement of science is one such meta-narrative and perhaps the most pervasive. Art history pedagogy is typically built around narratives of progress. If these no longer meet with general acceptance, the question arises, what should take their place? How should textbooks, courses of study, and even the layout of art museums change to enable individuals to develop alternate understandings of art?

Postmodern artists have investigated the concept of little narratives. In *Portrait of a Mother with Past Affixed Also,* Edward Kienholz and Nancy Reddin Kienholz's 1980-81 representation of Edward's mother refers to the life history of mother and son. Memorabilia are placed around the house reflecting the past of a lifetime, and the mother's portrait looks, like a mirror, at the child. The small size of the house reminds the viewer of the little narrative of an individual's life, while the crowded room and the view of outdoors suggest something of life's complexities.

Historical Narratives

Lyotard noted that narratives, such as those concerning progress, were efforts to legitimate the historical present. If he is correct, it makes no sense to interpret art as a stylistic unfolding in which later forms of art are more advanced and hence better. It becomes hard to justify new art as continuing to make progress when the progress of civilization itself is being questioned. If the progress narrative is taken away, what then should become the organizing principle around which art history is taught?

One option is to replace the meta-narrative with smaller narratives. The curriculum might be structured to deal with multiple developments and forms of art. A curriculum also can be thought of as a narrative, a kind of fiction used to portray possibilities for teaching and learning (Efland, 1990).

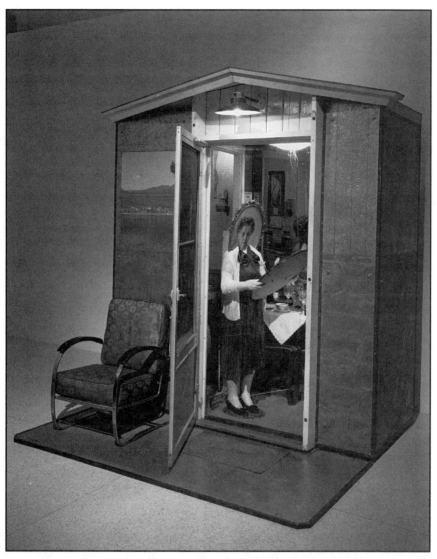

Edward and Nancy Reddin Kienholz, *Portrait of a Mother with Past Affixed Also*. 1980-1981. Mixed media environment. 99-7/8 x 94-5/8 x 81". Collection Walker Art Center, Minneapolis. Walker Special Purchase Fund, 1985.

It is also a tenable assumption that no universal curriculum is likely to satisfy all individuals, anymore than one universal kind of art is likely to fulfill the needs of all cultures and persons. Lyotard referred to "little narratives," which can be described as the stories of various cultures, subcultures, genders, and social classes, each evolving their own forms of linguistic and sometimes artistic expression. Each little narrative establishes its own story, narrator, and listeners: that is, its own autonomy. Each might be taken as the source of its own legitimacy. Everyone has the right of narration (Carroll, 1987; Readings, 1991).

Art history. As noted before, art historical study is usually framed around the progress narrative. This was so when Antonio Vasari wrote his *Lives of the Artists* late in the Renaissance. Then, the narrative was built around the belief that Giotto's art was a primitive version of what was to become fulfilled in the work of his successors, Leonardo, Raphael, and Michelangelo, more than a century later. A 20th century modernist narrative is that, as artists moved deeper into abstraction and abandoned realism, they, too, made progress. Donald Presiosi (1989) noted how many systems for the presentation of art historical knowledge—for example, the museum—rely heavily on these narratives.

> *All history is perforce a production—a deliberate selection, ordering, and an evaluation of past events, experiences and processes. Any museum, in incorporating selections and silences, is an ideological apparatus. In addition every museum generates ways of not seeing and inhibits the capacity of visitors to imagine alternate histories, or social orders, past or future. (p. 70)*

Presiosi singled out the peculiar role that photography has played in the teaching of art history, in particular, the art history slide.

> *The powerful network of apparatuses constituting the modern discipline of art history presupposes the existence of photography. From its beginnings ... filmic technologies have played a key role in analytic study, taxonomic ordering, and the creation of historical and genealogical narratives. Lantern-slide projection entered the field very early, establishing the formats of study, and analysis, and comparison of images In short the modern discipline has been grounded in metaphors of cinematic practice, to the extent that in nearly all of its facets, art history could be said to continually refer to and implicate the discursive logic of realist cinema. The art history slide is always orchestrated as a still in a historical movie. (pp. 72-73)*

Presiosi urged his readers to recognize that most instructional technologies presently in use, such as the college survey course, the textbook,

the museum, and the slide library, tend to exert a one-sided view showing a particular type of stylistic evolution. It is not that art historians have intentionally conspired to misrepresent their discipline. Rather, they are caught up in what might be termed a "conspiracy of convenience." It is easier to represent knowledge as an unfolding chronology and evolution of styles than to explain how changes of style and subject matter reflect the deeper changes occurring in the artist's social milieu.

The progress narrative is sometimes deeply implicated in the story of an individual artist. Mondrian's work is frequently interpreted in this way. For example, in an art appreciation book written for children, a Mondrian-like diagram was placed over de Hooch's *Interior with Soldiers* (Gettings, 1963, p. 27) to make the point that all good art, even realistic works like this one, have an underlying form like the abstract forms of Mondrian's art. Gettings implies that the presence of such structures gives this type of work its aesthetic value and that modern artists like Mondrian have progressed further in uncovering the underlying aesthetic character of all forms of art. Implied here is the belief that the representational aspects common in premodern art are of lesser importance and that modern art is somehow closer or higher in its aesthetic accomplishment for having eliminated representational images. As Mondrian and de Hooch are separated by several hundred years and had very different artistic purposes in mind, such examples might lead students to conclude that Mondrian developed his style from tendencies at work in 17th century Dutch painting. This would be a serious misunderstanding of Mondrian's achievement and his place in art history.

A second typically modernist narrative is the myth of the solitary genius, living in poverty and neglect, who is "discovered" only after his death, at which time his works bring extraordinary prices. Presiosi (1989) refered to the novel and film *Lust for Life* as embracing this view in its treatment of Van Gogh. The impression created by these fictionalized biographies is that Van Gogh's ideas were the result of his deep suffering and isolation. Though educators should not minimize the personal difficulties Van Gogh overcame to achieve his art, his ideas were influenced by several sources: his Impressionist forebears, the popular culture, and Japanese prints, to mention a few (Nochlin, 1990).

It is important for students to recognize how certain myths about artists become established and disseminated, often in novels and films. Students should be made aware that in fictionalized and dramatized stories about artists' lives the facts of art history may be misrepresented and that even among so-called factual accounts, there are also myths, biases, and contradictions. The object here is to recognize that in different arenas the facts of art history may be represented in conflicting ways.

Design history. The teaching of design is also dominated by the progress narrative. Peter Fuller (1987) uses Nicholas Pevsner's (1961)

Pioneers of Modern Design from William Morris to Walter Gropius to make this point. At the start of the industrial revolution, so the story goes, artisan designers adapted the designs developed through centuries of crafts production to the mechanized industries developing in the 19th century. This resulted in a devastating decline in the quality of the designs of manufactured goods. Starting with Morris and extending to the Bauhaus, modern principles of good design gradually supplanted the earlier tradition of aping the designs of past craft traditions. Modern design based on the machine thus came into being. This was also seen as progress; and, to this day, many teachers approach design as conceived within this narrative.

Within contemporary design criticism, however, one sees a growing awareness that the emphasis on functional design has not always led to human satisfaction. Michael McCoy (1989) discussed the plight of the postindustrial designer, noting that industrial products tend to become similar in design, such as microwave ovens that look like TV sets. There is a pervasive feeling that contemporary design has failed in some critical way to communicate very much about our lives and culture through the things being made by current productive processes. As long as the teaching of design is based on the progress narrative, it will be difficult to hold a critical discussion of design.

Little Narratives as a Model for Curricula

The meta-narratives of art history and industrial design illustrate the misconceptions that can occur. Many forms of art are produced in many styles, serving many purposes, and addressed to many specific audiences. It stands to reason that a curriculum reflecting a specific narrative will promote some forms of art and exclude others. However, a curriculum built on the idea of little narratives could deal with several stories, each one emphasizing a different content. Each story may give a specifically different answer to the question "Whose art gets taught?"

Little narratives could be written by individuals or groups about art that is currently overlooked. One might think that multicultural curricula would necessarily take the form of little narratives; however, if the curriculum is seen as one narrative representing the artistic progress of the dominant culture, merely adding multicultural content to that narrative is tokenism. The function of little narratives is to show that each cultural story is but one among many. It also could be maintained that mainstream art history should not be discarded but take its place as one story among many. With multiple narratives there is a greater likelihood that the shape of the curriculum will reflect a greater degree of cultural diversity.

Subject matter expertise. When the curriculum is represented as little narratives, who then assumes the role of subject matter expert? In the past curriculum writers turned to experts as influential resource persons, but in

many cases the individuals who serve as experts for little narratives are not experts in the conventional sense of possessing degrees or certification. Native informants of a particular culture or group might be the experts in this instance of little narratives. In the past, it has been assumed that such knowledge is not disciplined and hence has less standing. Yet, if the little narrative is about local artists, local artistic traditions, and locally shared experience, it makes sense to recognize that local people are the experts in this instance. To develop a curriculum based on local informants means that in some cases teachers and students may have to create knowledge for themselves, perhaps functioning as anthropologists (Stuhr, 1995).

Little narratives and national curricula. If there are many authors writing many curriculum narratives for many different students in various settings, then a nationally prescribed curriculum would, on first look, seem infeasible. In a nation with the diversity of the U. S. or Canada, a series of localized curricula sometimes representing local needs and interests and sometimes representing differing styles of art with differing problems of interpretation would appear to make greater sense. However, a proliferation of local initiatives might lead to a situation where little or no content is shared. Those favoring local curricula as opposed to national curricula fear the imposition of a homogenized curriculum written by panels of experts, who cannot possibly address local interests and needs. Nationally imposed aspects of the curriculum would tend to override the unique and particular aspects of art that deserve to be recognized and celebrated in the different locales of nations.

However, no matter how rich local content and resources might be, they are not sufficient. There should also be a sharing of local traditions across regions and groups. In other words, a postmodern curriculum may sanction content with local significance but is open to content that extends beyond the local situation. A national curriculum properly conceived might take the form of a program where differing local traditions are shared across groups: because as long as a curriculum remains local, it presents an isolated world view. However, when students learn about the local traditions of others, they have a better basis for understanding and valuing their own traditions.

THE RELATION OF POWER TO KNOWLEDGE

The second characteristic of a postmodern curriculum is found in the linking of "power with knowledge." The questions arise: Who has the power to shape the curriculum?, What shall be taught and to whom?, *Whose art* shall be accorded status as "high art?," Whose art is ignored or marginalized? How are these determinations made?, How are these decisions passed

on through instruction?, *Why* is some art accorded status as "high art" while other art is not?

In linking knowledge to power, Foucault was not referring to Francis Bacon's dictum that "knowledge is power" in the sense that knowledge gives humanity dominance over nature. Foucault addressed the ways that institutions and socially powerful groups often determine whose knowledge or which version of the facts is deemed educationally worthy, overriding the interests and desires of others lacking such power. He argued that there is an intimate relation between the emergence of disciplined knowledge and systems of social control made possible by this knowledge. The care of the insane was made both efficient and humane by psychiatry. It also exerted a form of social control on that segment of the population by placing many in asylums. Foucault's thesis is that the expansion of disciplined knowledge might also be viewed as a way of extending social control over certain social groups. Foucault's critique was directed toward the disciplines that make up the social sciences, but issues of power and control also can be found to apply in art history and art criticism.

Art history arose as a discipline when large public and private collections of art were being established, when it became necessary to demonstrate the authenticity of precious objects, and when it became necessary to distinguish originals from copies or forgeries to help create legitimate collections. Art criticism made its appearance when private art dealers became the means for disseminating new works of art to the public. Critics became the means through which major works were identified and explicated (Carrier, 1986; 1992). As their opinions circulated through journals and newspapers, works evaluated as culturally important enjoyed more prestige and enhanced market values. These opinions and values eventually become reified in textbooks. The practice of relegating Asian and African art to a few pages in the back of the art history survey text is an obvious way of asserting the dominance of European and American art over non-Western artistic traditions. Even within the professional fine art community, power issues can be discerned in the tendency of the artworld to marginalize crafts as "decorative art" and "popular art" as kitsch or entertainment.

How does one proceed to democratize an art curriculum, to make it more representative? To what extent can the disdain of popular culture by such modernist art critics as Clement Greenberg be construed as a power issue? Who has power in this instance, and who benefits from his claims that certain artistic developments are more important than others? Examples of powerknowledge issues arise in almost every area of artistic study.

98

Architecture and Architectural Criticism as a PowerKnowledge Issue

As architecture was one of the first of the visual arts about which the term postmodern was used, architectural criticism plays an important role in discussions of postmodern art. Indeed it is one art form where the difference between modern and postmodern architectural styles is dramatically discernible. It is also an arena where decisions made about the built environment cannot help but bring into play discussions of social power, its exercise and its consequences. Consider the following extracts by Andreas Huyssen (1990).

> The modernist utopia embodied in the building programs of the Bauhaus, of Mies, Gropius and Le Corbusier, was part of a heroic attempt after the Great War and the Russian Revolution to rebuild a war-ravaged Europe in the image of the new, and to make building a vital part of the envisaged renewal of society. A new Enlightenment demanded a rational design for a rational society, but the new rationality was overlaid with a utopian fervor which ultimately made it veer back into myth—the myth of modernization. Ruthless denial of the past was as much an essential component of the modern movement as its call for modernization through standardization and rationalization.

> After 1945, modernist architecture was largely deprived of its social vision and became increasingly an architecture of power and representation. Rather than standing as harbinger and promises of the new life, modernist housing projects became symbols of alienation and dehumanization, a fate shared with the assembly line. (p. 239-240)

Similarly, Christopher Alexander (1988) argued that modernist architects typically tried to eliminate complexity, confusion, and diversity in order to bring harmony to the urban environment. More often than not these "planned communities" failed to provide for actual human needs. Another example might be seen in the controversy that surrounded Richard Serra's site-specific sculpture *Tilted Arc,* where panels of experts commissioned this work on the basis of the artist's proposal. After the work was installed, it provoked a public controversy. Many viewers felt that the work "destroyed" the public space it occupied. A trial resulted in its removal and its virtual destruction amidst outcries of censorship by the artist and his supporters. One point made clear by the controversy is that both sides tried to exert political power to influence the fate of this work.

Popular Culture as a PowerKnowledge Issue

The study of popular culture and its disavowal in modernist art criticism is also an area where power issues can be discerned. Laura Kipnis (1986) noted that the opposition between high culture and mass culture was one of the effects of modernism.

> Dismantling the ideological scaffolds of modernism allows the rereading of modernism as constituted solely within this split, and existing only so long as it could keep its other—the popular, the low, the regional and the impure—at bay. We could redefine modernism as the ideological necessity of erecting and maintaining exclusive standards of the literary and artistic against the constant threat of incursion and contamination. The partial success of this project is what is generally given to us as the unity, modernism. (p. 21)

It is clear that a number of art historians have begun to recognize the extent to which imagery from popular culture, much of it consisting of commercial images associated with advertising, is discernible in such high modernist art as the Cubist still lifes of Picasso and Braque. This point was made abundantly clear in the *High-Low* show at the Art Institute of Chicago in 1992. Moreover, we have seen a number of contemporary artists such as Warhol and Lichtenstein have crossed the bounds that have been used to separate the serious from the popular.

In art such as *Fluxus*, popular culture and fine art meet, as seen in the Fluxus exhibitions at the Walker Art Center in Minneapolis and the Wexner Center in Columbus. Here, works of art assembled from recycled objects and images are often self-contradictory, such as having moving pieces that do not do anything.

The Crafts as a PowerKnowledge Issue

The crafts are another area where power issues affect discussions of art. Consider this statement from a leading textbook written in the late 1960s:

> Naturally all functional designs and man-made products cannot be considered works of art Contemporary pottery illustrates this fact in an obvious manner. Pottery may meet basic needs by providing roof or floor tile or simple containers for manufactured goods such as jelly or jam While the design of these forms may be excellent and functional, such qualities are not the main ingredients of art. Pottery functions as an art area only when the potter's concern is in the discovering of new shape and surface possibilities in the designing of personal forms in clay. Only then can pottery be considered an art form. (Schinneller, 1967, p. 35)

Schinneller wrote when modernist criteria was the unquestioned norm determining what could be art. However, these criteria do not readily hold up to scrutiny today, for there are innumerable hackneyed paintings, which are wholly derivative of other works and do not exhibit any striving for originality or artistic discovery. Kim Levin's essay "Sofa-sized Pictures" (1988a) explores a whole genre of made-to-order paintings using mass-production techniques, which by Schinneller's criteria might still be accorded status as art because they lack the functional purposes associated with craft. The rationale used by arts councils and galleries to confer the status of art on one kind of cultural artifact yet withhold it from another is often arbitrary, having to do with art politics and the wielding of power.

Elitism as a Construct of PowerKnowledge

Modernist experimentation with new styles by avant-garde or self-proclaimed elites has often put the public in the role of passive recipient. A traditional function of art education throughout the modern era was to reduce the gap between those elites, with their new stylistic innovations, and the public at large. However, there is evidence that suggests the art world no longer strives for the kind of alienating purity that typified avant-garde artists in the past. For example, a number of contemporary artists appropriate images from the popular culture as well as from the past.

Moving from an exclusive preoccupation with elitist styles of art means that art teachers do not have to limit themselves to the traditional fine arts but might also introduce students to the study of industrial design, urban planning, the work of craftspersons, as well as the arts of traditional folk cultures. The study of art can become more egalitarian in spirit, which implies that postmodern teachers need not impose an aesthetic on students in ways that past generations were taught about "good design" and the principles that supposedly made it good. In the early 1960s, Arthur recalls showing his middle school students a didactic film on modern design that showed two ceramic teapots, a bad one and a good one. One was shaped like an elephant with the trunk functioning as the pouring spout and the tail as the handle. The other was a purely functional shape, glazed white. As a modernist teacher, Arthur urged his students to value the white functional pot as the better design, but in many ways the elephant pot was probably more fun to use.

A postmodern teacher would have a choice among a variety of aesthetic orientations that did not exist as options at the height of modernism. It is now known that what determined the look of modernity had much to do with the ways that designers of the 1920s and 1930s felt about the look of machine-made products. The machine aesthetic was based on the preference for simple straight or curved lines unadorned with ornamental elements. With the knowledge that there was a high degree of arbitrariness in these notions of

design, especially those that originated with the Bauhaus, one is free to question their assumed universal validity.

The Cultural Mainstream Versus the Marginalized

Early modernists posited the notion of universals in art. The same elements and principles are there to be found in all the world's art. Although this kind of formalism made the art of others accessible to Western eyes, it also reduced the understanding of this art to principles, which told the learner why this art was beautiful, or significant in its form, but nothing about what it expressed within the cultures of their origin. Thus its expressive meaning was essentially lost. The art of the non-Western world was reduced to decoration. According to Paul Ricoeur,

> [t]he discovery of the plurality of cultures is never a harmless experience. When we discover that there are several cultures instead of just one and consequently at the time when we acknowledge the end of a sort of cultural monopoly, be it illusory or real, we are threatened with the destruction of our own discovery. Suddenly it becomes possible that there are just **others**, that we ourselves are an "other" among others. (in Owens, 1983)

Earlier, we discussed the issue of multicultural content in a curriculum modeled on the idea of little narratives, each representing differing groups of people. However, it is also clear that power/knowledge issues often lie at the very core of such distinctions between the mainstream and the margins, we and they, ourselves and others.

Language as a PowerKnowledge Issue

In claiming that power is linked to knowledge, Foucault also maintained that these are wielded and maintained through the control of social discourse. This includes the ways that totalitarian societies control their populations through propaganda and censorship and the ways that advertising shapes the behavior of consumers in market oriented economies. These are obvious examples. Foucault was especially interested in the subtler ways that discourse creates the realities by which people live their lives and through which they are controlled. For example, industrial societies often label people by their ethnic, religious, political, or sexual orientation and accord different rights, privileges, or penalties by virtue of being placed in one group or another. Psychological classifications of specific forms of sexual behavior as normal or deviant might be a use of the mantle of science to legitimate discrimination against gays and lesbians. Similarly, people are labeled and classified by their mental abilities with IQ or SAT scores. These examples illustrate that discursive practice creates social reali-

ties. This is obvious in courts of law and in schooling practices, but it also plays a role in art.

In the introduction to *Women, Art and Society*, Chadwick (1990) illustrated how language that referred to so-called feminine traits, such as "delicate" or "decorative," was frequently used as a basis for negative aesthetic valuations. As art criticism is talk about art, this language plays a significant role in creating aesthetic and market values. Recognizing that art criticism is a use of language, one also needs to be mindful that the models of art criticism adopted by past art educators are largely drawn from formal analysis, a method that became prominent with the appearance of abstract and nonrepresentational art early in the history of modern painting. "Aesthetic scanning" as an approach to criticism, which gained prominence in the 1970s, is also derived from formalist approaches. Although scanning might enable students to describe the surface features of works of art, it is relatively inert in its power to reveal cultural meanings. Formalist approaches are often quite inadequate even for many premodern art works, as Paul Ziff's (1953) modernist treatment of Poussin's *Rape of the Sabine Women* attests.

> *We may attend to its sensuous features, to its "look and feel."*
> *Thus we attend to the play of light and color, to dissonances,*
> *contrasts, and harmonies of hues, values, and intensities. We*
> *notice patterns and pigmentation, textures, decorations, and*
> *embellishments. We may also attend to the structure, design,*
> *composition, and organization for balance and movement. We*
> *attend to the formal interrelations and cross connections in the*
> *work, to its underlying structure. We are concerned with both*
> *two and three-dimensional movements, the balance and opposi-*
> *tion, thrust and recoil, of spaces, line, form and color. (in Smith,*
> *1986, p. 45)*

Ziff's concentration on the aesthetic aspects of this work seemed to blind him to the representation of a rape. He wrote when formal analysis was the principle method of criticism; but in the 1990s, a feminist writer might raise totally new issues about this painting today, such as: Who was the intended viewer? and Why is a rape scene a subject for aesthetic experience and pleasure?

Another potent illustration of language creating artistic values is provided by David Carrier in his essay "Art and its Market." He described how successful art critics create aesthetic and monetary values essentially by the power of their discourse.

> *What we want to know, the cynic might say, is the truth about the*
> *work, not what the critic persuades us to believe. I am arguing*
> *that this is an impossible demand. For if aesthetic judgments are*

just statements of art-world consensus, then asking whether they are really true is meaningless. A successful critic is one who convinces us to accept his or her claims. Initially, such a critic's statements are less true statements about the art-work than arguments for how we ought to see the work The critic's rhetoric is a way of inducing beliefs in art-world people, and when critics succeed, most people believe their claims, which therefore are true. This account may seem outrageous to those who believe that critics merely draw attention to significant features of art works. (in Hertz, 1986, p. 201)

THE IDEA OF DECONSTRUCTION

The term *deconstruction* was coined by the French philosopher of language Jacques Derrida to describe a method of reading in which conflicting elements of a text are shown to contradict and undermine any fixed interpretation. "The text," in Christopher Norris's words, "never exactly means what it says or says what it means" (Norris and Benjamin, 1988, p. 7). Though Derrida developed deconstruction as a way to read philosophical texts, it was widely adopted as a method to analyze literary texts as well. In addition the method has been applied to the visual arts, art criticism, and architecture.

A modernist critic, in contrast to a deconstructionist, presupposes that there can be a general interpretation based on prior agreement over the facts and methods of interpretation. The modernist may accept conflict or incommensurability but assumes that there will be a resolution of differences. The deconstructive critic, by contrast, takes conflict and incommensurability as the norm. The deconstructive critic attempts to uncover oppositions not so much to resolve them but to show that no points of view are privileged.

The modernist presupposes that there is a relation between what is being said in a work of art and how it is being said. Indeed modernist formalism is based on the idea that the meaning results from its form. The "what" and the "how" (the "sign" and the "signifier") form an indissoluble unity. Moreover, for the modernist there is a "right" meaning, that is, the meaning intended by the artist, author, or composer. The deconstructionist sees sign and signifier "'as continually breaking apart and re-attaching in new combinations'" (Harvey, 1989, p. 49). For example, in Walter Martin's 1985-86 work, *Old Fleece Preaching to the Sharks,* the sharks are represented not by objects or images that are signs for sharks, but bones that are remnants of those presumed to have been attacked by sharks. In other words, there is no physical sign for the signified (shark) in the piece, only bones that signify danger, death, and dying. The bones signify shark to let shark signify death.

The term *deconstructive criticism* is also applied to objects, such as buildings and conventional works of art. In such cases, inherent inconsistencies within these objects seem to defy the viewer to form a definitive,

104

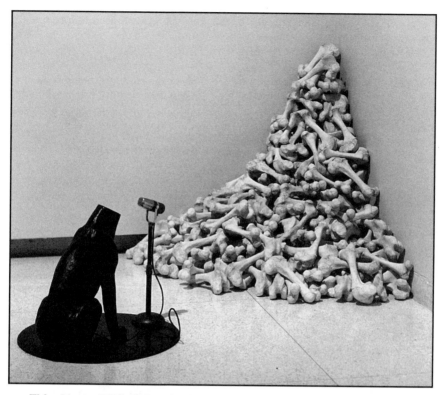

Walter Martin, *Old Fleece Preaching to the Sharks.* 1985-1986. Plaster, metal, steel, rubber. 36 x 72 x 84" overall. Collection Walker Art Center, Minneapolis. Clinton and Della Walker Acquisition Fund, 1986.

readily discernible interpretation. Consider Gablik's description of works by the artist David Salle.

> In the layered and slippery space of postmodernism, anything goes with anything, like a game without rules, images slide past one another, dissociated and decontextualized, failing to link up into a coherent sequence. When the Surrealists juxtaposed disjunctive and decontextualized images, they wanted to shatter the parameters of the rational, everyday world and to spark off new and unexpected poetic meanings. Salle, however, does not seem to be doing this; his images function more like Warhol's—neutral in their isolation, and "performing" without expressive or manipulative intent. Salle's images exist without any referent, Meaning becomes detachable, like the keys on a key ring. (1991, p. 30).

She liked this denial of meaning "to our stupefied fascination before the TV set, as we aimlessly flip from station to station" (p. 33).

From the perspective of deconstructionism, the lack of fixed meaning lessens the authority of the artist as the primary source of understanding. Deconstructionist criticism also raises the issue of authorship or originality, given that works of art are embedded in a cultural matrix from whence both artist and viewer derive symbols through which their communication takes place. Harvey discussed this issue in the following way.

> *Writers who create texts or use words do so on the basis of all other texts and words they have encountered, while readers deal with them in the same way. Cultural life is then viewed as a series of texts intersecting with other texts, producing more texts (including that of the literary critic, who aims to produce another piece of literature in which texts under consideration are intersecting freely with other texts that happen to have affected us in his or her thinking). This intertextual weaving has a life of its own. Whatever we write conveys meanings we do not or could not possibly intend, and our words cannot say what we mean. (p. 49)*

Jonathan Culler (1989) described deconstructionist criticism as a "reader-oriented" criticism. He sees it as replacing the "writer-oriented" criticism of modernism, which was dedicated to elucidating meanings intended by the author. According to Culler, the critical analysis of texts is based as much on assumptions about readers as about the artist originating the work. He gave as an example, the fact that several generations of male critics interpreted Thomas Hardy's novel *The Mayor of Casterbridge* in a similar way, as if no other reading of the novel was possible. Culler then raised the issue of how this work would be interpreted if critically read "by a woman" would read it. This is like our questioning of Ziff's interpretation of Poussin's *Rape of the Sabine Women,* in that both queries demonstrate how the postmodern audience is likely to be aware and react to issues that would not have come to consciousness in the mind of a modernist. The implication here is that the meanings of the works are not necessarily given by the artists but are socially constructed by the joint efforts of artists and their audiences. Moreover, these meanings change over time.

Deconstruction as a Curriculum Issue

The emphasis on the reader rather than the writer in literary studies has its parallel in the visual arts where recent instructional emphasis has shifted from an exclusive preoccupation with the production of art to activities that engage students in art criticism and art history. Literary studies have shifted from the emphasis on writing and writers, as in the "new criticism" of the 1950s, to the current emphasis on the reader and reading. The greater emphasis on the critical interpretation of works of art will, in all likelihood, continue through the postmodern era as well. Unlike the mod-

ernist who attempted to interpret the work of art for all times, the deconstructive critic is always involved in further interpretations of the work of art. For this reason the skills and practices of the art critic have become more important in the study of art.

Studio studies also are likely to be different in character from the traditional studies common in modernist art teaching. For example, when Derrida described the deconstructionist impulse as "to look inside one text for another, dissolve one text into another, or build one text into another," he also suggested "collage/montage as the primary form of postmodern discourse" (in Harvey, 1989, p. 51). This notion is particularly applicable to those media that permit one to borrow and modify images presently in existence in the culture. For this reason, technological media, for example, are likely to assume greater importance in postmodern curricula.

Photography, cinema, and computer graphics. Barrett (1990) explained why photographic media of current interest in the art world.

> *Today photography is at the center of postmodernism. As critic Woodward writes, "photography has moved from the margins toward the center of the art world's interests." Woodward cites reproduction as photography's main contribution to postmodernist practice: "Unlike a painting, a photograph is an infinitely reproducible image. (Paintings can be reproduced only by means of photography.) A photograph is also readily adaptable: It can be blown up, shrunk, cropped, blurred, used in a newspaper, in a book, on a billboard." Similarly Abigail Solomon-Godeau lists the formal devices "seriality and repetition, appropriation, intertextuality, simulation or pastiche" as the primary means of such artists using photography. (pp. 133-134)*

The arguments favoring photographic study in a postmodern curriculum would apply equally to the computer where photographic and nonphotographic images can be digitized, stored, and modified in more versatile ways than those available by photographic means alone. As an interactive medium, the computer has the potential for exceeding the limits of the photograph. It is beginning to break the traditional separation between artist and viewer with the onset of interactive programming in which user and programmer participate in social construction of aesthetic values neither would have been able to create without the other. The persuasiveness of photographic imagery also raises certain critical issues. Whereas the photograph is usually taken to be a faithful representation of reality, the endless repetition of the photographic image tends to distort and desensitize the viewer to the reality being depicted. This is especially true of the mass media's depiction of the news.

Curriculum as a text. Deconstruction is a method of reading that attempts to uncover inherent oppositions in a text or work of art. A curriculum as a text is not immune from a deconstructive reading. The point of such reading is also to uncover oppositions. These could include such oppositions as teacher-student, modern-postmodern, nature-culture, form-content, mas-

culine-feminine, ourselves-others, mainstream-margins, universal-plural, local-national, individual-group, etcetera. Oppositions may position the little narrative against the meta-narrative, or one little narrative against another little narrative. The purpose of such deconstructive readings is to locate sites of conflict and to make these into focal points for study.

ART AS DOUBLY-CODED CULTURAL FORMS

Charles Jencks identified "double-coding" as the principle characteristic that distinguishes postmodern objects from the modern. To some extent his theory stands in opposition to the deconstructive views of the postmodern just reviewed, because deconstructive theorists tend to have as their principal focus the repudiation of the modern. By contrast, Jencks did not repudiate the modern. He viewed the postmodern "as the *preservation* as well as the *transformation* of modernism" (Rose, 1991, p. 113).

To make his case, Jencks (1991) cited the architectural example of Stirling's addition to the Staatsgalerie in Stuttgart, Germany, a building that juxtaposes modern technology with references to beautiful classical ruins such as those on the Acropolis. The code of classical architectural forms is pitted against a 20th century technology based on reinforced concrete. He wrote:

> One can sit on these false ruins and ponder the truth of our lost innocence: that we live in an age which can build beautiful, expressive masonry as long as we make it skin deep We are beautiful like the Acropolis or Pantheon, but we are also based on concrete technology and deceit." (Jencks, 1991, p. 6)

In *The Language of Postmodern Architecture* Jencks explained that architecture has "to be understood as sending out messages to its users in a similar way to other codes or speech acts." *Double-coding* as a term refers to the idea that postmodern architecture adds a second code or set of messages to that of the modern style (Jencks, cited in Rose, 1991, p. 102). If we think of the functionalism of the International style as modernist architecture in its purest form, then the adding of other codes integrates other meanings into the modern.

Double-coding can be seen in the work of Jannis Kounellis. Kounellis, an Italian artist born in Greece, believes that

> (P)ost-war Europe is fundamentally a fragmented culture that needs to regain a cohesive outlook His blockading of doors and windows, means of access both physical and visual, has been interpreted as a comment on obstructed vision since these blockaded passages occur in galleries and museums, as a critique of the art world. (Walker Art Center, 1990, p. 293)

Another example of double-coding can be seen in Jackie Ferrara's 1988 work *Belvedere*, the suggestion of a stage (on which someone is

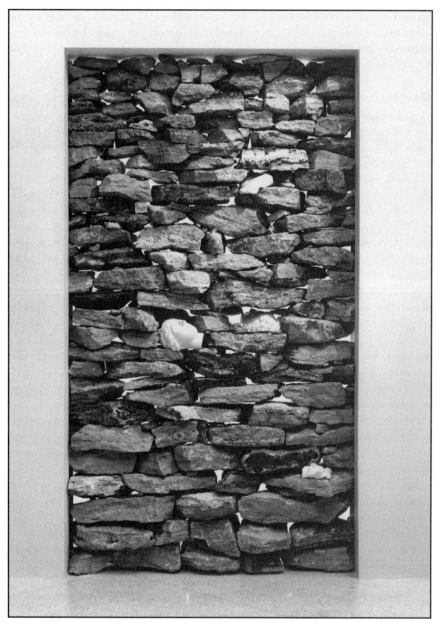

Jannis Kounellis, *Untitled*. 1982. Feather River Travertine, cast plaster, steel. 86-1/2 x 59 x 16". Collection Walker Art Center, Minneapolis. Waker Special Purchase Fund, 1987.

viewed), and a belvedere (from which something is viewed) as well as the contradictory messages of a functional object made of natural material in a natural setting contrasted with those indicating the object is a work of fine art at a museum (and therefore, not to be touched or used).

Double-Coding as a Curriculum Principle

Double-coding might serve as a fourth curriculum principle by suggesting a strategy for change. As with much postmodern architecture, which incorporates other styles into the modern, one need not discard modernist content in the formation of new curricula. Like the architect borrowing from the classical tradition, one can insert premodern and postmodern features of content into a curriculum grounded in modernism. This insertion might begin with the modernism of the recent past, a philosophy that may be seen as a naive modernism. Then, calling attention to forms of art that developed outside the modernist stream, one might compare modernist formalism with a postmodern approach to critical interpretation, thus determining which methods extend or limit the viewer's understanding of the work in question.

In Chapter Three, it was noted that throughout this century, the modernist conception of curriculum change advocated the discarding of older content and teaching practices, followed by their replacement with new and presumably better ones. Modernist curricula was supposed to change in a manner akin to modern art itself. In actual practice, most art teachers did not discard older versions of curricula as new ones were proposed. The elements and principles of design, introduced at the start of the 20th century, are still in evidence in current practice and seen in current textbooks. The practices that arose with creative self-expression are still prevalent today. Just as postmodern artists and architects appropriate motifs from past art styles and insert them into modernist buildings, so it might make sense to appropriate content from previous modernist approaches.

The purpose served by reference to former practices might be to show their limitations. For example, a formal analysis of a Warhol soup can and a real soup can would not reveal significant differences in their forms. Yet the Warhol is considered art whereas the real soup can is not. The attempt to use formal analysis in this instance dramatizes its limitation. This may be a way to understand that what makes something art is not its form and composition alone, but the social context in which it is perceived. Similarly, a postmodern curriculum might feature the study of Van Gogh, one of the heroes of modernism. However, today's student might be led to interpret Van Gogh's works with a set of meanings less likely to be emphasized in the modernist past, when it was common to subscribe to the myth of the solitary genius for an explanation of the writhing lines in his landscapes as a reflection of his isolation and anguish. By contrast recent scholars devote more attention to the influences on Van Gogh's style, such as Japanese prints or

Jackie Ferrara, *Belvedere*. 1988. Cedar. 126 x 506 x 407". Collection Walker Art
Center, Minneapolis. Gift of the Butler Family Foundation, 1988.

images from the popular culture of his time (Nochlin, 1990). The modernist
past would not be discarded in postmodernism curriculum, but it would be
subject to different interpretations, possibly playing on the current interest in
multicultural influences on the West.

SUMMARY AND CONCLUSIONS

In this chapter the four pervasive characteristics of the postmodern in
discussions of art and culture are explained. If these are characteristics of
postmodern discourse in general, it stands to reason that they will emerge in
discussions of the curriculum as well. The characteristics are summarized in
the Table 4.

The Character of a Postmodern Art Curriculum

Table 4—POSTMODERN CURRICULUM PRINCIPLES AND THEIR IMPLICATIONS

THE LITTLE NARRATIVE

A. Curricula shifts from the universalizing tendencies of the modern to the pluralizing tendencies of the postmodern.

B. The exclusive preoccupation with disciplined knowledge based on communities of scholars shifts toward a greater use of local knowledge and local informants.

C. There is a greater receptivity to non-Western art, the art of minorities and women, and the arts of popular culture. The inclusion of these types of art may be described as a general tendency to democratize the curriculum and to move away from a preoccupation with elitist conceptions of art.

D. There is a melding of local content and regional interests with national interests.

THE POWER-KNOWLEDGE LINK

A. Power-knowledge issues emphasize the impact of social forces on the arts and education, and how these validate some forms of knowledge while marginalizing other forms.

B. Power-knowledge issues exemplified in architectural decisions, industrial design, art history, art criticism, and crafts.

C. Elitism and egalitarianism arise as a conflict between dominant and less dominant social groups in validating knowledge.

D. Art criticism is an area where language issues are particularly sensitive. Discourse creates the meanings and values derived from works of art.

DECONSTRUCTION

A. Deconstructive critics alter the traditional function of criticism from the elucidation of works of art in the attempt to find meaning in a culture where the meanings of images and words are not fixed.

B. Criticism moves toward reader- or viewer-oriented criticism, and away from writer- or artist-oriented criticism.

C. Postmodern art media emphasizes collage, montage, and pastiche, with photography and computers assuming greater importance.

D. The interactive character of the computer has a potential for altering the traditional separation between artist and viewer.

DOUBLE-CODING

A. As the postmodern object possesses codes or sets of messages in addition to those of the modern, adding other codes to the modern might also be a useful model for proceeding with curriculum change. (such as, integrating alternative meanings into the modern curriculum).

It is not claimed that these principles are consistent with one another, for certainly the deconstructive views of the postmodern suggest quite different sets of outcomes and understandings than double-coding. On the other hand, the use of little narratives as a working principle is consistent with the deconstructive view in that both can be seen as a means for analyzing texts and works of visual art. Curriculum planners may play one attribute against another, choose from among them, or work with other postmodern attributes not treated in this chapter.

A curriculum based on these characteristics will lack the structural clarity of subjects based on the modernist view of the disciplines as having structures such as clearly defined and agreed on boundaries and certain leading ideas that could be used as a basis for sequencing instruction. In 1960, Jerome Bruner showed how these structures could be placed in a curriculum using the metaphor of the spiral shape. The spiral form suggests, for example, how leading ideas in disciplines could serve as recurrent features. Each time a child revisits the leading idea, it should be experienced with greater complexity and depth. The problem confronting the planner today is that it is difficult, if not impossible, to identify leading ideas in advance. Also, consensus among experts is rare, and boundaries of disciplines are breaking down. Interdisciplinary work is becoming more common. In fact, even historical attempts to base the selection of content on the disciplines have usually been arbitrary rather than governed by the nature of the disciplines themselves (Efland, 1987).

Indeed it may be easier to find points of conflict than consensus. But just as reality emerges as a social construction, what may emerge as the leading ideas in a curriculum come about through the social interaction of teachers and learners as they engage in artistic inquiries. The spiral models that were suggested in the 1960s, might need to be replaced in the 1990s with models that look more like a collage where oppositions such as past-present, male-female, mainstream-marginal, and high-art/popular art are juxtaposed.

In the final chapter, we suggest some alternatives to the spiral curriculum. We also present a series of classroom illustrations that attempt to capture the main features of a postmodern approach to art education.

POSTMODERN CONCEPTS IN THE CLASSROOM

In this chapter, we illustrate how postmodern sources of content might be used in the teaching of art. These illustrations take the form of sample teaching scenarios which suggest ways of dealing with postmodern attributes and principles in art instruction. Teaching about postmodernism and postmodern art has far-reaching implications for schooling in general and involves problems of general culture. For this reason postmodernism is likely to be interdisciplinary in its curriculum focus. Though it is particularly relevant to the study of the visual arts, it also affects, for example, the study of the humanities and social studies. Each subject in its own way deals with the social construction of reality.

Each school subject, including art, offers representations of reality. Postmodern culture can be thought of as a recombination of these cultural representations produced by the stress of contemporary life. Consequently, education from a postmodern perspective is likely to share the collagelike character of contemporary existence itself. Postmodern education seeks to make connections and disjunctions among subject areas more apparent to students. This contrasts with the modernist preference for the teaching of subjects in isolation as autonomous disciplines.

In Chapters Two and Five we suggested that the curriculum itself, might be pictured as a type of collage. This does not mean that information should be randomly thrown at students. Rather, it means that educators and students should work together to construct meaning out of the fragmented experience of schooling and that we can facilitate such construction with an approach to curriculum that draws on disciplines considered outside the purview of art education. Like a collage, education from a postmodern perspective is full of multiple, complex, and nonlinear meanings.

Other postmodern models of curricula have a lattice or weblike structure, which invites the learner to pursue meaning in multiple directions along many routes of intellectual travel (Efland, 1995). For example, in the realm of computer assisted instruction, hypertext curricula organize knowledge in ways that enable students to explore multiple representations of phenomena. Psychologist Rand Spiro and his associates (1988) liken a par-

ticular hypertext curriculum prepared for medical students to a landscape undergoing exploration.

> *Deep understanding of a complex landscape will not be obtained in a single traversal. Similarly for a conceptual landscape. Rather, **the landscape must be crisscrossed in many directions** to master its complexity and to avoid having the fullness of the domain attenuated. The same sites in a landscape (the same cases or concepts in a knowledge domain) should be revisited from different directions, thought about from different perspectives, and so on. (Spiro, Coulson, Feltovich, & Anderson, p. 6)*

These models of postmodern curricula stress the need to avoid the hierarchical organization implied by modernist approaches to study.

At the conclusion of the previous chapter it was noted that discipline-oriented curricula, made popular by the curriculum reforms of the 1960s, began by having a community of scholars identify the leading ideas to be emphasized in instruction. Then curriculum experts built a curriculum structure by moving from these ideas to subordinate ideas through simple structures of logic. Such curriculum structures can be likened to a tree trunk (main idea) connected to the tree branches (subordinate ideas). Tree-like models tended to be favored in modernist curricula. When knowledge is represented as a tree, the learner's inquiry moves from the main idea to subordinate ideas or the reverse. The curriculum in these cases would be organized by inductive or deductive forms of reasoning. Figures 1 and 2, shown below, portray differences between the logical structures of curricula based on the tree or the lattice. The tree has the virtue of simplicity, the lattice the virtue of complexity. Latticelike structures are more adequate to handle the complexity of postmodern content.

Another objection to discipline-oriented curricular forms is the difficulty of finding consensually agreed on leading ideas that might serve as organizing centers. It is also evident that a consensus among the disciplinary scholars, even when possible, often eliminates points of conflict and risk. This trivializes the nature of inquiry in art and eliminates its cultural importance.

When knowledge is represented as a collage, or as an interconnecting web or lattice, inquiry is less likely to proceed in a hierarchical fashion based on traditional logic. Instead it takes on the character of a narrative or, better yet, a multiplicity of little narratives. Jerome Bruner (1986) describes two modes of cognitive functioning, which he calls the "logical or paradigmatic mode" and the "narrative mode."

Figure 1: Representation of a Tree

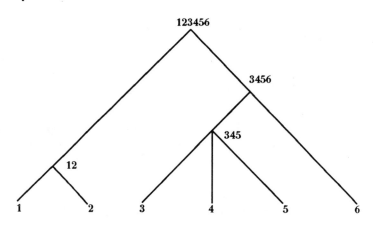

Concepts and ideas as linked in modernist curriculum designs. Based on 10 concepts showing no over-lapping interconnections. Based on *Alexander, 1988, p. 69.*

Figure 2: Representation of a Lattice

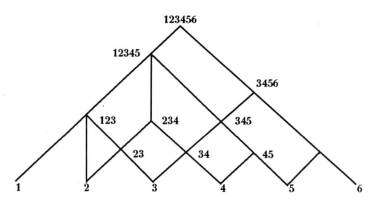

Concepts and ideas as linked in a postmodern curriculum design. Based on 10 concepts showing possible interconnections. Based on *Alexander, 1988, p. 69.*

Each of the ways of knowing, moreover, has operating principles of its own and its own criteria of well-formedness. They differ radically in their procedures for verification. A good story and a well formed argument are different natural kinds. Both can be used as a means for convincing another. Yet what they convince of is fundamentally different, arguments convince one of their truth, stories of their life-likeness. The one verifies by eventual appeal to procedures for establishing formal and empirical proof. The other establishes not truth but verisimilitude. (Bruner, 1986, p. 11)

Bruner observed that stories may not exist to know truth but to endow experience with meaning. Both are important sources of knowledge in general education. The importance assigned to narrative in postmodern discussions of education reinforces the position of those subjects in the curriculum.

The lessons that follow are examples of the many practical ways teachers can integrate postmodern concepts into classroom instruction. Fundamental to these lessons are the postmodern assumptions that art is a form of sociocultural production, all types of visual culture (multicultural forms, fine art, mass media, etc.) should be included in art education, and understanding art *necessarily* involves an understanding of the context in which the object was created and appreciated.

Several of the lessons include interdisciplinary connections between art and other school subjects. For example, the first lesson draws on Amish quilting traditions and the appropriation and transformation of this cultural form using computer technology. The second lesson focuses on conceptions of time and space through the production and reproduction of popular culture by recycling postcards in student art. The third deals with power/knowledge issues and the political, conceptual conflict that resulted in the destruction of Richard Serra's site specific sculpture, *Tilted Arc*. The fourth example treats the idea of deconstruction as used in the interpretation of works of art. The final lesson presents multiple readings of a Native American powwow in terms of cultural fragmentation, power relations, and a concern for otherness.

The Importance of Questioning: Multiple Readings, Conceptual Conflict

Student higher-level thinking depends on the development of analytical skills and an understanding of contexts of analysis. An awareness of the fundamental relevance of culture to artistic production and appreciation is vital to this understanding. Students should be acquainted with ways to form questions and search out answers in order to gain access to such fundamental aspects of art. A student might get different answers from differ-

ent sources and may have answers that differ from answers reported or developed by other students. These conceptual conflicts can result in rich discussion in class. We suggest facilitating the activity of investigation using the following questions.

1. In which culture was the art form produced? (This is "the culture.")
2. Identify and describe the geographical features of the region/place inhabited by the producers of this object. In what ways have climate, landform, vegetation, and natural resources affected the art form produced?
3. In what time period was the art form produced?
4. Describe the physical appearance of the art form.
5. How did/does the art form function in the culture?
6. What aspects of the cultural aesthetic production are most important? the process, the product, or the symbolic significance?
7. What is/was the social significance of the art form?
8. What are/were the aesthetic values of the culture?
9. Who were the artists? What was their gender? Age? Social status?
10. How were they selected to become artists?
11. How were they trained?
12. For whom do/did they produce the art form?
13. Is the art form being produced today? Is it the same or different? How?
14. How is the art form being used in the culture today? (Stuhr, et al., 1992, p. 23-24).

Not all of these questions will be relevant in each lesson. In some instances, the question concerning the object undergoing study may be: Why should it be treated as art?

LESSON ONE: TRANSFORMING AMISH QUILTS BY COMPUTER

Based on a lesson developed by Sheryl Hess in a course at the University of Minnesota.

In this lesson, students will study Amish quilt-making traditions, borrow certain codes of design from these traditions to produce their own series of computer graphic quilt designs, and construct a quilt from their designs using traditional materials. The purpose of learning, appropriating, and transforming traditional Amish quilting codes is not primarily for production purposes however. If the lesson were to stop at that level, important

postmodern issues concerning the lesson would not be addressed. The rationale for the production aspects of this lesson is to bring about student awareness of the processes of cross-cultural appropriation and transformation that occur continually in a postmodern world, issues surrounding these processes, and their potential effects.

The integration of the new technology with traditional textile media reflects the postmodern acceptance of conceptual conflict, fragmentation, and the recycling of historical forms. The fact that traditional motifs acquire new meanings in the productive environment made possible by the computer suggests that these forms are doubly coded. Historically, people have often responded to technological development by giving renewed attention to traditional crafts (Naisbitt, 1982). The quilt design portion of the lesson builds on previous experience with new technology and requires a synthesis of new information about traditions in order to produce a thought provoking learning experience and work of art. This lesson is designed for secondary students and will require their use of computer graphics hardware and software.

Postmodern Concepts

The postmodern concepts listed here are examples of those that could be focused on in this lesson:

1. The relation of art and culture
 reflection of cultural conditions
2. New conceptions of time and place
 recycling
 transformation
3. Democratization and a concern for otherness
 multiculturalism
 appropriation
4. Acceptance of cultural conflict
 fragmentation
 collage
5. Multiple readings
 attached meanings
 double-coding

Incorporation of these postmodern concepts into curriculum requires cultural exploration that can be facilitated by using the investigative questions stated above. These questions should be answered by the students through their own research. In some locations, the students may be able to find answers to these and other similar questions through interviews and other empirical means. The information discussed in the following section is

the type of data that would be collected based on the suggested investigative questions.

An Introduction to Amish Quilt-Making

Not many historical examples of quilts exist due to the temporary quality of textile media. General wear and tear, insects, degradation of fibers, and natural disasters such as floods and fires all contribute to the destruction of quilts. It is impossible to trace quilting back to its original roots, but quilting probably began out of necessity for physical comfort rather than decoration.

The basic process in the construction of the quilt is that of sewing together layers of material laid and stretched on top of one another, ensuring that they cannot become detached, in effect like collage, creating a single fabricated form. The fabric pieces and stitches produce decorative patterns guided by function and culturally-defined visual codes. Quilt codes have some characteristics in common across Amish communities, but they differ in design and color scheme in different areas of the U. S.

Amish Quilt Visual Codes

Designs by Amish women involve tacit but formal rules based on cultural knowledge and values. The quilt form is inspired by a particular American rural, physical, and social environment that recalls the past, renews it in the present, and transforms it into an object that reifies cultural values. An important characteristic of these quilts is color scheme. The color scheme of a quilt is selected by a particular quilt-maker from a group of colors that are typical of the local community. The community colors act as a boundary code within which the women create. The color schemes often include desaturated hues, complementary colors, and split complements. Approximately half of the quilt color schemes are limited to traditional clothing colors. The other half includes red-violet, green, blue, pink, and sometimes red, orange, and yellow. These last three colors are generally used for borders only. Quilt designs are also heavily influenced by tradition and community aesthetics. They tend to be based on geometric shapes (squares, triangles, diamonds), may include subtle pattern, and have simple organizations. Amish quilts have a border and an "inside" design. There are several traditional designs: crazy, bar, split bar, diamond in square, nine patch, and sixteen patch. The simplicity of the quilt design may be seen as reflecting Amish lifestyle. Quilts serve a utilitarian purpose while remaining within a determined set of aesthetic boundaries. The fabric selected for use in the quilts is often recycled, that is pieces of material taken from worn-out clothing retired to scrap bags.

Difference within a Shared Tradition

As there is variety in quilt design across Amish communities, students should become acquainted with quilts from several communities. This diversity is illustrated by the following examples:

LANCASTER, PA

- very traditional
- quilt types: diamond in square, log cabin, bars, nine patch, sunshine and shadow
- quilts are almost square in dimension
- wide outside borders (about 10-15")
- large corner blocks
- muted natural colors: brown, gray, medium to deep blue, green, purple
- also brighter colors and contrasts (brilliant and vibrant synthetic shades): royal to medium blue, purples, red, wine, warm brown, tan, pink, teal, aqua, olive, parrot green

NEBRASKA

- most traditional and conservative
- humility, modesty, and obedience are responsible for their color restrictions
- the simple and modest expression of the community's interpretation of the proper way to live
- colors: natural, brown, blue, dark purples, black, dark green, yellow, ochre, tan, dark reds

MIFFLIN COUNTY, PA

- similar to Ohio and other Midwest communities
- type: bar, sunshine and shadow, four and nine patch, crazy, log cabin
- nine to ten inches longer than wide
- gridlike design of inside borders and blocks
- small borders to isolate patchwork
- colors: bright pink, green, orange, blue, yellow, and purple combined with deep blues, browns, and black or with high contrast combinations of pink-orange, pink-green, fuchsia/turquoise-orange/green (these color combinations can be disconcertingly beautiful).

SOMERSET COUNTY, PA

- jumping off point for western migration, therefore the quilts are less traditional Amish, a bit "wilder"

OHIO

- borders with diamonds, sawtooth, zigzag, and keyboard piecework
- lots of log cabin designs
- colors: black background; brown, red, blue, turquoise, green, and purple overlay patterns
- rich, bright arrangements

IOWA

- midwestern block pattern, influenced by region
- types: shoo-fly, nine patch, bow-tie
- less complex patterns
- never achieved artistic intensity such as is evident particularly in Ohio
- small amount of printed fabric: dots, checks, small stripes, small flowers
- colors: white, pastel blue, pink, black, blue, green, purple

Lesson Procedure Narrative

The lesson could be introduced by showing the students examples of Amish quilts. With the students, discuss the cultural foundation of the formal qualities of quilt-making, particularly color scheme and composition. Modernist formal analysis (formalism) alone is inappropriate to postmodern lessons because it involves discussions of elements and principles of design isolated from their cultural context. All visual culture, including Western fine art, is shaped by codes peculiar to its context of production. The discussion of the visual codes in Amish culture will provide an understanding of the quilting elements that the students will recycle using the computer.

It will be necessary to divide the students into several, small, cooperative groups to enable them to do historical research into Amish culture and quilt-making. The investigative questions presented earlier can be utilized by each group to frame their research. Following research time, the groups should be brought together to share the information they acquired.

In order to experience the processes of appropriation and transformation, the students can borrow Amish quilt color schemes and other visual codes they learn about in their research. The information about the tradi-

tional technology of quilt-making can be recycled using contemporary technology: the computer. To recycle the Amish quilt designs, each group of students can reproduce an Amish quilt pattern or color scheme on the computer. This can be done by recreating the color scheme using a paint software palette or by digitizing a quilt or photograph of a quilt with a camera or color scanner. Ask students to use the palette to produce a picture that illustrates how artists appropriate ideas and images from their own or mainstream American culture. Student pictures can be derived from fine art, popular culture, advertisements, clothing, etcetera. Once these images are produced and saved on disk, the students can use cut-and-paste and other functions of the software to create a series of abstracted images. A computer graphic series can be produced using the process of seriation. The term *seriation* refers to the process of creating, saving, and changing computer graphics images in a branching network that begins with a single image (Freedman, 1989, 1991).

Students can manipulate the abstracted images on the computer to create patterns that are similar to traditional Amish or contemporary quilt designs (see examples on front cover). They may print their designs out on a color printer in the classroom, have them printed out on a color laser printer at a commercial printer, or take slides of their seriated images. Individual students can then fabricate quilts based on their designs, or groups can select a single design to construct together.

Rather than a formalist, expressionist, or technical critique of the objects at the end of the lesson, a postmodernist consideration of issues should be held throughout. In part, this can be initiated by using the investigative questions stated earlier. However, the students should also reflect on the relationships of art and culture constructed as a result of the juxtapositions within the lesson and discuss the implications for multiple readings and double-coding that result from the use of multicultural visual codes. For example, in order for issues of appropriation and transformation to be addressed, the students could discuss how and why they selected the Amish quilt color scheme they "recycled," how they made it "theirs," and what they considered while developing their series of images. (Did they think about the Amish cultural aspects of the lesson, the traditional or contemporary technology, or only what was on the computer screen? Why or why not?)

At the end of the lesson, the students could write an explanation of their production process and show the class the seriation used to design the quilt, including the fine art or popular image on which the seriation was based. The seriation process can help them recall their thought processes because it is a record of the development of the series. A class discussion of the individual's or of the group's written descriptions and presentations of

their visual forms might be directed to include the interaction between fine arts, popular culture, and Amish quilting.

Resources for this Lesson

Barker, Vicki and Tessa Bird, *The fine art of quilting*, E.P. Dutton, New York, 1988.

Colby, April, *Quilting*, Charles Scribner's Sons, New York, 1971.

Duke, Dennis and Deborah Harding, *America's glorious quilts*, Macmillan Publishing Company, New York, 1987.

Endler-Sterberg, Carol, *American county folk crafts*, Harry N. Abrams, Inc. Publisher, New York, 1987.

Freedman, Kerry, Microcomputers and the dynamics of image making three art classrooms, *Journal of Research on Computers in Education*, *21*(3), 1989, 290-298.

Freedman, Kerry, Possibilities of interactive computer graphics for art instruction: A summary of research, *Art Education*, 1991.

Leavitt, Ruth, *Artist and computer*, Harmony Books, New York, 1976.

Lourie, Janice R., *Textile graphics/computer-aided*, Fairchild Publications, New York, 1973.

Slivka, Rose, *The crafts of the modern world*, Horizon Press, New York, 1968.

Wheatcroft-Granick, Eve, *The Amish quilt*, Good Books, Pennsylvania, 1989.

Wong, Wucious, *Principles of color design*, Van Nostrand Reinhold Company, New York, 1987.

LESSON TWO: POSTING IDEAS: POSTCARDS AS A POSTMODERN METAPHOR

One of the objects theorists and artists have used as a metaphor for postmodernism is the postcard. A theme common to discussions of postmodern culture involves the power of imagery to cause desire. Postcards are a form of popular culture and commercial art that reflect ideas about leisure time, tourism, conspicuous consumption, and vacation. They usually do not evoke thoughts of the serious, stable, or creative.

Postmodernism points to the many results of juxtaposition, particularly the juxtaposition of picture and text. As illustrated by the *SuitCase Studies* exhibition described in Chapter Two, postcards are a collage of picture and text. They usually contain a picture, such as a reproduction of fine art, a photograph of a place, or some other image that has been decontextualized, reduced in size, and turned into a form of popular culture. The postcard recycles works of fine art, making them decorative, turning them into

popular culture, and putting them to a new use. Often juxtaposed with these images are words written on the picture and by the sender concerning a visit to the place referred to by the picture. Recipients of postcards are able to see a picture of the location visited by the sender and read the sender's comments about it. In a sense, postcards collapse time and space. A postcard extends place through an image and makes the recipient feel desire to see an object or visit the place that is pictured. It is an idealized representation of an object or place. A postcard carrying a reproduction of a work of art suggests the refinement of museums, and postcard photographs of a location are often taken through filters that enrich the blues of an ocean or reds of a sunset.

The concept of superficiality or facade are also implied by postcards. Usually, people do not write important messages on them. Postcards tend to carry simple salutations and brief messages, such as: "Having a great time! Wish you were here!" Such text is a fragment of discourse.

This lesson is written for elementary school children but can be translated for older students. The production part of the lesson can be carried out by individuals or cooperative groups. The lesson focuses on the following few postmodern concepts, which are appropriate for younger students.

Postmodern Concepts
1. Relationship of art and culture
2. New conception of time and place
 recycling
3. Democratization and a concern for otherness
 popular culture
 collaboration
4. Acceptance of cultural conflict
 collage

The incorporation of these postmodern concepts into curriculum requires cultural exploration that can be facilitated through classroom discussion and/or student investigation using the investigative questions stated earlier in this chapter.

Lesson Procedure Narrative

To begin this lesson, each student should have at least one blank, unused postcard. The students may use postcards from a trip they have taken or ones that have other personal meaning for them. The postcards can contain any image: photographs of a locale, reproductions of fine art, cartoons, etcetera. In order to address the aforementioned postmodern concepts, a wide variety of card types would be beneficial.

When the students in the class have chosen their postcards, the teacher should talk with the students about why they chose their cards. Ask the investigative questions at the beginning of the chapter and add questions specific to this lesson, such as: Have you ever sent a postcard to someone? Where were you when you sent it? What picture was on it? Why did you select that card? What did you write on it? Did your message have anything to do with the picture? Showing and discussing examples that have been previously received by someone in the class will help students understand the purpose of postcards. Discussing the idea of lots of people sending the same picture or sending a piece of one place to another for enjoyment will draw students' attention to the postmodern concepts listed previously.

The issue of selecting one picture over several others to send to a particular person might be analyzed from a postmodern perspective. A modernist ideal of art appreciation is that a viewer will be engaged with a work of art as a result of its formal or expressive qualities. The engagement is quite different for the sender when selecting a postcard of a work of art that is to communicate an intention to the receiver. Consider the ways in which this form of visual culture functions differently from others. For example, in what ways is the process of selecting a postcard different from or similar to a gallery owner selecting works of fine art for sale or a museum curator choosing a particular painting for an exhibition.

Following the general investigation and discussion, students should consider how they can use the cards they have in class. The teacher might ask the students: How could we recycle these postcards? How might we use them to make a new work of art? The teacher should have some examples of works of art that include postcards and other similar media. Fine art, such as some of Picasso's collages with newspaper and Rauschenburg's multimedia objects, can be used as resources to point out the integral relationships between fine art and popular culture and between pictures and words.

Each student should mail his or her postcard to a previously selected partner in class. (The postcards can be delivered through the postal service or in school.) On his or her postcard, the sender can write a message with a recommendation for how the receiver might use the postcard to make a work of art. When the recipient receives the new postcard, he or she should create a new work of art, incorporating the postcard and taking into account the recommendation(s) of the sender. The product, while made by an individual, can be considered a collaborative effort. The new art objects can be collages, found object sculptures, photographs, computer graphic images, paintings, and the like. They can also incorporate other postcards, photographs, cartoons, or reproductions of fine art.

When the students have completed their work, a discussion of the use of the postcards will aid in reviewing the postmodern concepts. Each stu-

dent should show his or her work to the class and particularly to his or her partner. Encourage discussion about the cooperative aspects of the product.

LESSON THREE: RICHARD SERRA'S *TILTED ARC* ON TRIAL

This lesson entitled *Serra's Tilted Arc on Trial* explores the link between power and knowledge. It focuses on the controversy surrounding Richard Serra's site-specific sculpture *Tilted Arc*, which was destroyed in 1989. This work was commissioned in 1979 by the General Services Administration (GSA). It was to be located at the Federal Plaza in New York City. The National Endowment for the Arts (NEA) was responsible for recommending several artists, from whom the GSA could make a selection for a sculpture commission. In 1980, Richard Serra was chosen and his concept was approved. His sculpture *Tilted Arc* was installed in 1981. A few years later, a letter writing campaign was started in which *Tilted Arc* was declared a hazard and nuisance and its removal urged. In 1984, the GSA urged a hearing to decide whether *Tilted Arc* should be relocated. The hearing was held in 1985 with 122 people testifying in favor of retaining the work in its original location while 58 favored relocation or removal. Nevertheless, the panel recommended by a four-to-one vote to relocate *Tilted Arc*, which had the practical effect of destroying the work. In 1989, after several court appeals, the sculpture was officially destroyed by the same agency that had commissioned it 10 years earlier.

The lesson narrative presented here is for high school age students. In an interdisciplinary program of instruction, it might be linked to courses in civics and government or serve as a unit in a course on problems in democracy.

Postmodern Concepts

1. The link between power and knowledge
 impact of social forces on the arts
 conceptual conflict
2. The issues of elitism and egalitarianism
 Who decides what is art?
 Who has the right to select the specific site?
3. The role of discourse in shaping social assent or dissent
 Who controls the discourse?
 Who participates and who listens?
4. The issue of representation
 Who can speak for the artist?
 Who can speak for the audience?
 Who can speak for the environment?

Lesson Procedure Narrative

A secondary school art teacher is in the midst of a unit on contemporary American sculpture. The teacher introduces the students to the story of the controversy surrounding the destruction of Serra's *Tilted Arc*. The teacher poses a series of questions to prompt students to discuss such issues as the advantages and disadvantages of using panels of experts to select works of art on behalf of the public. Using the published testimony from the trial's proceedings, the teacher suggests that the class might stage a reenactment of the trial. One student takes on the role of Serra, another the judge hearing the case. Others take on roles as witnesses, either pro or con, who are asked to testify either in favor of retaining the sculpture at the original site or of removing it from the site. The students make a video of their reenactment.

Lesson Objectives

1. Recognize that social power directly affects the arts.
2. Help familiarize students with the facts and opinions surrounding the commissioning of *Tilted Arc* and the legal and extralegal procedures that ultimately led to its destruction.
3. Identify important social issues triggered by the controversy (e.g., the censorship of artists, the rights of the majority vs. the elite, and government involvement in the arts).
4. Gather information about the effects of media in shaping public opinion regarding the arts.
5. Relate the destruction of the sculpture to the destruction of other works in the history of art such as the destruction of the Diego Rivera murals in the Rockefeller Center.
6. Explore whether there are limits to the free expression of the artist in a free society.
7. Explore the relationship between art and the environment.

The teacher introduces the class to the work of Richard Serra with a slide presentation of several large steel pieces including *Tilted Arc*, ending the presentation with slides or photographs showing the dismantling of the sculpture.

The students are asked to describe the qualities of Serra's work, starting with his medium of large steel plates, each weighing several tons. They compare Serra to Picasso's Chicago sculpture and to works by sculptors David and Tony Smith. Using comparative exemplars, the students can recognize the magnitude of Serra's pieces and understand why *Tilted Arc* may have frightened and angered some viewers.

The teacher describes some of the circumstances that led to the controversy over the sculpture, and the trial at which testimony was taken from people on both sides of the issue. The teacher reveals that though 122 persons favored preserving the sculpture, the court decided that the piece should be relocated, in the effect destroying the piece. The class is asked to read some of the testimony from both sides of the controversy to reveal the depth of feeling the issue raised among the artist's supporters and detractors.

The teacher proposes doing a role play reenactment of the trial. Each student chooses a role to play in the trial: witness, juror, judge, or the artist, himself. In addition there can be investigative reporters explaining who the witnesses are and the importance of their testimony. Also there can be jurors who, in the end, have to decide on the fate of the work of art.

The teacher makes and passes out copies of the statements made at the actual trial to the students to help with their role decisions. The teacher explains how some witnesses saw the issue as a matter involving the freedom of the artist to express himself without fear of censorship. Other witnesses saw the work as the property of the government, becaue it was built with federal funding. They felt the government had the right to dispose of the sculpture, if it is deemed a threat to public safety or a public nuisance. Others argued that the commissioning procedures were too elitist, in that all decisions regarding the selection of the work were made by panels of experts without input from the people.

The students discuss the possibility of using the published documents as a script. However, rather than read lines, they prepare for their roles by identifying the issues and training like debaters. The teacher also introduces the students to other works of art that have met with public resistance, or censorship. The teacher refers to the massive show called "Degenerate Art" staged in 1937 in Nazi Germany where all forms of modern art were ridiculed and condemned. She asks the students to consider whether the trial raises the issue of censorship and control, in this case the right of the work to exist.

The students stage their mock trial, perhaps with other classes serving as the audience. At the conclusion of the trial, the students review the issues to recognize that, whereas American society does not always regard art as an important aspect of daily living, works of art nevertheless are often at the center of public controversies.

Resource for this Lesson
Weyergraf-Serra, C. & Buskirk, M. The Destruction of *Tilted Arc*: Documents. Cambridge MA: MIT Press.

LESSON FOUR: MESSAGE REPRESENTATION

This lesson is based on the idea of deconstruction. In this instance deconstruction is used as a method to analyze a work of art to bring to light conflicting elements within it that undermine the possibility of a fixed interpretation. The students are exposed to the idea of the possibility of alternative interpretations, none of which is necessarily the correct one. The teacher introduces a work by the surrealist painter René Magritte, entitled *This Is Not a Pipe* and *Brushstrokes* by Roy Lichtenstein's. The teacher challenges the students to deal with the contradictory elements in art and attempts to get the students to question the assumptions inherent in the paintings. In *This Is Not a Pipe* and *Brushstrokes* assumptions are that the representations of the pipe and the brushstrokes *are* those objects when, in fact, they are pictures of them and do not carry the same meanings as a physical pipe and brushstrokes do. The teacher concludes the lesson by assigning the students the task of creating a picture in which the image is not a representation of something but is the thing itself.

Postmodern Concepts

The idea of deconstruction
1. Art forms as deconstructive objects
 the issue of representation representation and reality
2. The relationship of art and culture
 reflection of cultural conditions
3. Multiple readings
 attached meanings presenting historically influenced meanings.

Lesson Objectives

1. Become acquainted with the critical process known as deconstruction.
2. Recognize that works of art may embody contradictory elements that may rule out exact interpretations.
3. Recognize assumptions viewers are likely to hold, which may limit their understanding of art.

Lesson Procedure Narrative

The teacher introduces a lesson based on the work of the surrealist René Magritte. Using the painting *This Is Not a Pipe*, the teacher asks the students to describe the subject of the painting. They will probably answer that it is a pipe with the statement in French "Ce n'est pas une pipe." To encourage discussion the teacher may ask a question such as, what does the

artist means by this peculiar contradiction of a pipe and a slogan saying, "this is not a pipe?"

The students offer their interpretations. The teacher and students discuss how Magritte's image of a pipe might look like a pipe but is not an actual pipe. It is merely a representation and not the real thing. The class investigates a further question: How can Magritte's statement affect the way we look at other paintings? The teacher might broaden the lesson concept by using an overhead projector to project an image of a realistic landscape on a screen. It could be a landscape painting by the English artist Constable. Then, the teacher overlays the transparency with a blank acetate sheet and on it writes, "This is not a meadow with cows grazing."

The teacher then asks the students, "Now what do you think is meant by the statement 'This is not a meadow with cows grazing?'" A student may venture an opinion such as "You are saying that it i not a meadow with cows but is a picture of a meadow with cows. The landscape is not the acutal scene, but is a picture of a scene." The concept that this idea applies to all representational painting is discussed. The teacher explains that representational painting is a form of art in which the real things, such as people and places, are not really present, but only represented or pictured. This is what Magritte may have meant by his picture' *This Is Not a Pipe*. His intent was to question how any kind of picture made up of canvas and paint can represent what it is not.

This lesson, provokes the students to question their tendency to use realism as a basis for understanding and evaluating art. The teacher should not have students discard reality as a reference for understanding art but does want the students to recognize why some artists and critics have found realistic art to be self-limiting.

Next, the teacher introduces works by the American artist, Roy Lichtenstein. Working with a series of his *Brushstrokes* paintings, the teacher lays the groundwork for more discussion on the topic of representation. The subject of these works are brushstrokes, but the artist has used a painting technique in which the brushstrokes are not visible. To make this point the teacher arranges reproductions of works by Franz Kline and Wilhelm De Kooning, whose abstract expressionist works are marked by vigorous and spontaneous gestures made up of actual brush strokes, next to those by Lichtenstein.

The students are encouraged to compare the difference and similarities between them. The class also investigates the link between popular printed images such as comic book illustrations and newspaper images and Lichtenstein's paintings. This exploration may expose apparent contradictions between the subject matter of the work and the technique used to produce it.

The question could be discussed as to whether artists like Magritte and Lichtenstein were deliberately trying to confuse the viewer by making works with elements that are self-contradictory, and if so, why? Many may feel that the artists are trying to confuse the public. Some might feel the paintings are "inside" jokes of the art community. Other students believe the artists are making statements with their paintings in order to get their audience to question the validity of realism as an art style.

Students could be reqested to produce a realistic piece of art in which the subject matter is actually the content of the piece. For example, students could make a painting of sand, using sand as the medium, on which is written: "This is made of sand." Or another example might be a blank sheet of paper on which is written: "This is no longer a blank page." Still another example is pressed flowers to make a picture of a bouquet, which contains the words; "This is a dead bouquet." A mirror could be glued down and a student stands before it, "Student Before a Mirror." The students work should be discussed in class.

The teacher might conclude the lesson by a discussion about "Why would artists consider the issue of realistic representation to be a controversial problem?" Some artists—for example, the surrealists and pop-artists—questioned their own "mental imaging" perspectives and those of their audiences. Were there artists trying to show how all art, even "realistic" art, was not real in a strict sense but only an image of reality.

Resource for this Lesson

Foucault, M. (1982). This Is Not a Pipe. Harkness, J. (trans). Berkeley, CA: University of California Press.

LESSON FIVE: READINGS OF A NATIVE AMERICAN POWWOW

In this lesson, the class, possibly in conjunction with members of a Native American community, will investigate the powwow as a cultural and artistic form. The students will first need to understand how Native American people, culture, and art have often been stereotyped and misrepresented in textbooks and art activities in the classroom. This type of negative curricular activity generally takes place because the perspective of Native Americans has not been sought out and included in the presentation of native life and art forms in curricula. Our lesson, based on the powwow, helps alleviate this situation by making use of the Native American community as a direct curriculum resource. The lesson is grounded in the cultural, lived artistic activities of Native American communities. Individuals from these communities share their knowledge and expertise and act as cultural informants for the students and teacher(s).

The students and teacher(s) in the class form their understandings by using knowledge seeking strategies borrowed from the fields of sociology and

anthropology. These strategies include carefully noted observations and formal and informal interviews with Native Americans. Formal interviews are prearranged and use prepared questions. Informal interviews are spontaneous and conversational in nature. Examples of the types of questions suggested for cultural interviews are provided at the beginning of this chapter. Once permission has been granted from study participants, observations and interviews can be recorded using hand-written notes, photographs, and/or video and film . Information gathered through ethnographic methods reveals personal discoveries concerning the cultures and communities of Native Americans involved in the powwow, which the students are investigating.

There are a number of reasons for teaching this lesson in addition to teaching students methods for studying the art or aesthetic production of people and cultures. There are many important social issues related to religion and ethnicity that affect Native American peoples, that may be made obvious by studying the powwow as an aesthetic or art form. Many of these issues involve prejudice and discrimination against native peoples. The type of knowledge gathered about the effects of racism and prejudice, as made evident through the study of Native American society, has application to the students' and teacher(s)' own lives, if only to help students understand the privileged status of the dominant middle-class culture. Such study also aids in the recognition of both the benefits and problems that result from diversity within the school population. In the process of studying the powwow, it may also be possible to discover how different cultures influence each other in both positive and negative ways through the processes of enculturation and acculturation.

Postmodern Concepts

The postmodern concepts listed here are examples of those that could be focused on in this lesson.

1. The "little narrative" as a source of curriculum content
 cultural fragmentation
2. Student engagement with power knowledge issues
 power relationships and negotiation
 construction of knowledge
 reconceptualization of teacher/student roles
3. Concern for otherness
 investigation of oppression and racism
 social reconstructivist action based on democratic
 decision-making
 ecological place and responsibility

4. Nondisciplinary learning
 dissolution of artificially constructed boundaries between
 school subjects

Lesson Procedure Narrative

This lesson is interdisciplinary in nature and would be taught most effectively by cooperation among the art and social studies teachers and possibly the English teacher. When the teacher(s) introduce this lesson, they might ask students for information concerning what they already know about the powwow. Stereotypes and misinformation concerning the cultural event might be exposed through this dialogue.

The teacher can assist students in starting the investigation of the powwow by providing information about the location of a powwow, which is to be held locally, either through the introduction of a poster describing the event or a local or Native American newspaper.[7] A book, video, or film presenting the powwow might also be used for motivation and background information.[8] If computer networking is a possibility, NativeNet, a USENET bulletin board, is an option for gaining information. Important aspects of the powwow such as: ceremonial and religious rituals, attire, dancing, and drumming, as well as native artifacts and the type of foods available at powwows might be discussed. Students and teacher(s) may be able to identify important social issues related to religion, environment, ethnicity, socioeconomic class, gender, age, and mental and physical abilities through this discussion.

Now the students are ready to collect information related to the issues they've identified with the aid of their teacher(s) and, possibly, local/NativeNet American Indian community assistance. It will first be necessary to explain to the students that they are acting as researchers to uncover information about the powwow and its local participants and artists because there may be ways in which the local powwow is unique to the native people in that area. It should also be explained that not all cultures and their aesthetic production are equally well documented and why.

It is wise to practice observation skills and interview strategies in the classroom before setting out to study the powwow and its participants. When making observations and recording them, students should focus on how each of their senses is affected by the experience so that observation is

[7] The names of two Native American newspapers that have a wide circulation and advertise powwows are: *News from Indian Culture* and *Indian Country Today*.

[8] *Powwow*, by George P. Horse, describes a Northern Plains powwow. *Powwow Highway* is the name of a video that can be rented at most video rental stores.

more than mere visual documentation. It should be stressed that the expert is not the interviewer but the person being interviewed. The questioner must refrain from distorting the information given to him/her with his/her personal biases. Teachers can prepare students to understand that the people they interview may not want to answer all of their questions or that they may not know the answers to them. The students should be encouraged to respect the wishes of the people with whom they talk and to acknowledge that everyone has limits to their understanding of situations.

The teacher might explain that when the students go to the powwow they should observe how different groups of people do diverse activities or produce various aesthetic forms. For example, a group might be organized to ask questions of the following powwow participants: organizers, dancers, singers and drummers, vendors, or the observers. Students should be encouraged to observe whether or not the powwow participants they investigate do things differently than those that appeared in the video they watched or the book they used. Students might ask the performers how they learned the dances, how a particular part of their ceremonial outfit was made, or who influenced the artist in the production of his or her forms. Prior to going to the powwow site, students with the aid of the teacher(s) could go over a list of the type of questions that might be good to ask. Teachers could suggest that students work in small focus groups of two or three to practice observing and interviewing. These same small groups could work together to generate questions that they might have concerning the powwow arts and cultural aesthetic forms and rehearse these questions with each other.

The teacher should encourage the students to ask questions not only about the production and performance of art forms, but also of the social context in which they are produced or performed. In this way issues concerning gender, age, social class, and religion can be addressed. Students should be encouraged to pay attention to who performs which activities and when. For example, who does the drumming and singing, and who does the dancing? What activities are done only by males? Which activities do women, children, or the older members of the community do? Are all participants allowed equal participation in the powwow? Why or why not? The teacher(s) should direct students to make connections between these issues and their own social practices. If discrimination is recognized, students could be encouraged to discuss how they could change their practices and then attempt to implement these changes.

Students and teacher(s) can also note the roles that non-native peoples play in the powwow. What artifacts or art forms have been acculturated from other cultures for use by the Native American people in their ceremonial dress and in the powwow celebration? For instance, some of the powwow dance participants might be wearing sunglasses, visor caps, or

136

blue jeans; modern technology such as a P.A. system might be used to amplify the music; and a dish called Indian tacos might be served at a refreshment stand. When cultural practices, roles, or forms are adopted from another culture, this is called acculturation.

After the students have collected information at the powwow, and have reconvened back in the art room, they might give oral reports to the class on what they discovered about the area of the powwow that they investigated. After discussion led by the art and social studies teachers, the students could decide to produce a book illustrated with their photographs, pamphlets, and other visuals collected at the site. The English teacher could be asked to participate in the project and help the students organize their written reports and visuals into a book form or computer technology such as video disks could be used to organize student material.

In concluding this lesson, the teacher(s) could follow up the powwow experience by having the students investigate social issues that affect contemporary Native American peoples such as: unemployment, alcoholism, high student dropout rates, high suicide rates, and racial discrimination. The class could discuss how these issues affect the nation in general and how the treatment of native peoples affect our country's image abroad.

CONCLUSION

We have attempted to show the characteristics of a postmodern curriculum through sample lesson scenarios. By themselves these presentations do not constitute a curriculum. But are merely suggestions for ways that postmodern issues might be addressed. Several postmodern characteristics can be found a lesson. For example, the idea of basing content on little narratives is strongly invoked in the powwow lesson, which also raises the power/knowledge issue. Power knowledge is also raised in the lesson on Serra's *Tilted Arc*.

What these lessons do not reveal are the possibilities for sequencing several lessons into larger curricular entities such as units of instruction or courses. Art by its very nature does not lend itself to a single hierarchial form of organization. There were times when design principles were thought to provide an organizational scheme for the sequencing of lessons and units, but such a focus denies the relation of art to its cultural context by focusing only on formal characteristics. The discipline-centered curricula of the 1960s were based on hierarchial assumptions about the nature of knowledge. These assumptions were largely derived from the sciences and were not well-suited for representing the structures of knowledge in the humanities and the arts. A better structure for these realms the narratives structure. The curriculum might be seen as a landscape in which works of art, significant concepts, and understandings might be considered as "sites in a landscape that are visited

and revisited from different directions and thought about from different perspectives" (Spiro, et al., 1988). Each student might start from a somewhat different point of view and experience the encounters with works of art and ideas in a different way.

How and where the teacher begins to organize instruction around postmodern issues depends on the teacher and the students. Perhaps it could begin with a question brought to class by the students, themselves. For example, the question "Why are there no women artists in our art history book?" raises power/knowledge issues as the answer lies in centuries of male domination in the arts. The infusion of multicultural content opens the possibility for "little narratives," and the recycling of past art forms into the present raises the possibility of studying art objects as doubly-coded forms.

The road ahead will be adventurous and the stakes are high. If a postmodern perspective can be applied successfully to art education, a solid connection between the arts and academic education can be made. The connection will enrich education for all students. A background in cultural diversity fills in the gaps left between bare facts. An education built on multiple perspectives promotes critical thinking, acceptance of and tolerance for difference, and opportunity for the practice of democratic action, and a re-evaluation of our ecological responsibilities.

REFERENCES

Adorno, T. W., Frenkel-Brunswik, E., Levinson, D. J., and Sanford, N. (1950). *The authoritarian personality.* New York: Harper and Row.

Ahmed, A. S. (1992). *Postmodernism and Islam: Predicament and promise.* London: Routledge.

Alexander, C. (1988). A city is not a tree. In J. Thackara (Ed.), *Design after modernism: Beyond the object.* New York: Thames and Hudson.

Apple, M. W. (1986). *Teachers and texts: A political economy of class and gender relations in education.* New York: Routledge.

Arac, J. (1988). Introduction. In J. Arac (Ed.), *After Foucault: Humanistic knowledges, postmodern challenges.* New Brunswick, NJ: Rutgers University Press.

Aronowitz, S. (1988). Postmodernism and politics. In A. Ross (Ed.), *Universal abandon? The politics of postmodernism.* Minneapolis: University of Minnesota Press.

Aronowitz, S., & Giroux, H. A. (1991). *Postmodern education: Politics, culture, and social criticism.* Minneapolis: University of Minnesota Press.

Banks, J. A. (1993). Multicultural education: Characteristics and goals. In J.A. Banks & C.A. McGee Banks (Eds.), *Multicultural education issues and perspectives* (2nd ed., pp. 3-28). Boston: Allyn and Bacon.

Banks, J. A., & McGee Banks, C. A. (1989). *Multicultural education issues and perspectives.* Boston: Allyn & Bacon.

Barkan, M. (1962). Transition in art education. *Art Education. 15*(7), 12-18.

———— (1965). Curriculum and the teaching of art. In J. Hausman (Ed.), *Report of the Commission on Art Education.* Reston, VA: National Art Education Association.

———— (1966). Curriculum problems in art education. In E. Mattil (Ed.), *A seminar in art education for research and curriculum development* (U.S. Office of Education Cooperative Research Project #V-0002). University Park: State College, Penn State University.

Barrett, T. (1990). *Criticizing photographs.* Mountain View, CA: Mayfield Press.

Baudrillard, J. (1983). *Simulations.* New York: Semiotext(e).

Belenky, M., Clinchy, B., Goldberger, N., & Tarule, J. (1986). *Women's ways of knowing: The development of self, voice, and mind.* New York: Basic Books.

Bell, C. (1914). *Art.* London: Chatto & Windus.

Berger, J. (1972). *Ways of seeing.* London: Penguin Books.

Berman, M. (1988). The experience of modernity. In J. Thackera (Ed.) *Design after modernism: Beyond the object* (p.36). New York: Thames and Hudson.

Best, S., & Kellner, D. (1991). *Postmodern theory: Critical interrogations.* New York: Guilford Press.

Bowers, C. A. (1988). *The cultural dimensions of educational computing: Understanding the non-neutrality of technology.* New York: Teachers College Press.

Bourdieu, P., & Passeron, J. (1977). *Reproduction in education, society, and culture.* Beverly Hills, CA: Sage.

Bransford, J., Stein, B.S., Shelton, T.S., & Owings, R.A. (1980). Cognition and adaptation: The importance of learning to learn. In J. Harvey (Ed.), *Cognition, social behavior, and the environment* (pp. 93-110). Hillsdale, NJ: Erlbaum.

Brommer, G. F. (1981). *Discovery and art history.* Worchester, MA: Davis Publications, Inc.

Bruner, J. (1960). *The process of education.* Cambridge: Harvard University Press.

———— (1986). *Actual minds, possible worlds.* Cambridge: Harvard University Press.

Bullivant, B. M. (1993). Culture: Its nature and meaning for educators. In J.A. Banks & C.A. McGee Banks (Eds.), *Multicultural education issues and perspectives* (2nd ed., pp 29-47). Boston: Allyn and Bacon.

Burger, P. (1984). *Theory of the avant-garde.* Minneapolis: University of Minnesota Press.

Burgin, V. (1986). *The end of art theory: Criticism and postmodernity.* Atlantic Highlands, NJ: Humanities Press International, Inc.

Carrier, D. (1986). Art and its market. In Hertz (Ed.), *Theories of contemporary art.* New York: Prentice Hall.

———— (1992). Teaching the new art history. In P. Amburgy, D. Soucy, M. Stankiewicz, B. Wilson, & M. Wilson, (Eds.), *The History of Art Education: Proceedings from the Second Penn State Conference, 1989.* Reston, VA: National Art Education Association.

Carroll, D. (1987). *Para-aesthetics.* New York: Methuen.

Cera, J. (1991). *Modernist strong (strangle) holds in postmodern writings.* Unpublished manuscript.

Chadwick, W. (1990). *Women, art & society.* New York: Thames and Hudson.

Chalmers, F. G. (1992). D.B.A.E. as multicultural education. *Art Education, 45*(3), 16-24.

Chapman, L. (1985). *Discover art.* Worcester, MA: Davis Publications.

Cherryholmes, C. (1988). *Power and criticism: Poststructural investigations in education.* New York: Teachers College Press.

Clark, G., Day, M., & Greer, W. D. (1987). Discipline-based art education: Becoming students of art. *Journal of Aesthetic Education, 21*(2), 129-196.

Clifford, J. (1988). *The predicament of culture: 20th century ethnography, literature, and art.* Cambridge: Harvard University Press.

Clifford, J., & Marcus, G. E. (Eds.) (1986). *Writing culture: The poetics and politics of ethnography.* Berkeley, CA: University of California Press.

Collingwood, R. G. (1938). *The principles of art.* Oxford: Clarendon Press.

Collins, J. (1989). *Uncommon cultures: Popular culture and post modernism.* New York: Routledge.

Cowley, M. (1934). *Exile's return.* New York: Viking Press.

Croce, B. (1922). *Aesthetic* (D. Ainslie, Trans.). London: Macmillan. (Original work published 1913)

Culler, J. (1989). *On deconstruction: Theory and criticism after structuralism.* London: Routledge.

Danto, A. (1990). *Encounters and reflections: Art in the historical present* New York: Farrar Straus Giroux .

Derrida, J. (1976). *Of grammatology.* Baltimore: Johns Hopkins University Press.

deLauretis, T. (1987). *Technologies of gender.* Bloomington: Indiana University Press.

Dow, A. W. (1899). *Composition.* New York: Doubleday Doran.

Eagleton, T. (1987-1989). Awakening from modernity. *Times literary supplement* (Feb. 29, 1987) Cited in Harvey, 1989, pp. 7-8.

———— (1990). *Ideology of the aesthetic.* London: Basil Blackwell.

Efland, A. (1976). The school art style: A functional analysis. *Studies in Art Education, 17,* 37-44.

———— (1987). Curriculum antecedents of discipline-based art education. *Journal of Aesthetic Education, 21*(2), 57-94.

———— (1990). Curricular fictions and the discipline orientation in art education. *Journal of Aesthetic Education, 24*(3).

———— (1995). The spiral and the lattice: Changes in cognitive learning theory with implications for art education. *Studies in Art Education. 36*(2), 136–156.

Exhibition statement posted in *AMISH: The art of the quilt.* (1990). M. H. de Young Memorial Museum, San Francisco, CA., June 9-September 2.

Fiedler, L. (1971). *The collected essays of Leslie Fiedler* (Vol. 2). New York: Stein & Day.

Fleming, P. S. (1988). Pluralism and DBAE: Towards a model for global multi-cultural art education. *Journal of Multicultural and Cross-Cultural Research in Art Education, 6*(1), 64-74.

Fish, S. (1980). *Is there a text in this class?* Cambridge, MA: Harvard University Press.

Foucault, M. (1970). *The order of things: An archaeology of the human sciences* (Rev. ed.). New York: Random House.

———— (1965). *Madness and civilization: A history of insanity in the age of reason.* (R. Howard, Trans.) New York: Vintage Books.(Original work published 1961)

Freedman, K. (1987). Art education and changing political agendas: An analysis of curriculum concerns of the 1940s and 1950s. *Studies in Art Education, 29*(1), 17-29.

———— (1989a). Dilemmas of equity in art education: Ideologies of individualism and cultural capital. In W. G. Secada (Ed.), *Equity in education* (pp. 103-117). New York: Falmer.

———— (1989b). Microcomputers and the dynamics of image making and social life in three art classrooms. *Journal of Research on Computing in Education, 21*(3), 290-298.

———— (1991a). Possibilities of interactive computer graphics for art education: A summary of research. *Art Education, 44*(3), 41-47.

———— (1991b). Recent theoretical shifts in the field of art history and some classroom applications. *Art Education, 44,* 40-45.

———— (1993). Aesthetics and the social production of computer graphics. In R. Muffeletto & N. N. Kupfer (Eds.), *Computers in education: Social, political, and historical perspectives* (197-206). Cresskill, NJ: Hampton Press.

Freedman, K., & Popkewitz, T. S. (1988). Art education and social interests in the development of American schooling: Ideological origins of curriculum theory. *Journal of Curriculum Studies, 20*(5), 387-405.

Freedman, K., Stuhr, P., & Weinberg, S. (1989). The discourse of culture and art education. *Journal of Multicultural and Cross-Cultural Research in Art Education, 7*(1), 38-55.

Fry, R. (1925). *Vision and design.* London: Chatto & Windus.

Fuller, P. (1988). The search for a postmodern aesthetic. In Thackera (Ed.), *Design after modernism: Beyond the object.* New York: Thames and Hudson.

Gablik, S. (1984). *Has modernism failed?* New York: Thames and Hudson.

———— (1991). *The reenchantment of art.* New York: Thames and Hudson.

Geertz, C. (1983). *Local knowledge: Further essays in interpretive anthropology.* New York: Basic Books.

Gettings, F. (1963). *The meaning and wonder of art.* New York: Golden Books.

Giroux, H. A. (1992). *Border crossings: Cultural workers and the politics of education.* New York: Routledge.

Giroux, H. A., & Simon, R. I. (1989). *Popular culture, schooling and everyday life.* Granby, MA: Bergin & Garvey.

Glaser, R. (1984). Education and thinking: The role of knowledge. *American psychologist, 39,* 93-104.

Gollnick, D. M., & Chinn, P. C. (1986). *Multicultural education in pluralistic society* (2nd ed). Columbus, OH: Charles E. Merrill Publishing Co.

Goodman, P. (1960). *Growing up absurd.* New York: Vintage Books.

Goodenough, W. H. (1976). Multiculturalism as the normal human experience. *Anthropology and Education Quarterly, 7*(4), 4-6.

Graff, G. (1987). *Professing literature: An institutional history.* Chicago: University of Chicago Press.

———— (1988). Teach the conflicts. In B. J. Craig (Ed.), *Literature, language, and politics.* Athens: University of Georgia Press.

Grant, C. & Sleeter, C. (1989). Race, class, gender, exceptionality, and educational reform. In J.A. Banks & C.A. McGee Banks (Eds.), *Multicultural education issues and perspectives* (1st ed., pp. 49-66.) Boston: Allyn and Bacon.

——— (1993). Race, class, gender, and disability in the classroom. In J.A. Banks & C.A. McGee Banks (Eds.), *Multicultural education issues and perspectives* (2nd ed., pp. 49-66). Boston: Allyn and Bacon.

Greenberg, C. (1961). Avant garde and kitsch. In C. Greenberg, (Ed.), *Art and Culture* (pp. 3–21). New York: Beacon Press. (Originally published in 1939 in *Partisian Review*)

Haggerty, M. (1935). *Art a way of life.* Minneapolis: University of Minnesota Press.

Hamblen, K. (1989). The reality construction of technocratic-rationality through DBAE. *Journal of the Social Theory Caucus in Art Education, 9,* 49-52

Harris, M. (1979). *Cultural materialism: The struggle for a science of culture.* New York: Random House.

Harvey, D. (1989). *The condition of postmodernity: An enquiry into the origins of cultural change.* Oxford: Basil Blackwell.

Hassan, I. (1971). *The dismemberment of Orpheus: Toward a postmodern literature.* Madison: University of Wisconsin Press.

Hawkins, J., Sheingold, K., Gearhart, M., & Berger, C. (1982). Impact on the social life of elementary classrooms. *Journal of Applied Developmental Psychology, 3,* 361-373.

Henley, D. R. (1991). Affective expression in post-modern art education: Theory and intervention. *Art Education, 44*(2), 16-22.

Holt, D. K. (1990). Post-modernism vs. high-modernism: The relationship to D.B.A.E. and its critics. *Art Education, 43*(2), 42-46.

Horne, D. (1986). *The public culture.* London: Pluto Press Ltd.

Hutcheon, L. (1989). *The politics of postmodernism.* London: Routledge.

Huyssen, A. (1990). Mapping the postmodern. In Nicholson (Ed.), *Feminism/Post Modernism* (pp. 234–277). New York: Routledge.

Jameson, F. (1985). Postmodernism and consumer society. In H. Foster (Ed.), *Postmodern culture.* London: Pluto.

Jencks, C. (1977). *The language of postmodern architecture* (5th ed.). London: Academy Editions.

——— (1987). *Post-modernism: The new classicism in art and architecture.* New York: Rizzoli.

——— (1989). *What is post-modernism?* (3rd ed.). London: St. Martin's.

——— (1991). Postmodern vs. Late-Modern. In I. Hoesterey (Ed.), *Zietgiest in Babel: The postmodernist controversy.* Bloomington: Indiana University Press.

Jones, O. (1982). *The Grammar of ornament.* New York: Van Nostrand Reinhold. (Originally published by another author in 1856)

Kincheloe, J. E., & Steinberg, S. R. (1993). A tentative description of postformal thinking: The critical confrontation with cognitive theory. *Harvard educational review, 63*(3), 296-320.

Kipnis, L. (1986). 'Refunctioning' reconsidered: Towards a left popular culture. In C. MacCabe, (Ed.), *High theory/ low culture.* New York: St. Martin's Press.

Kuhn, T. (1970). *The structure of scientific revolutions* (2nd ed.). Chicago: University of Chicago Press. (Originally published in 1962)

Lacan, J. (1977). *Ecrits*. New York: Norton.

Levin, K. (1988). Sofa-sized pictures. In K. Levin, (Ed.), *Beyond modernism: Essays on art from the 70s and 80s* (pp. 143-150). New York: Harper and Row.

———— (1988). Farewell to modernism. In K. Levin, (Ed.), *Beyond modernism: Essays on art from the 70s and 80s*. New York: Harper and Row.

Levine, L. (1988). *Highbrow/lowbrow: The emergence of cultural hierarchy in America*. Cambridge: Harvard University Press.

Lewis, J. (1990). *Art, culture and enterprise: The politics of art and the cultural industries*. London & New York: Routledge.

Lippard, L. R. (1990). *Mixed blessings*. New York: Pantheon Books.

Lyotard, J. F. (1983). Regles et paradoxes et appendice svelte. *Babalone 1*, 67-80 [Rules and paradoxes and svelte appendix]. In *Cultural critique*, 1986-87, 5 Winter, 209-219 (B. Massumi, Trans.)

———— (1984). *The postmodern condition: A report on knowledge*. Minneapolis: University of Minnesota Press. (Trans. by G. Bennington & B. Massumi).

McCoy, M. (1989). Problems in industrial design. In *ARTU: Bulletin of the University of Industrial Arts: Helsinki*. Helsinki, Finland.

Naisbitt, J. (1982). *Megatrends: Ten new directions for transforming our lives*. New York: Warner Books.

Nash, M. (1989). *The cauldron of ethnicity in the modern world*. Chicago: The Chicago University Press.

National Commission on Excellence in Education. (1983). *A nation at risk: The imperative for educational reform*. Washington: Government Printing Office.

Nicholson, C. (1989). Postmodernism, feminism, and education: The need for solidarity. *Educational Theory*, *39*(3), 197-205.

Nochlin, L. (1990).*The politics of vision: Essays on nineteenth century art and society*. New York: Harper and Row.

———— (Ed.) (1990). *Feminism/Postmodernism*. New York: Routledge.

Norris, C., & Benjamin, A. (1988). *What is deconstruction?* New York: St. Martins Press.

Osborne, H. (1955). *Aesthetics and criticism*. New York: Philosophical Library.

Owens, C. (1983). The discourse of others. In H. Foster (Ed.), *The Anti-aesthetic*. Seattle, WA: Bay Press.

Parks, M. (1989). Art education in a post-modern age. *Art Education*, *42*(2), 10-13.

Pevsner, N. (1961). *Pioneers of modern design from William Morris to Walter Gropius*. London and New York: Penguin Books.

Presiosi, D. (1989). *Rethinking art history: Meditations on a coy science*. New Haven, CT: Yale University Press.

Rabinow, P. (1986). Representations are social facts: Modernity and post-modernity in anthropology. In J. Clifford & G. E. Marcus (Eds.), *Writing culture: The poetics and politics of ethnography* (pp. 234-261). Berkeley: University of California Press.

Ragland-Sullivan, E. (1986). *Jacques Lacan and the philosophy of psychoanalysis*. Urbana: University of Illinois Press.

Readings, B. (1991). *Introducing Lyotard: art and politics* (pp. xxii). London and New York: Routledge.

Rorty, R. (1979). *Philosophy and the mirror of nature*. Princeton: Princeton University Press.

Rose, M. A. (1991). *The post-modern and the post-industrial: A critical analysis*. Cambridge: Cambridge University Press.

Rousenau, P. M. (1992). *Post-modernism and the social sciences: Insights, inroads, and intrusions*. Princeton: Princeton University Press.

Rugg, H., & Shumaker, A. (1928). *The child-centered school*. New York: World Book Co.

Sawicki, J. (1991). *Disciplining Foucault*. New York: Routledge, Chapman and Hall, Inc.

Schinneller, J. (1968). *Art, search and self discovery*. Scranton, PA: International Textbook Co.

Schon, D. A. (1987). *Educating the reflective practitioner*. San Francisco: Jossey-Bass.

Sontag, S. (1972). *Against interpretation*. New York: Deli.

Sleeter, C. E. & Grant, C. (1987). An analysis of multicultural education in the U. S. *Harvard Educational Review, 57*(4).

Sleeter, C. & Grant, C. (1988). An analysis of multicultural research in the U. S. *Harvard Educational Review, 57*(4), 421-445.

Sloan, D. (1980). *The computer in education: A critical perspective*. New York: Teachers College Press.

Smith, G. A. (1992). *Education and the environment: Learning to live with limits*. Albany: State University of New York Press.

Snedden, D. (1917). The waning powers of art. *American journal of sociology, 23*, 801-821.

Spiro, R., Coulson, R., Feltovich, P., & Anderson, D. (1988). Cognitive flexibility theory: Advanced knowledge acquisition in ill-structured domains. In *Technical Report No. 441*. Campaign: Center for the Study of Reading, University of Illinois

Stuhr, P. (1995). A social reconstructionist approach to multicultural art curriculum design based on the powwow. In R.W. Neperud (Ed.), *Context, content, and community: A post postmodern art education*. Teachers College Press.

Stuhr, P., Petrovich-Mwaniki, L., & Wasson, R. (1992). Guidelines for the multicultural art classroom. *Art Education, 45*(1), 16-24.

Sully, J. (1890). *Studies in childhood* (pp. 298-330). London: Longmans & Green Co.

Ulmer, G.L. (1985). *Applied grammatology: Post(e)-pedagogy from Jacques Derrida to Joseph Beuys*. Baltimore, MD: John Hopkins University Press.

Vasari, A. (1946). *Vasari: Lives of the artists*. B. Burroughs (Ed.). New York: Simon and Shuster.

Walker Art Center (1990). *Walker Art Center: Painting and sculpture from the collection*. New York & Minneapolis: Rizzoli & Walker Art Center.

Wasson, R., Stuhr, P., & Petrovich-Mwaniki, L. (1990). Teaching art in the multi-cultural classroom: Six position statements. *Studies in Art Education, 31*(4), 234-246.

Wilson, B. & Wilson, M. (1982). *Teaching children to draw: A guide for teachers and parents*. Englewood Cliffs, NJ: Prentice Hall.

Winslow, L. (1939). *The integrated school art program*. New York: McGraw Hill.

Wolfe, T. (1989). *The painted word*. London: Black Swan Books. (Original work published 1975, April, in Harpers Magazine)

Ziegfeld, E. (1944). *Art for daily living: The story of the Owatonna Project*. Minneapolis: University of Minnesota Press.

Ziff, P. (1986). The task of defining a work of art. In R. A. Smith (Ed.), *Excellence in art education: Ideas and initiatives*. Reston, VA: National Art Education Association. (Original work published 1953 in *The Philosophical Review, 62*(1), 60-61.)

Zurmuehlen, M. (1992). Post modernist objects: A relation between past and present. *Art Education, 45*(5), 10-17.